HISTORIC PHOTOS OF
NASHVILLE
IN THE 50s, 60s, AND 70s

TEXT AND CAPTIONS BY ASHLEY DRIGGS HAUGEN

TURNER
PUBLISHING COMPANY

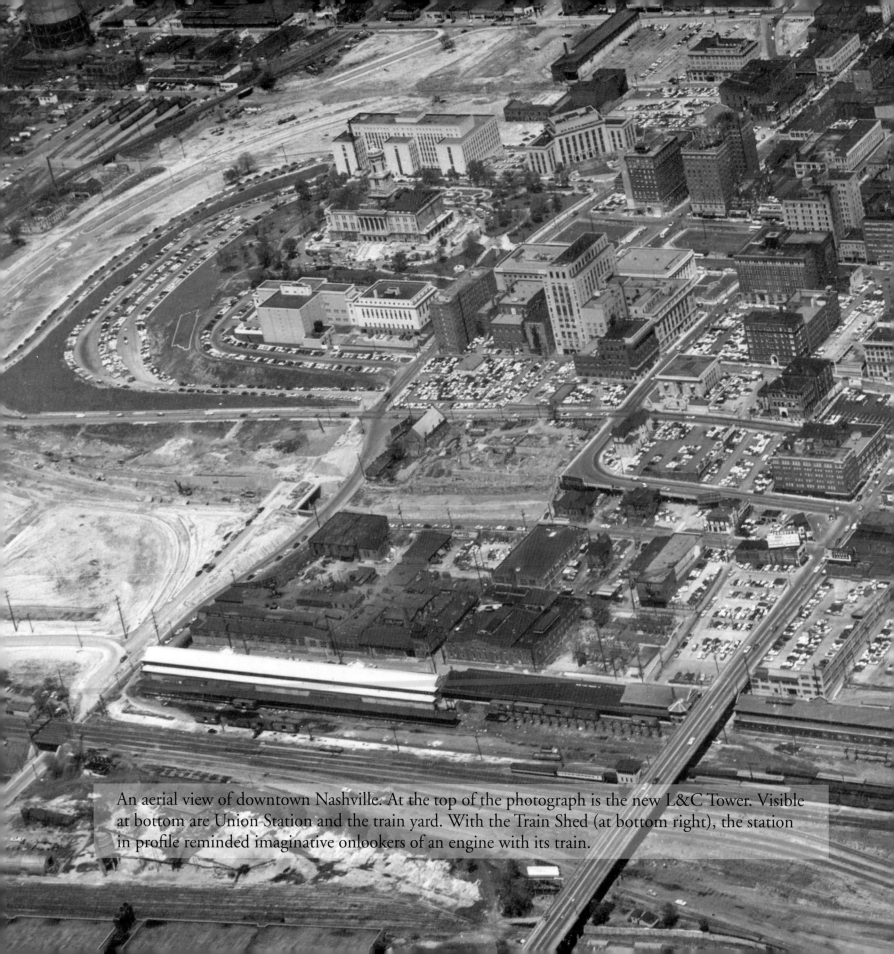

An aerial view of downtown Nashville. At the top of the photograph is the new L&C Tower. Visible at bottom are Union Station and the train yard. With the Train Shed (at bottom right), the station in profile reminded imaginative onlookers of an engine with its train.

HISTORIC PHOTOS OF
NASHVILLE
IN THE 50s, 60s, AND 70s

Turner Publishing Company
200 4th Avenue North • Suite 950
Nashville, Tennessee 37219
(615) 255-2665

www.turnerpublishing.com

Historic Photos of Nashville in the 50s, 60s, and 70s

Library of Congress Control Number: 2009922629

ISBN: 978-1-59652-539-9

Printed in the United States of America

09 10 11 12 13 14 15 16—0 9 8 7 6 5 4 3 2 1

CONTENTS

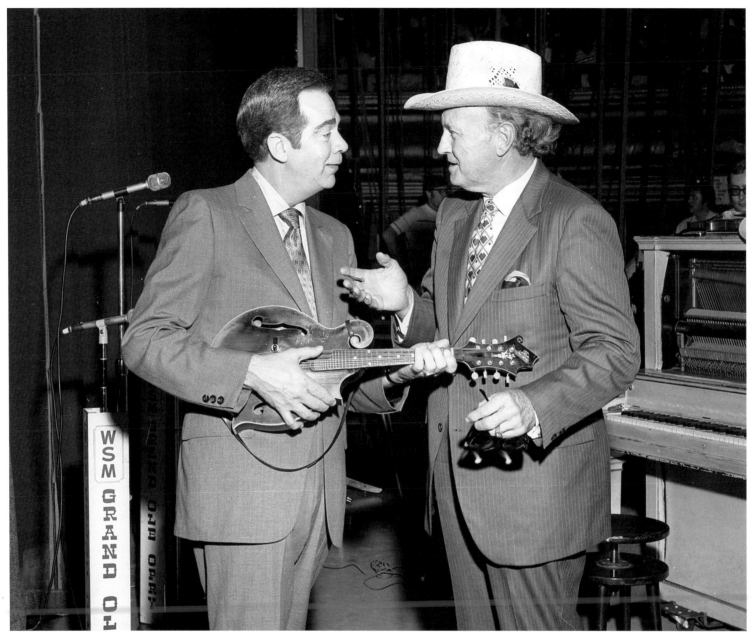

Bluegrass legend Bill Monroe is shown here at the Opry in the 1970s. Often venerated as "the Father of Bluegrass," Monroe joined the Grand Ole Opry in 1939.

Acknowledgments

This volume, *Historic Photos of Nashville in the 50s, 60s, and 70s,* is the result of the cooperation and efforts of many individuals and organizations. It is with great thanks that we acknowledge the valuable contribution of the following for their generous support:

Brenda Colladay, Museum and Photograph Curator, Grand Ole Opry

Deborah Oeser Cox, Metro Davidson County Archives

Chip Curley, Nashville history enthusiast

Ken Fieth, Metro Archivist

Leila Grossman, Owner, Grannis Photography

Aubrey B. Harwell, Jr., Chief Manager, Neal & Harwell, PLC

Bill Lundy

Special Collections Division of the Nashville Public Library

Jimmie and Elizabeth Stevens

———————

Prints of images appearing in this publication can be purchased by visiting the Grannis Photography Web site at

www.grannisphotography.com

PREFACE

In the footsteps of the wildly popular *Historic Photos of Nashville,* we present *Historic Photos of Nashville in the 50s, 60s, and 70s,* a continuation of the pictorial journey of this great southern metropolis. The photographs presented on the following pages come exclusively from the archives of longtime Nashville photographer Bob Grannis of Grannis Photography. His collection is still highly regarded as an intriguing and appreciative look at all that was Nashville in the decades most directly shaped by the watershed events of World War II.

These photographs were selected from thousands of Grannis's negatives, all of which have been carefully preserved by Leila Grossman, who purchased Grannis Photography in 1997. The photos selected for inclusion in this book represent Nashville in the truest sense, as a city that rode the postwar high in the fifties, weathered the political, social, and cultural changes of the sixties, and eventually settled into the seventies as a rapidly growing and expanding metropolis.

The images, which span the postwar era up to the late 1970s, showcase Nashville during its most developmentally vulnerable period. As the city emerged following World War II, her citizens were eager for good things they hoped would come—and nothing seemed impossible! In the 1950s, downtown Nashville flourished, relishing its role as the go-to spot for shopping, dining, and leisure activities. For school kids, the Children's Museum in the Peabody Building on Rutledge Hill, with its O-gauge model railroad, mysterious grand pendulum pacing the foyer, and two shrunken heads lining the balustrade of a creaky wooden staircase, was not to be missed. The decade was a storybook time that held an almost tangible air of confidence.

In the late 1950s and 1960s, the consolidation of government, desegregation, the building of the Interstate system, and relaxing of the blue laws brought significant political, cultural, and social shifts. Nashville was seeking to shed its "Old South" image in favor of something deemed more sophisticated. By the 1970s, downtown prosperity had begun to subside as Nashvillians left in droves for the suburbs and urban restructuring kicked into high gear. One harbinger of what was to come was 100 Oaks Mall off Powell Avenue beside Thompson Lane, erected so quickly that shoppers treading its

shuddering floors wondered aloud whether it might collapse. This shoppers' mecca proved so popular that malls began sprouting up in outlying areas citywide. Nashville as its citizens had known it, was becoming a thing of the past.

Nashville's history is rich, and its more recent history is arguably the most interesting. A lot happened in three decades, and the images on the following pages are evidence of those changes. Mr. Grannis's photographic documentation of all that occurred during these volatile years is a treasure trove for all who love Nashville. His photographic eye undeniably captured the city like no one else, and his images tell the city's story quite poignantly all by themselves. Look closely at each photograph and the not-so-distant history captured in each one. Perhaps you will recognize some of the places and faces. You will likely recollect a time "way back when." More than anything, perhaps you will experience both a memory and a smile.

—Ashley Driggs Haugen

A bird's-eye view of the L&C Tower, Nashville's first modern skyscraper. In the foreground at right, the Sudekum Building at 535 Church Street stood tall as Nashville's leading example of Art Deco architecture. The building was razed in 1992 behind a sign that announced, "If it was built, we'll wreck it."

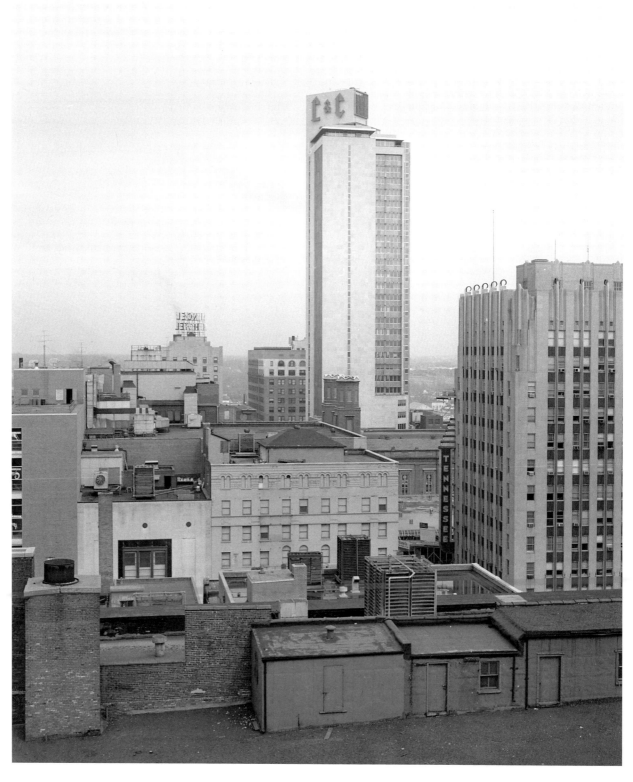

AFTER THE WAR

(1946–1959)

Following World War II, Nashville enjoyed a postwar boom. The general mood was that of celebration—"If we can triumph in a world war, we can conquer anything!" People were buying houses and cars, and higher education was becoming a possibility and a priority. Americans who once had thought they could never afford college were now attending universities on the GI Bill. In the Athens of the South, they attended David Lipscomb College, Watkins Institute, Belmont College, and Vanderbilt University, among others.

Five-and-dimes, department stores, and luncheonettes flourished in the downtown area. Among them was Varallos chili parlor, which would celebrate its 100th anniversary in 2007 as Nashville's oldest eatery. It was during the 1950s that the Capitol underwent the first of two restorations, and the L&C Tower was erected, claiming the title as the tallest skyscraper in the Southeast, at least for a time. Families dressed up for a drive downtown, whether to shop, dine, or simply to take in the sights.

The 1950s were also the defining decade for Nashville's music industry. The city was officially ordained "Music City USA," and the opening of numerous recording studios and record labels helped mold 16th and 17th avenues into what is now the world-famous Music Row. The Country Music Association was founded, and the Grand Ole Opry had comfortably settled into its home at the Ryman Auditorium, where it remained until moving to Opryland in 1974. By the 1960s, the connection between Nashville and music had been made. When local TV's Miss Nancy, host of "Romper Room," asked one youngster where she lived, the tongue-tied youth couldn't think "Nashville," so she replied "Music City USA."

Whether attending parades, hanging out at Fair Park, or simply watching a Nashville Vols game at Sulphur Dell, Nashvillians were enjoying the good life. The city was thriving, and its people enjoyed being a part of it.

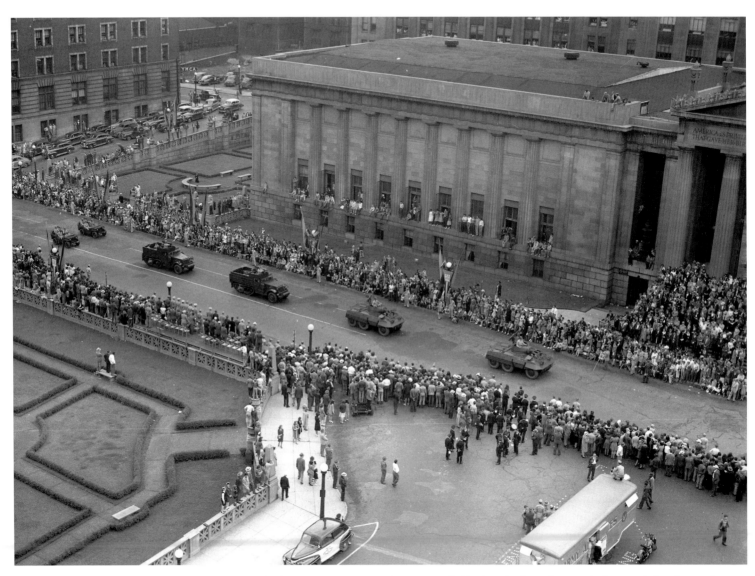

A celebration commemorating the sesquicentennial of Tennessee in June 1946 was attended by hundreds. Military vehicles paraded in front of War Memorial Plaza on Capitol Boulevard. A United States commemorative stamp was issued in observance of the milestone.

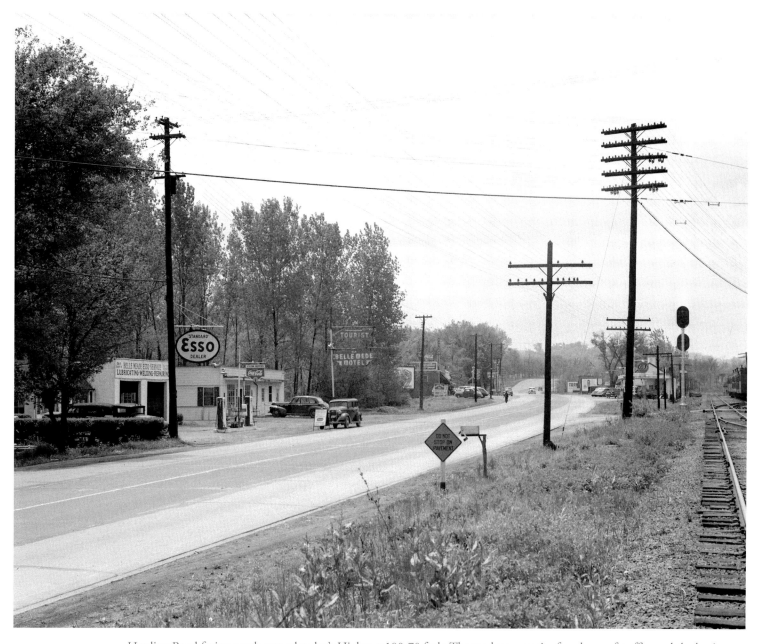

Harding Road facing south toward today's Highway 100-70 fork. The road now carries four lanes of traffic, and the businesses pictured are long since gone. The building housing the Gulf Station at right is today home to Global Motorsports auto dealership, and not too far away is Nashville's time-honored toy store, Phillips Toy Mart. The nation's worst railroad accident occurred in 1918 along this Nashville-to-Memphis railroad line at Dutchman's Curve, a mile or two northeast of the area in view here.

Fourth Avenue South facing north toward Broadway, around 1947. Businesses in view include Hardison Seed in the foreground, and in the distance, Third National Bank.

4

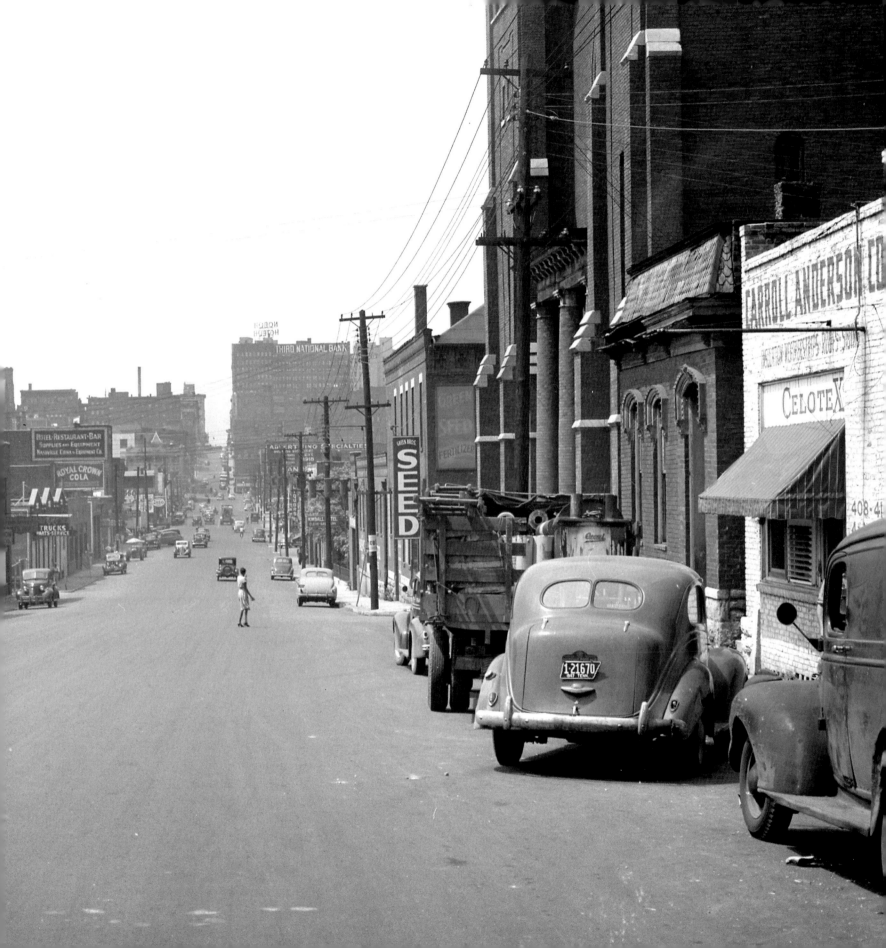

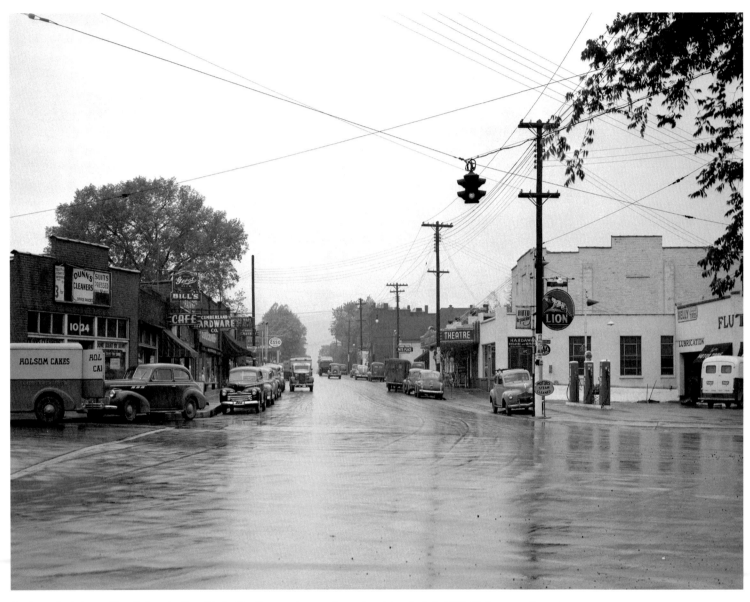

A rainsoaked day at Five Points in East Nashville. Forrest Avenue is on the right. At left, Bill's Cafe serves Gerst beer, a longtime Nashville favorite brewed locally up to 1954.

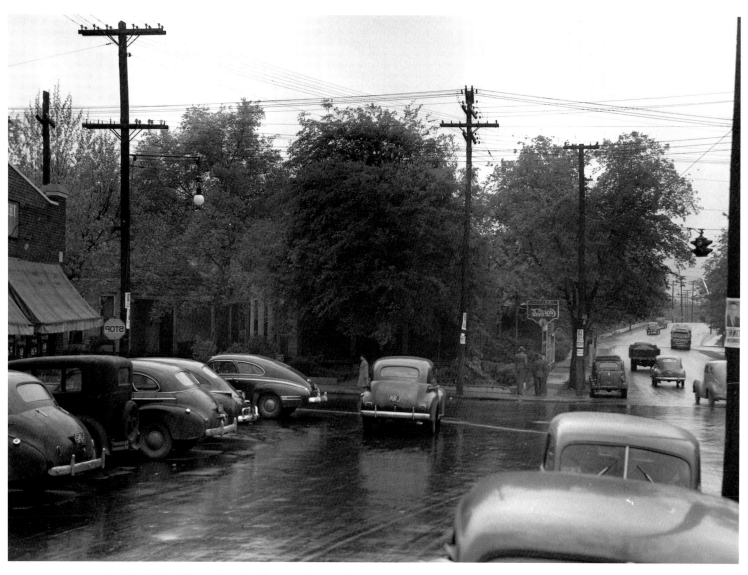

An East Nashville neighborhood. From the great fire of 1916 to the tornado of 1998, the city's east side has weathered its share of natural disasters, yet has managed to preserve the charm of its historic neighborhoods.

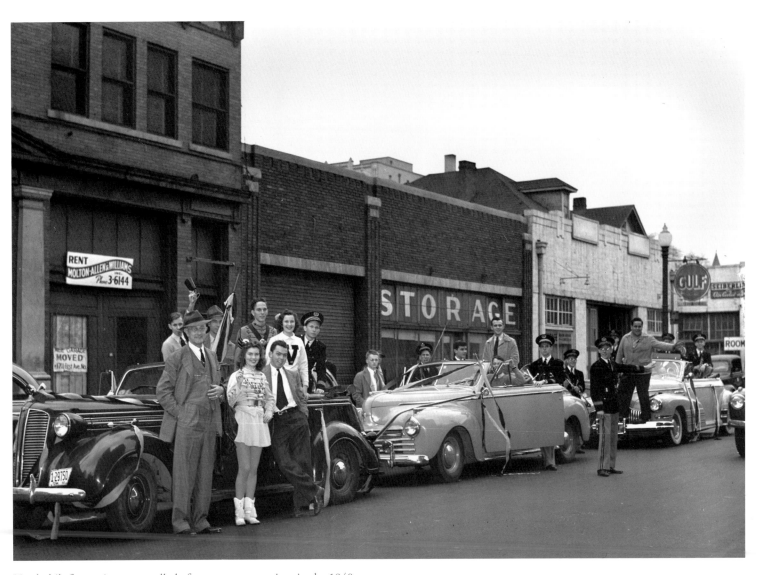

Vanderbilt fans enjoy a pep rally before a game sometime in the 1940s.

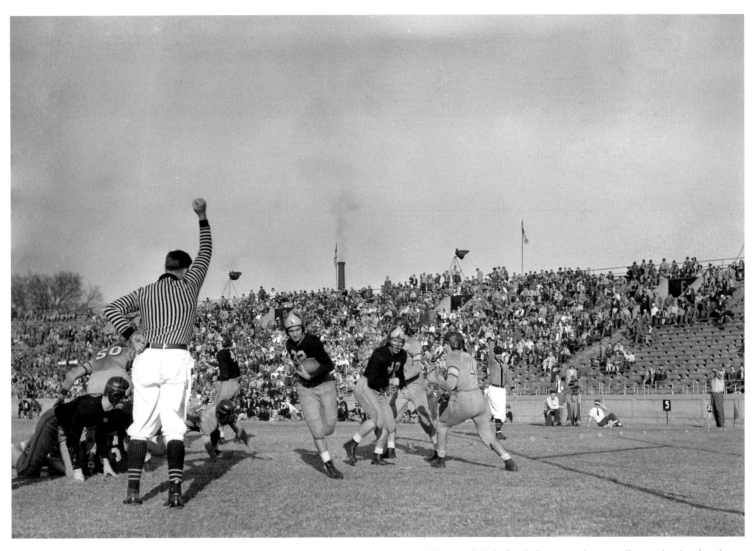

At this 1940s Vanderbilt football game, players still wore leather headgear.

Following Spread: A wintry day left Nashville covered in snow. This photograph shows West End Avenue, facing downtown. The white stone bungalow at center is the only structure in view still standing today, and it is believed the arboreal elders that still nod quietly to every alert motorist are the same magnolia trees visible in the front yard here.

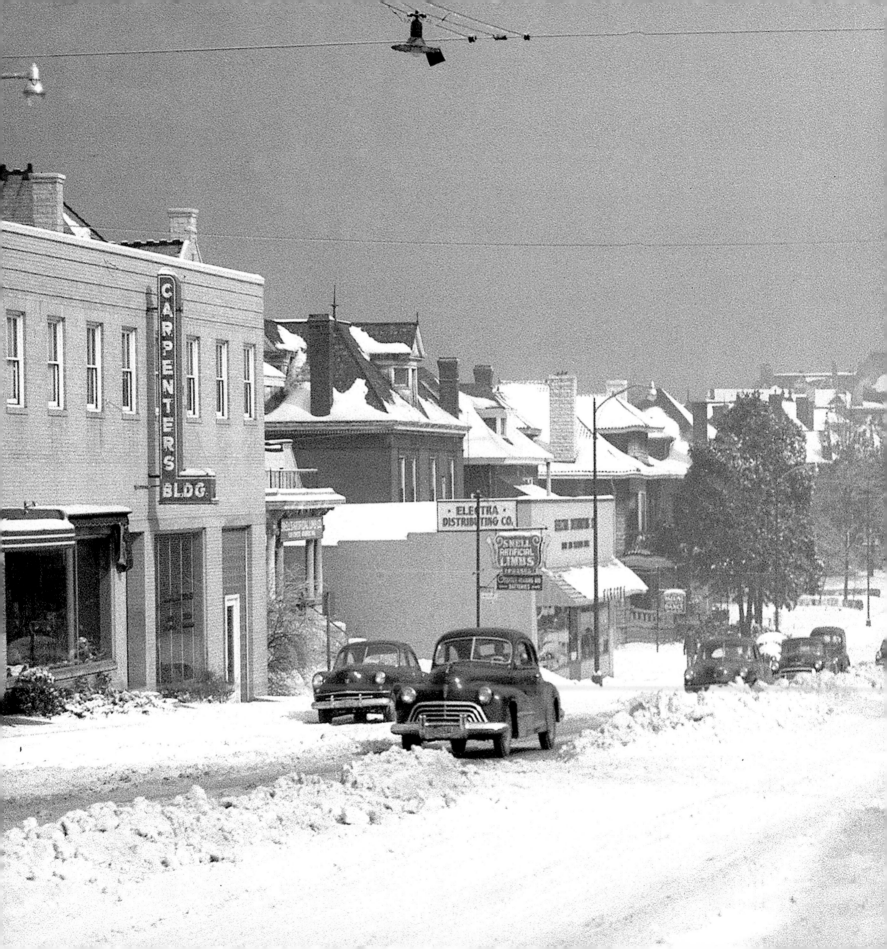

The scene at the corner of Eighth Avenue and Lafayette Street on a day in the 1950s. To this day, Nashvillians do not agree on how to pronounce "Lafayette," which becomes Highway 41 on its way to Murfreesboro, Chattanooga, and eventually, Florida. To the right, Eighth Avenue becomes Highway 31 (Franklin Road) to Franklin.

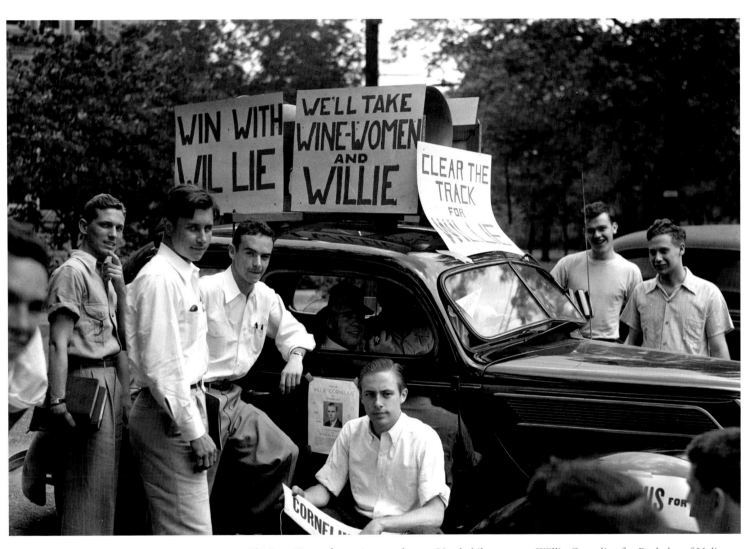

Phi Beta Kappa fraternity members at Vanderbilt promote Willie Cornelius for Bacheler of Ugliness.

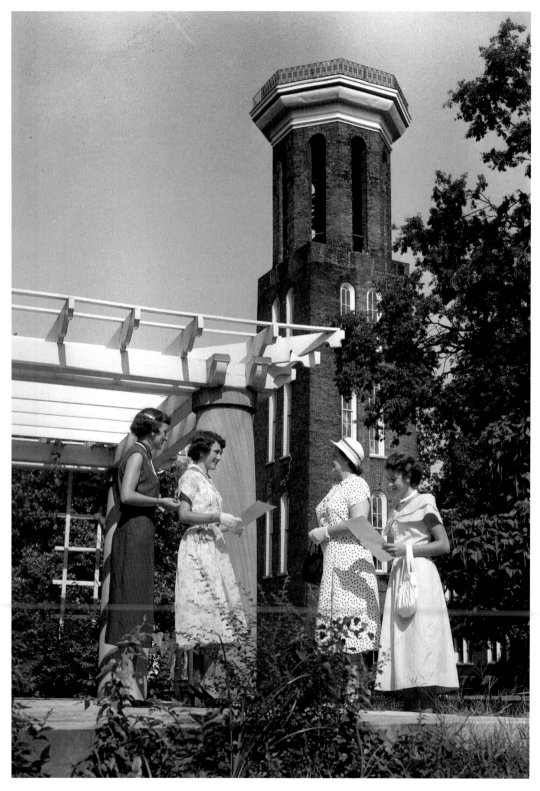

Women gather on the Belmont campus in 1951, the same year the school became the co-ed Belmont College. Prior to that year, the school was known as Ward-Belmont and was an all-girls educational institution.

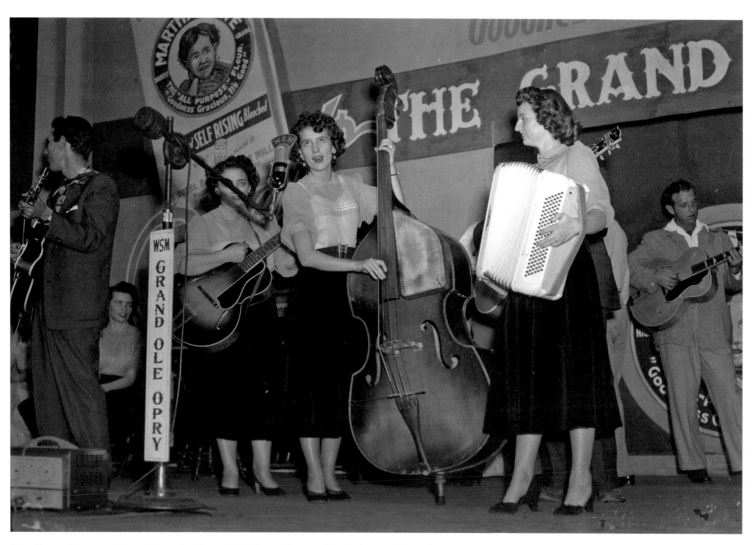

The Carter Sisters perform live at the Grand Ole Opry. From left to right are Chet Atkins, June Carter (seated), Maybelle Carter, Anita Carter, and Becky Bowman.

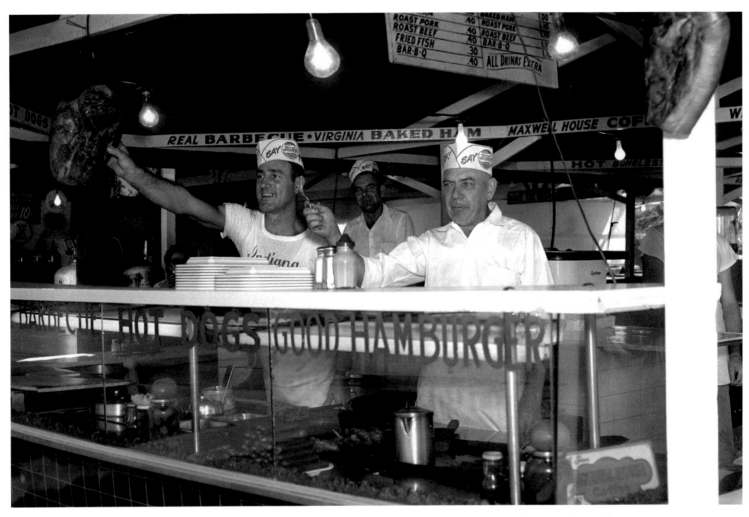

"Real Barbecue" is 40 cents at the concessions stand at the 1951 Tennessee State Fair. Begun in 1869 to showcase the state's agricultural products, by the 1950s the fair had become a prized event for school kids and their families each September.

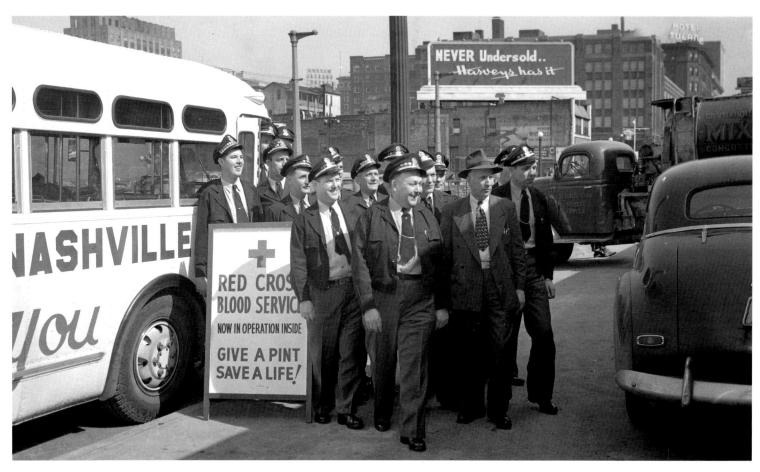

Bus drivers arrive to donate blood at the American Red Cross.

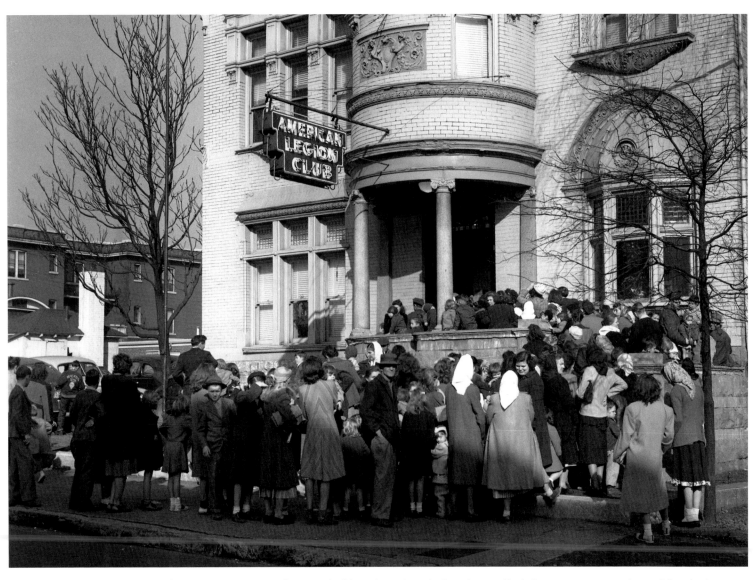

The American Legion, photographed here in 1952 at its location on Sixth Avenue, was a popular social gathering spot.

Members of the American Legion ham it up for a photographer. The fellow at left seems to have a well-supplied bag of tricks for regaling the happy group.

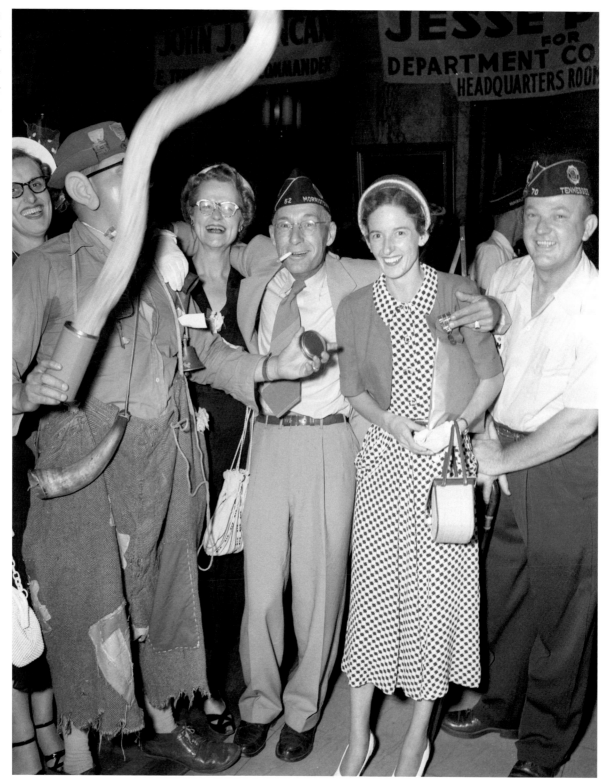

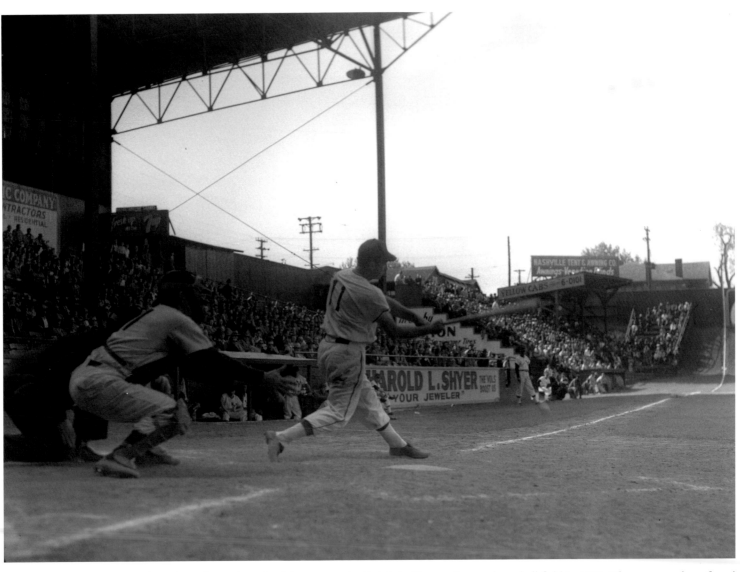

Sulphur Dell Stadium, located north of the state capitol in Nashville, was first used as a ball field in 1870. The area was also referred to as Sulphur Springs Bottoms, for the natural sulphur spring that ran through the area. In the nineteenth century, residents drank the sulphurous waters medicinally. Babe Ruth himself came to town in 1927 to play an exhibition game at the stadium. Sulphur Dell baseball ended early in the 1960s, but the stadium would linger until 1969, when it was dismantled.

A crowd at Sulphur Dell stadium in 1953 enjoys soft drinks at the game. Famed sportswriter Grantland Rice, who began his career in Nashville, gave the stadium its name. Rice is perhaps best remembered for the words, "For when the one Great Scorer comes to write against your name, / He marks—not that you won or lost—but how you played the game."

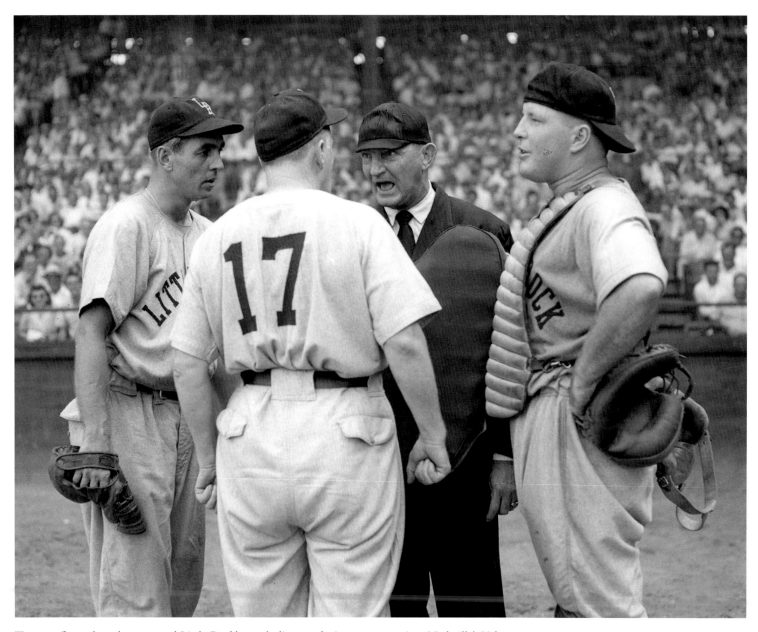

Tempers flare when the ump and Little Rock's coach disagree during a game against Nashville's Vols.

Equipment is checked before a Nashville Vols game in 1952.

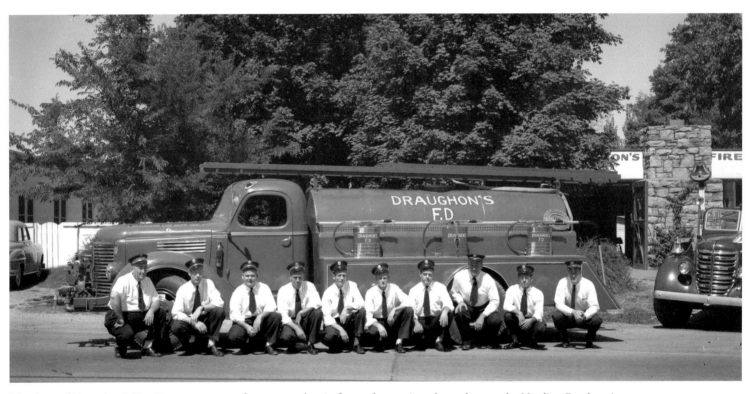

Members of Draughon's Fire Department pose for a group shot in front of an engine, shown here at the Harding Road station.

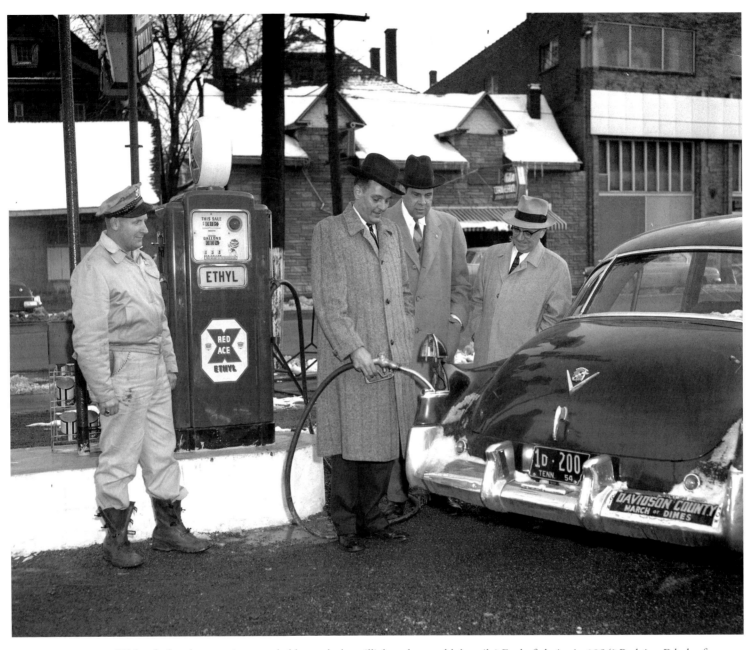

With a fuel tank reservoir concealed beneath the taillight, who wouldn't smile? Fuel of choice in 1954? Red Ace Ethyl, of course. Across the street is Rotiers Restaurant, still in business at its Elliston Place location today. Originally the carriage house for a West End home, Rotiers is known far and wide for its cheeseburgers and milkshakes.

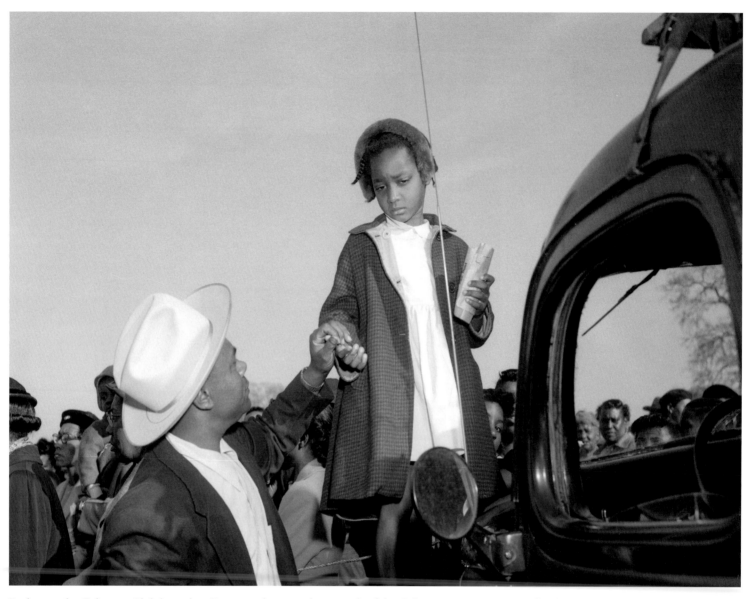

Each year, the Colemere Club hosted an Easter egg hunt on the grounds of the Colemere Mansion on Murfreesboro Road, which later became New Orleans Manor restaurant. This hunt was under way in the early 1950s.

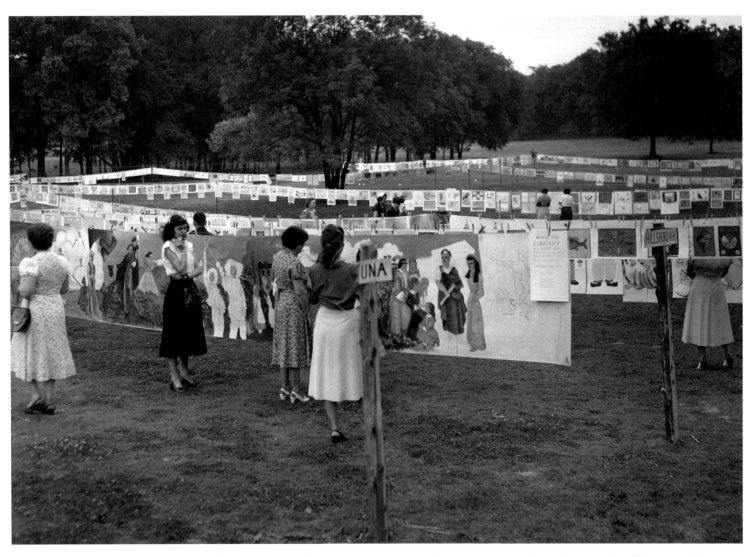

Various area schools showcase student artwork in an art show at Percy Warner Park off Highway 100. In the foreground is a mural by Hillsboro High School students. Created in 1927, Percy and Edwin Warner parks have long been popular retreats prized by local Nashvillians.

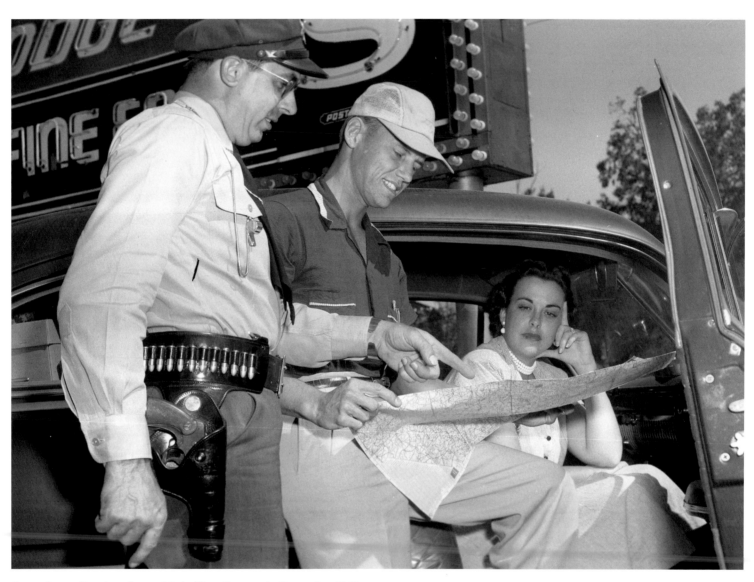

A couple get directions from a Nashville policeman in September 1953.

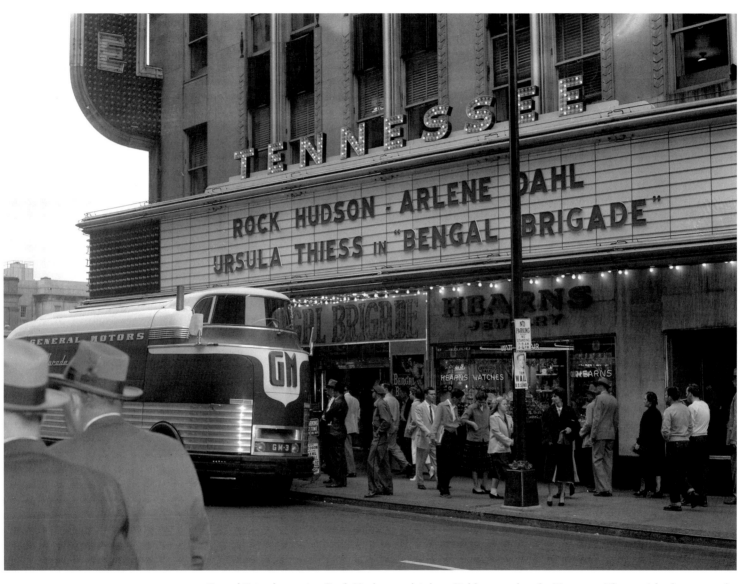

Bengal Brigade, starring Rock Hudson and Arlene Dahl, opened at the Tennessee Theater (also known as the Sudekum Building) on Church Street in 1954.

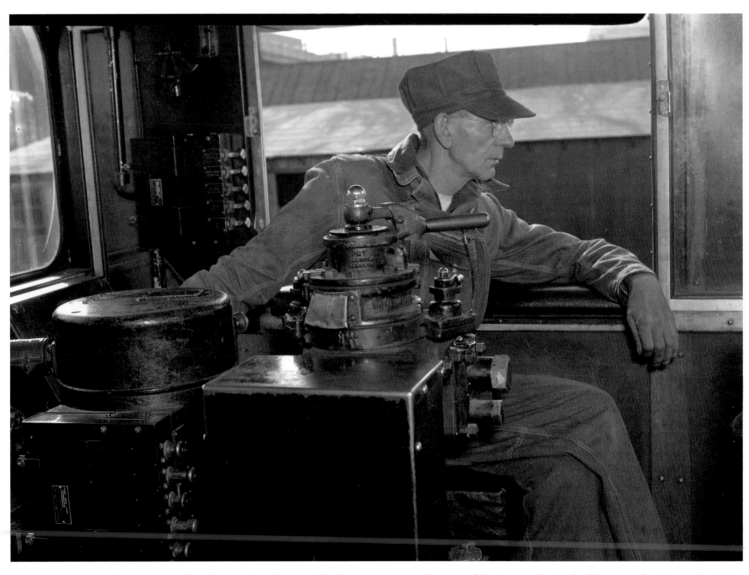

Sporting overalls and an engineer's cap, a diesel train engineer takes care of business at the Nashville terminal in December 1952.

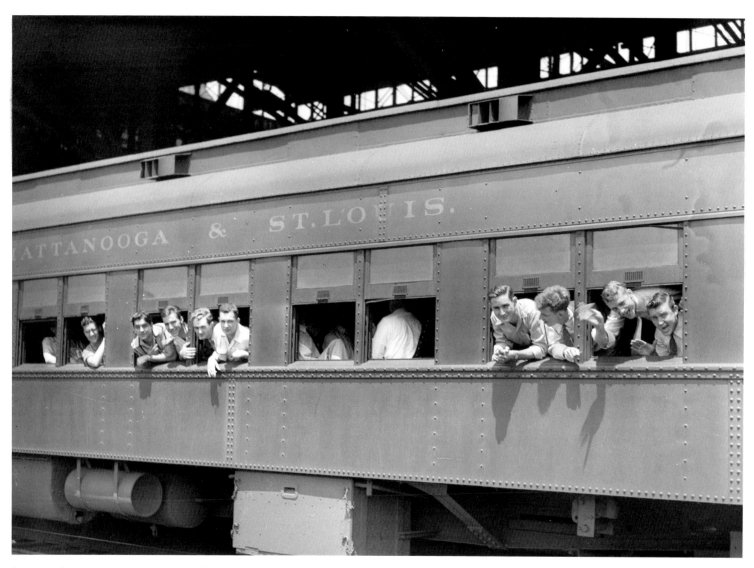

In 1953, these men are en route for military training on the "Dixie Flyer," a well-known train that chugged through Nashville's Union Station along its route from the Midwest to Florida. The passenger car idles beneath the Train Shed, the largest single-span, gabled-arch structure in the world when it opened in 1900. Five hundred feet long and 250 feet wide, the shed could provide trackside shelter for 10 trains side by side. The centenarian was razed in early 2001 amid public outcries for its preservation.

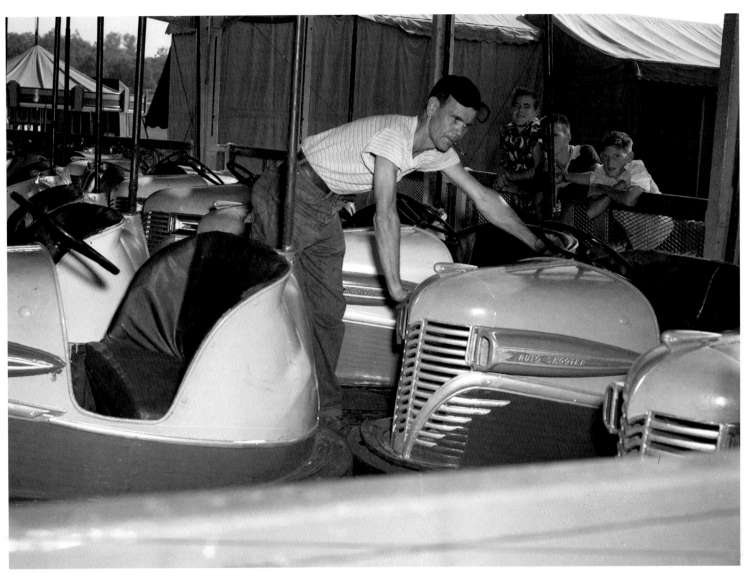

The bumper cars were long a favorite attraction at Fair Park, located at the state fairgrounds. Other ever-popular rides included the giant wooden roller coaster known as the Skyliner, and for younger tikes, the miniature railroad handcars.

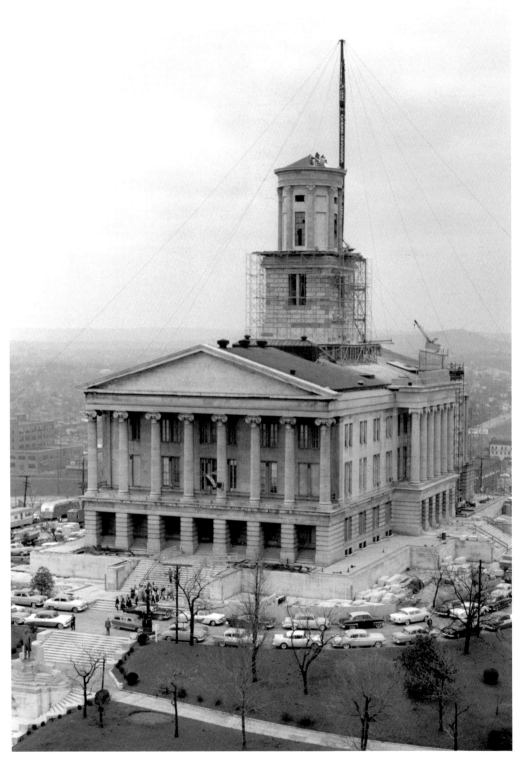

The Tennessee State Capitol in downtown Nashville, designed by William Strickland in the Greek Revival style, was built over a period of 14 years from 1845 to 1859. By the 1950s, the building was in need of restoration, shown here in progress. In 1970, the structure was added to the National Registry of Historic Places, and in 1971, it was designated a National Historic Landmark. A time capsule buried on the Capitol grounds in 1927 will be unearthed in 2027. Nashvillians are advised to mark their calendars.

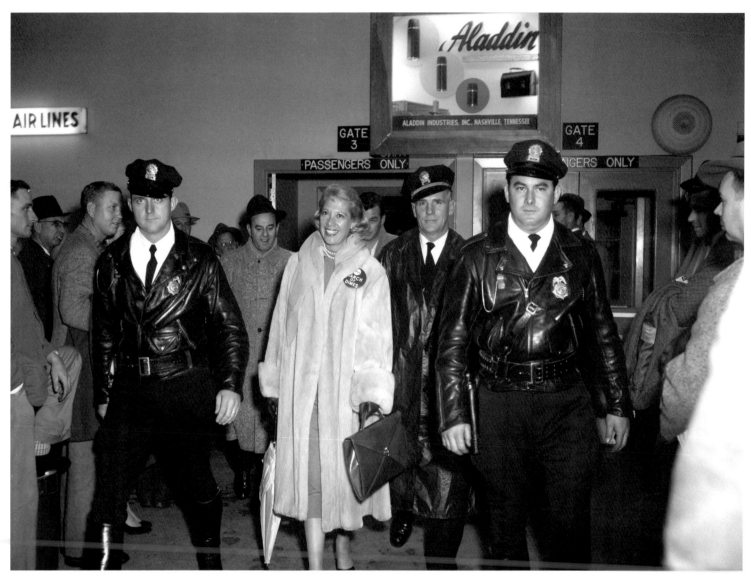

Born in Winchester, Tennessee, singer and actress Dinah Shore attended Hume Fogg High School in Nashville and later Vanderbilt, where she was a cheerleader. She made a return visit to Nashville at the height of her career in the early 1950s.

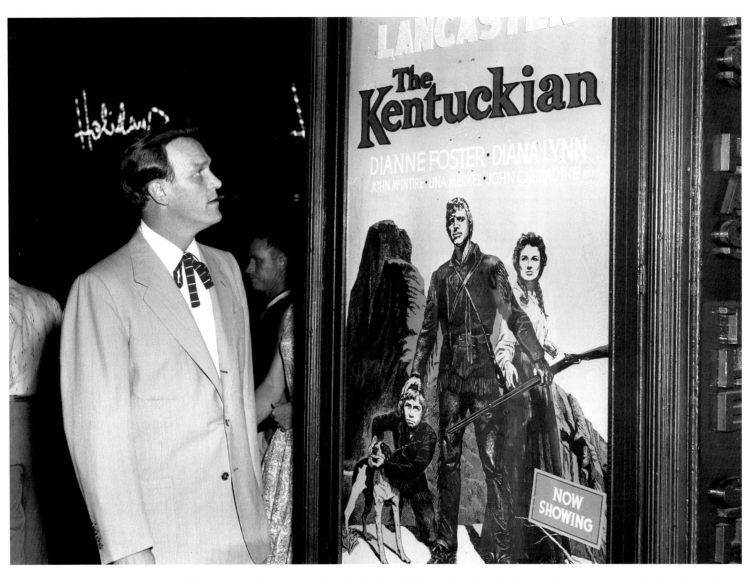

Eddy Arnold, who recorded "Cattle Call" and "Kentuckian Song," observes the movie poster for *The Kentuckian,* a 1955 movie release starring Burt Lancaster and showing at the Loew's Theater downtown. In his later years, Arnold was sometimes spotted dining at the widely enjoyed Belle Meade Cafeteria.

Eddy Arnold performs at the WMAK-radio toy drive in
November 1950.

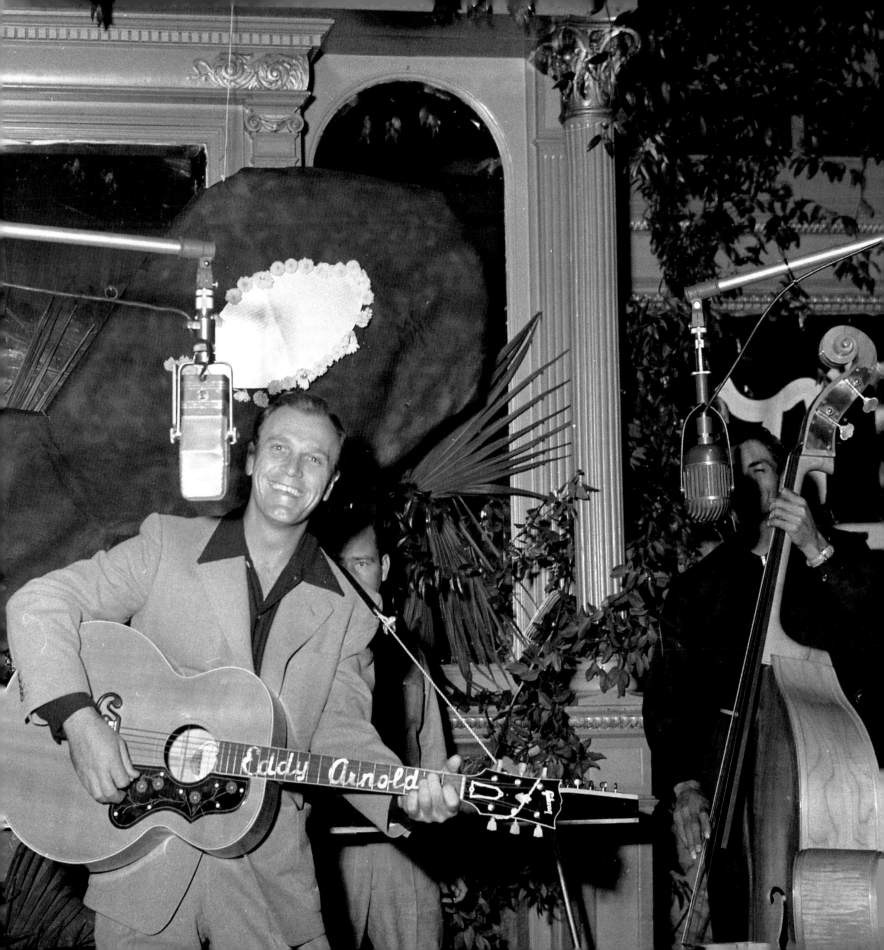

Vanderbilt graduates line up before commencement
near College Hall.

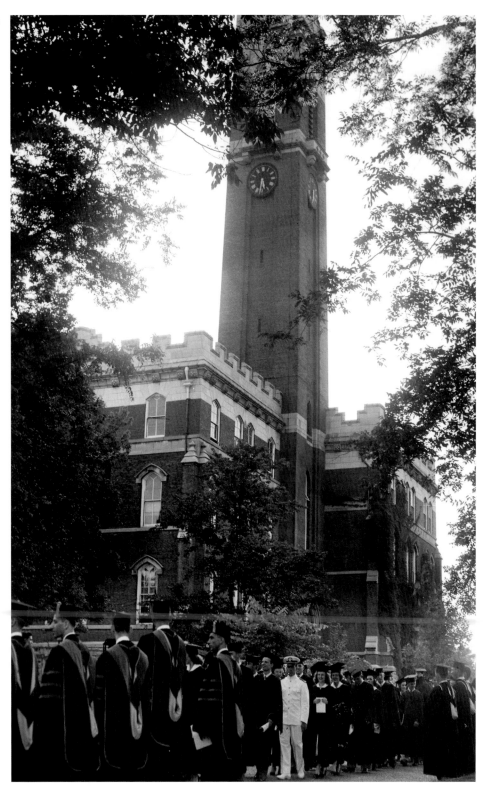

Overbrook School students participate in May Day activities in May 1954. Overbrook School, located on the Dominican Campus on Harding Road, opened in 1936 with nine students. It still operates at the same location, albeit in a new building, serving students in grades preK through eight.

Coffee was a dime and a steak dinner was 65 cents at this Fifth Avenue eatery, shown here around 1950. Fifth Avenue was home to several five-and-dime stores, each of which featured diners similar to this one.

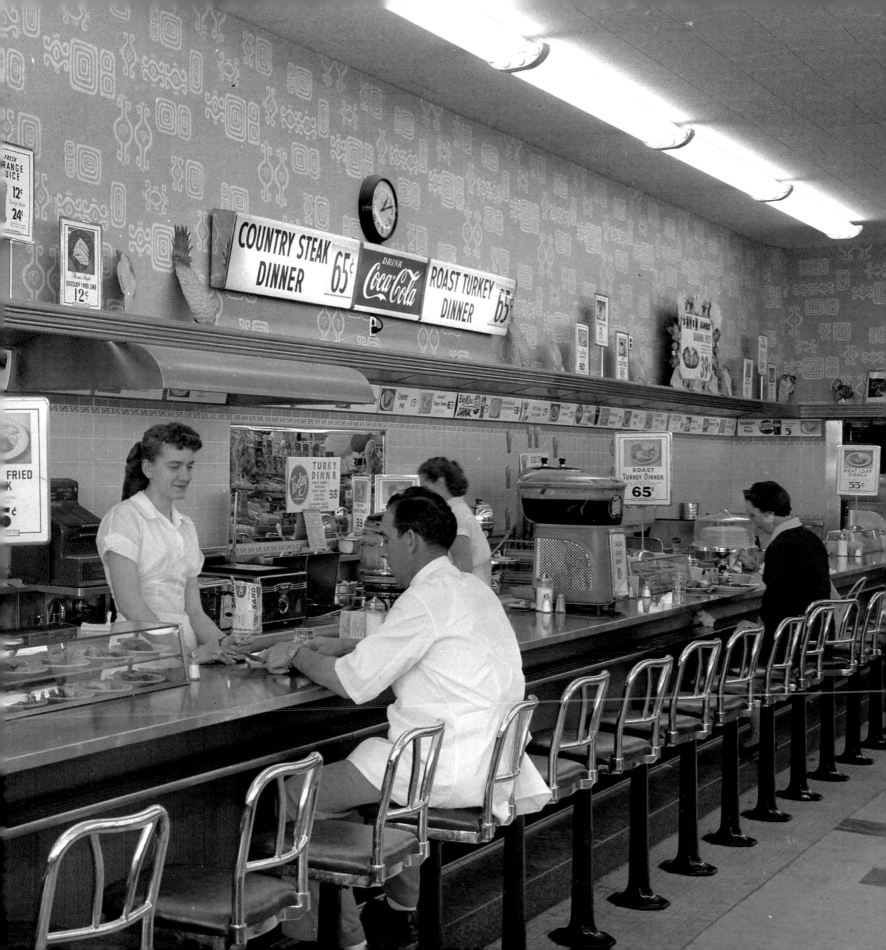

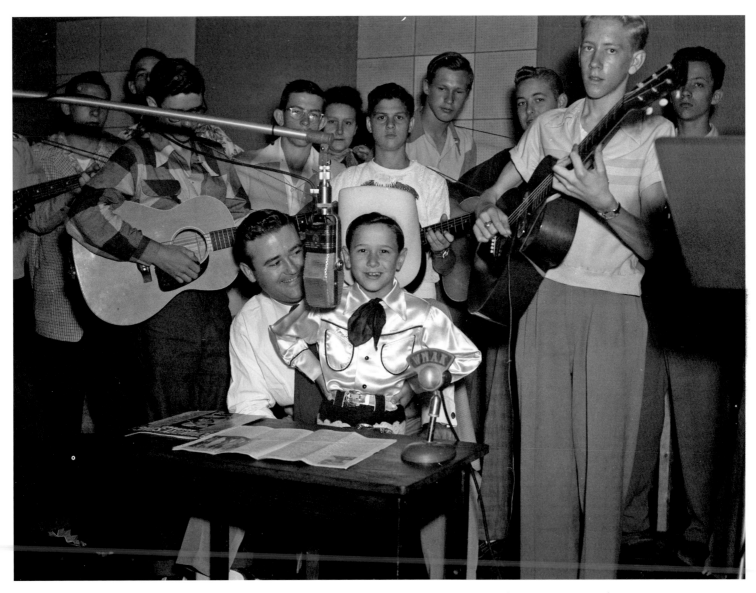

WMAK disc jockey and longtime music businessman Joe Allison (beside one talented youngster) makes some music inside the WMAK studio at the Maxwell House Hotel at Fourth and Church.

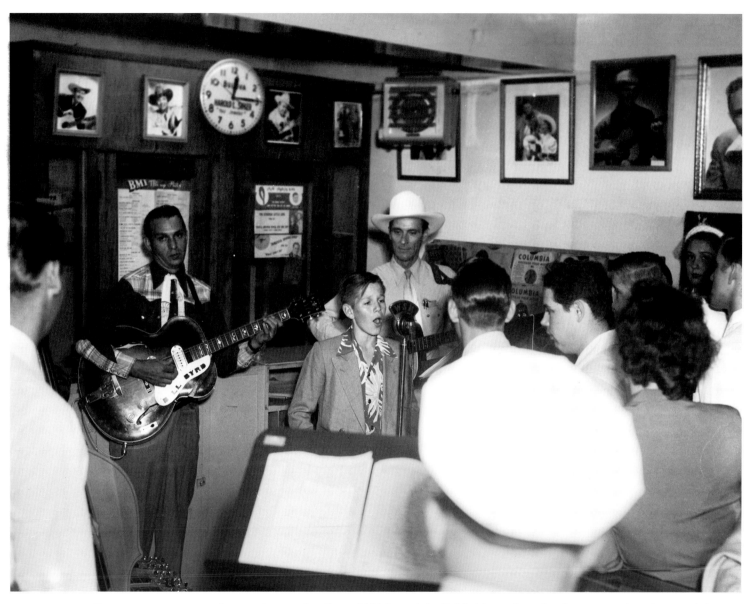

For many years, country singer and songwriter Ernest Tubb hosted the "Midnight Jamboree" radio program from his record shop on lower Broadway every Saturday night following the Grand Ole Opry. Billy Byrd is on guitar; Tubb is in the white hat.

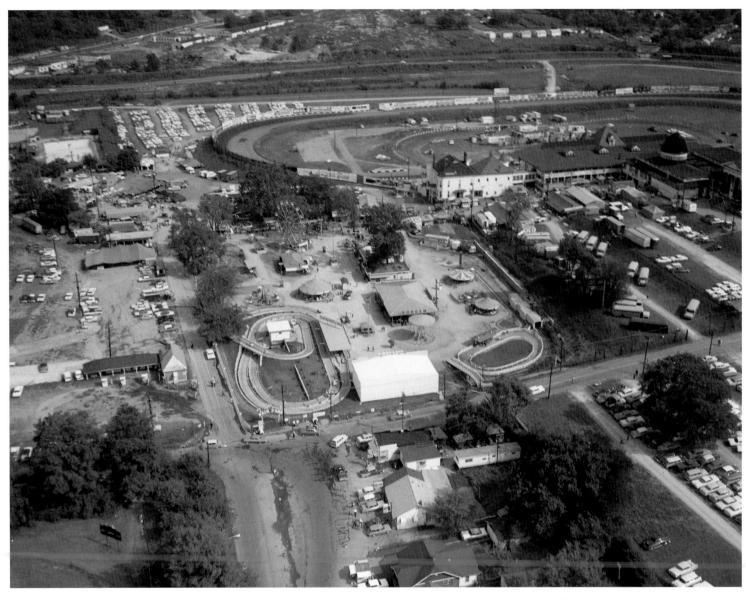

Fair Park, located in south Nashville off Wedgewood Avenue, was an entertainment paradise. The grounds included putt-putt golf, the Cascade Plunge swimming pool, an amusement park, and more.

Work is under way on the Ferris wheel at Fair Park amusement park in 1953.

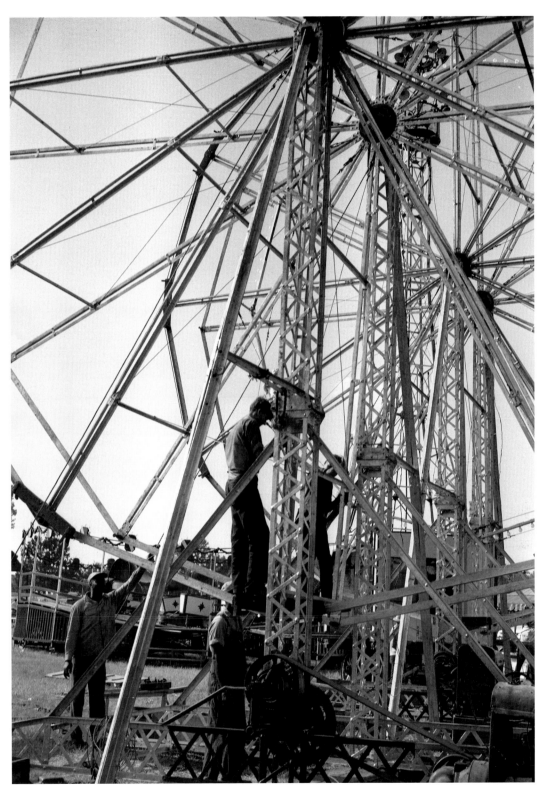

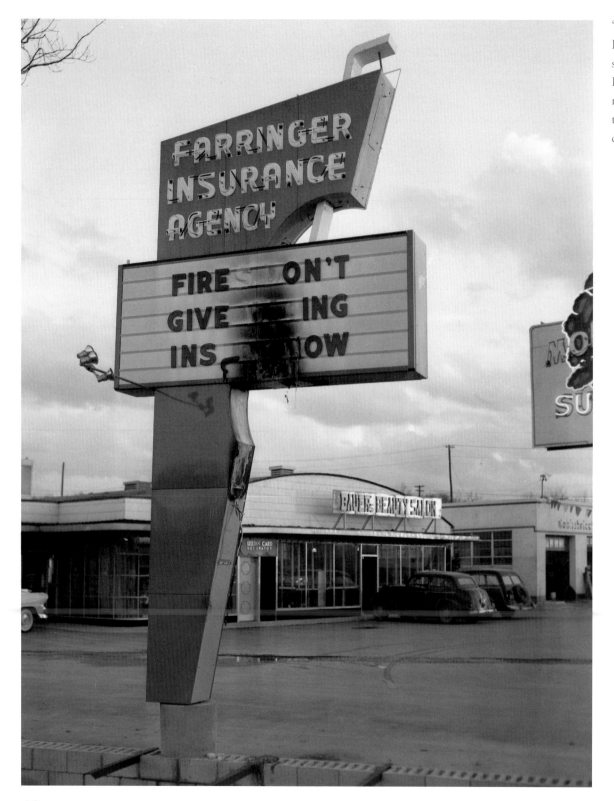

"Fires Don't Give Warning. Insure Now," read the signage for Farringer Insurance Company, which must have been preoccupied that day with filing its own claim.

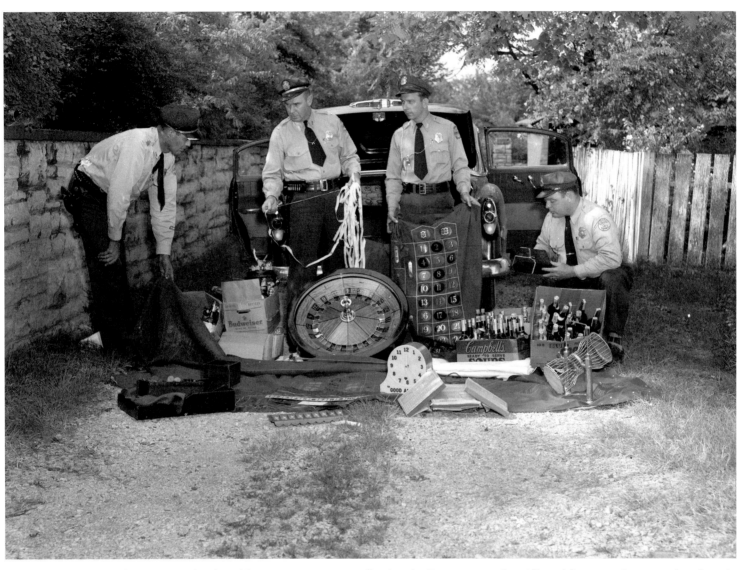

Police uncover a local gambling operation in 1953, illegal under Tennessee state law. All gambling operations were shut down in 1964 when prominent Nashville attorney James Neal was appointed U.S. Attorney by President Lyndon B. Johnson.

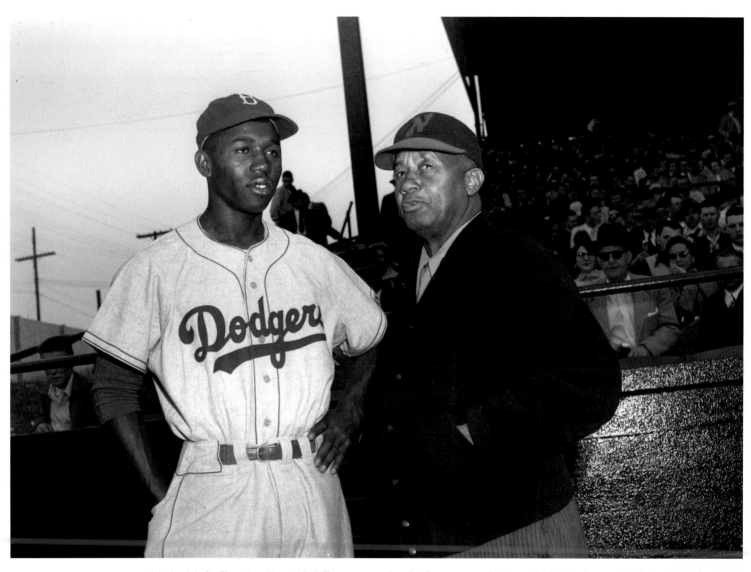

Native Nashvillian Jim "Junior" Gilliam returned to his hometown playing with the Dodgers at Nashville's Sulphur Dell. He is pictured here with Willie White, at right. Sulphur Dell would later meet its end in 1963.

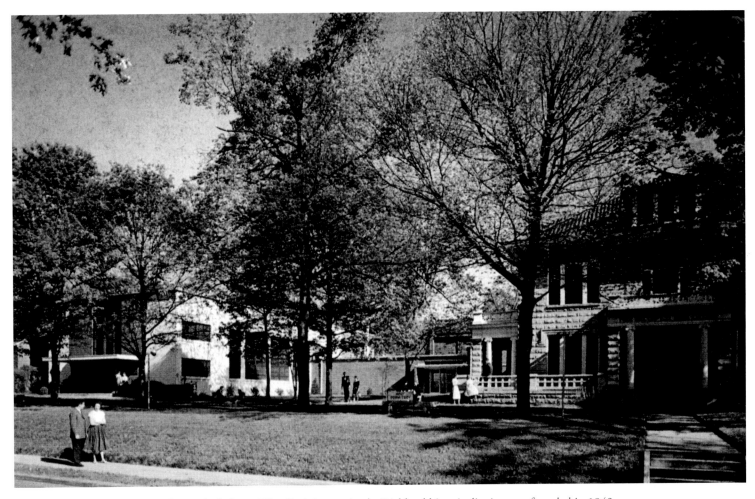

The Free Will Baptist Bible College, which fronts West End Avenue in the Richland historic district, was founded in 1942 with eight students. The handsome buildings on campus offer pleasant surroundings for student scholars, who still come to the school from far and wide to pursue a Bible-based education.

Following Spread: The Billy Graham Crusade lit up Vanderbilt's Dudley Field in September 1954. As of 2008, he had preached to an estimated 2.2 billion people across the globe, more than any other Protestant. Throughout its history, printing and publishing have contributed enormously to Nashville's economy. Prominent in religious publishing are interdenominational Thomas Nelson, and for Southern Baptists like Graham, Lifeway Publishing.

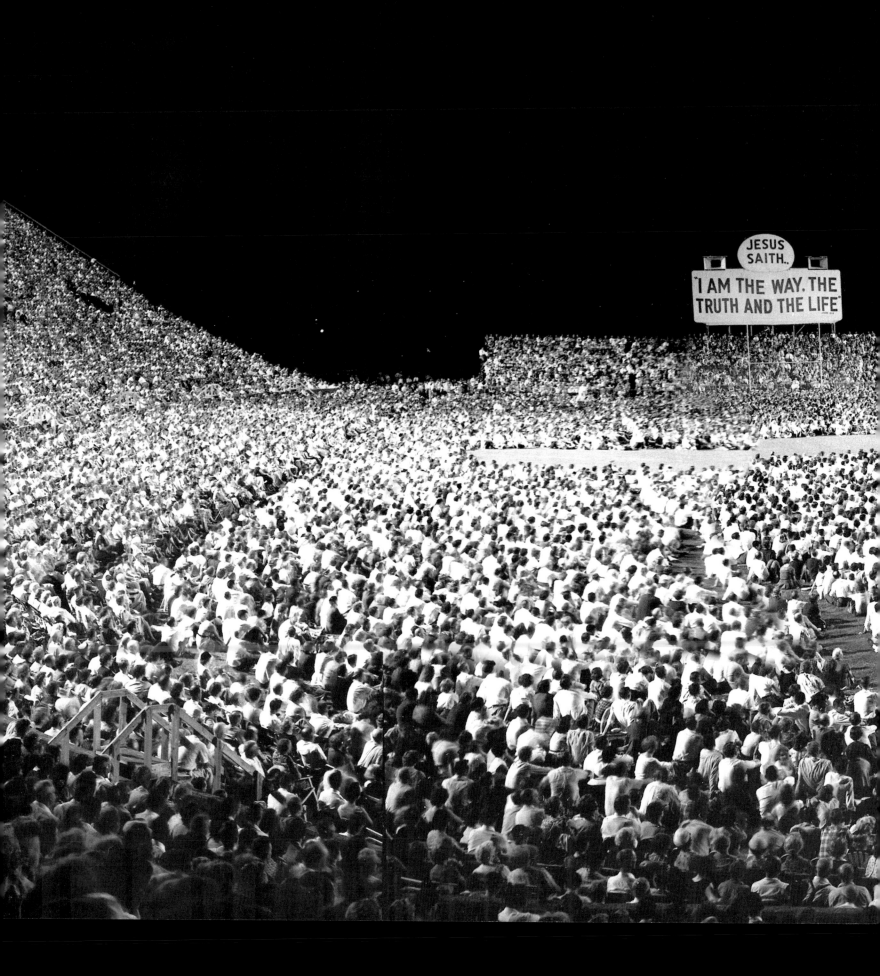

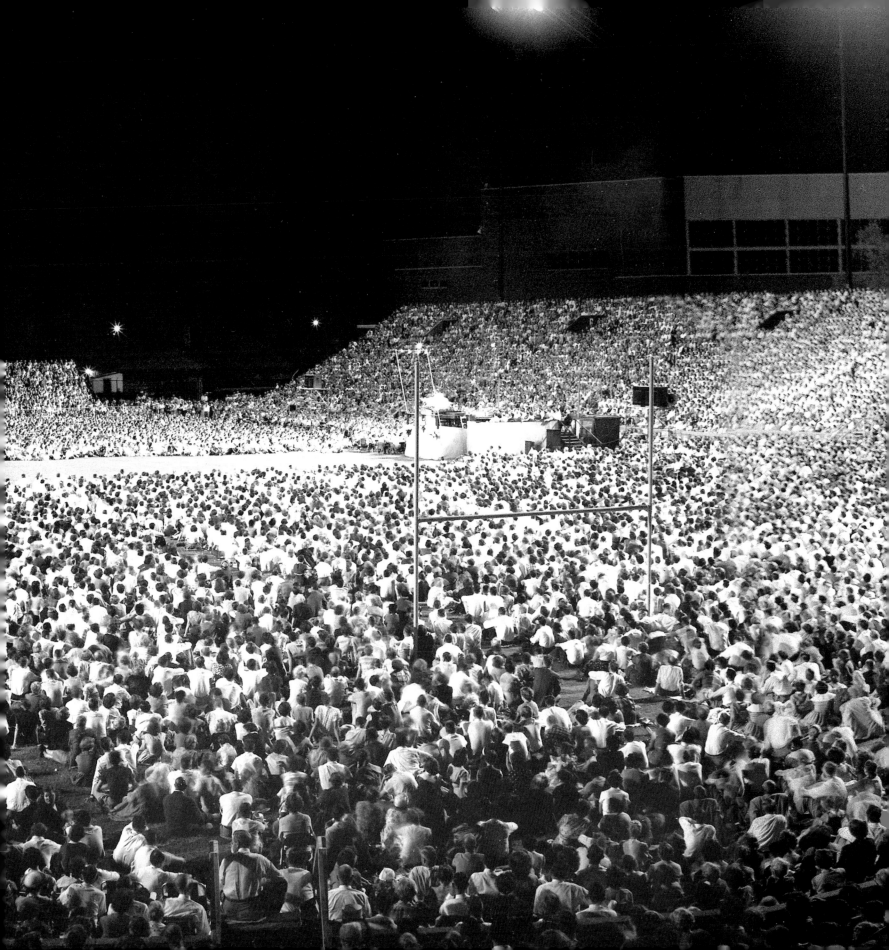

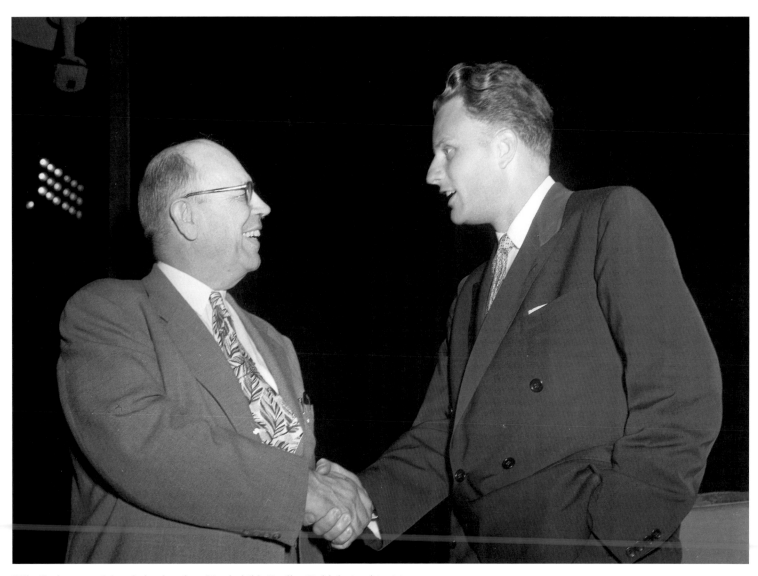

Billy Graham, at right, shakes hands at Vanderbilt's Dudley Field during his visit.

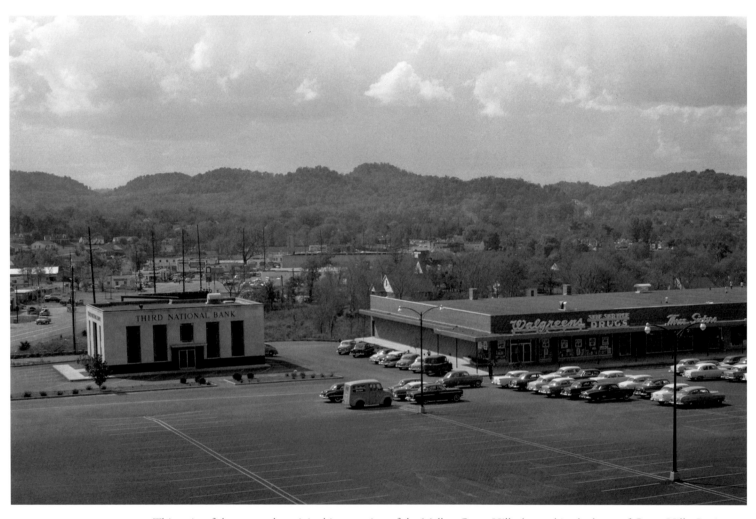

This strip of shops was the original incarnation of the Mall at Green Hills, located in the heart of Green Hills. Businesses occupying the strip in the fifties and sixties included Woolworth's five-and-dime, local photography and artist supply store Dury's, Family Booterie shoes, Castner-Knott department store, and others. Hillsboro Road is visible at left.

An exterior shot of Church Street downtown. In view are Grant's five-and-dime store, Chesters, and in the distance, Castner-Knott. At left is the building that once housed Watkins Institute, a school for budding artists founded by local businessman Samuel Watkins in 1885. Known today as Watkins College of Art, Design and Film, the school offers B.F.A. degrees in various art specialties at its new facility in MetroCenter.

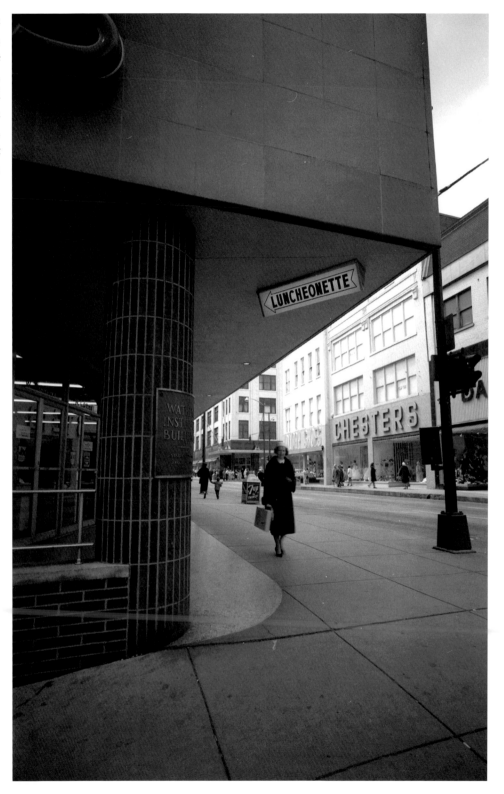

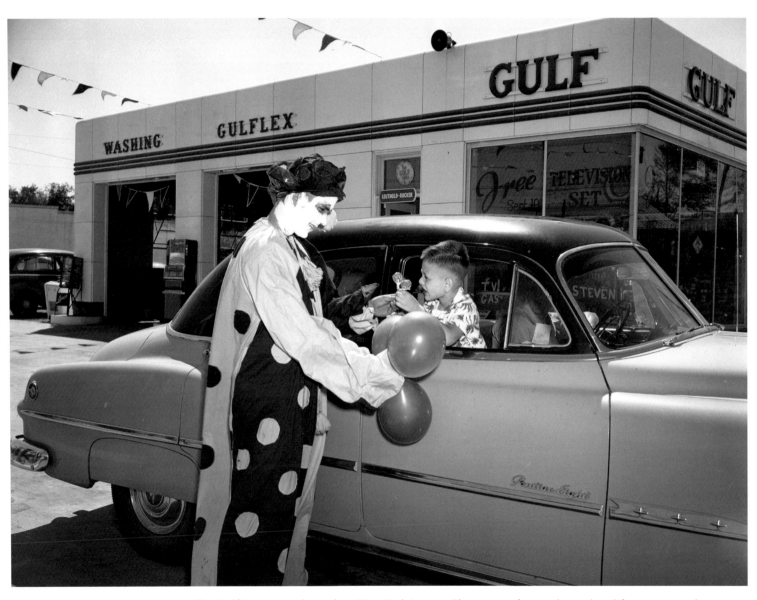

This Gulf Station was located on West End Avenue. Clowns were frequently employed for promotional purposes.

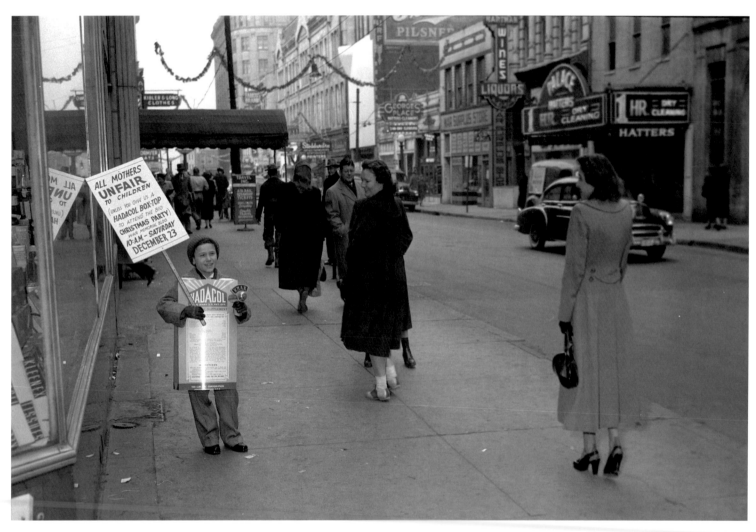

A young boy carries a sign for a Hadacol Box Top Christmas Party. Hadacol was a cough syrup made primarily of alcohol with a splash of cherry syrup. This photo was taken along Church Street.

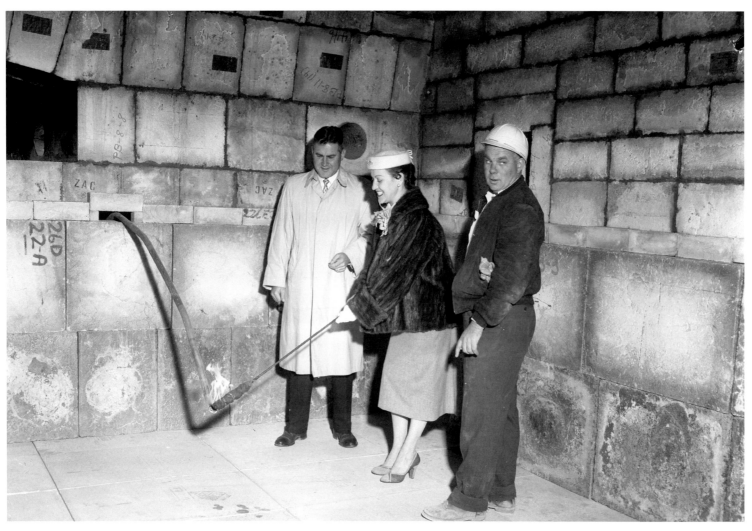

The Ford Glass Company opened in West Nashville in 1956, creating many jobs and the need for more housing for plant workers. It is a safe bet that the torch-bearing woman in the mink coat was not present for a job interview.

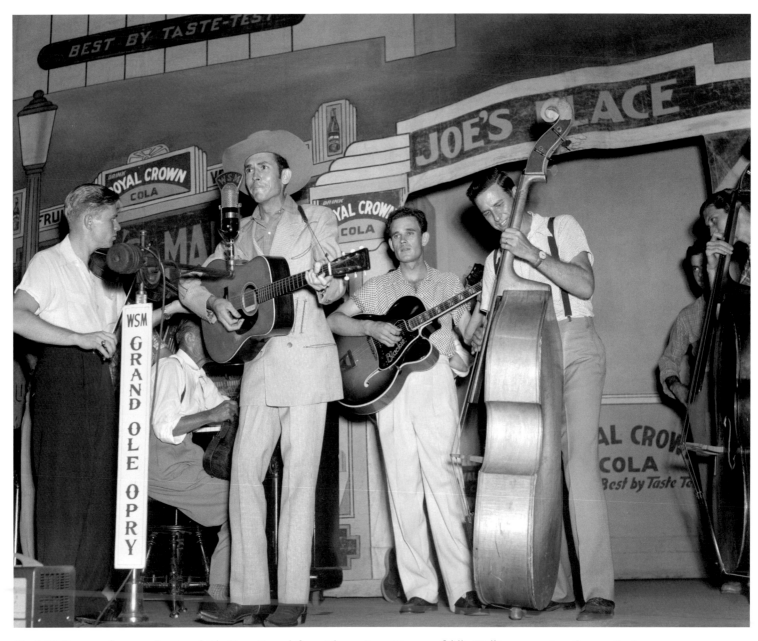

Hank Williams performs at the Grand Ole Opry. From left to right are Jerry Rivers on fiddle, Williams on guitar, Sammy Pruitt on guitar, and Howard Watts (also known as Cedric Rainwater) on bass. Williams would die at the age of 29 in 1953 on his way from Knoxville to a performance in Canton, Ohio.

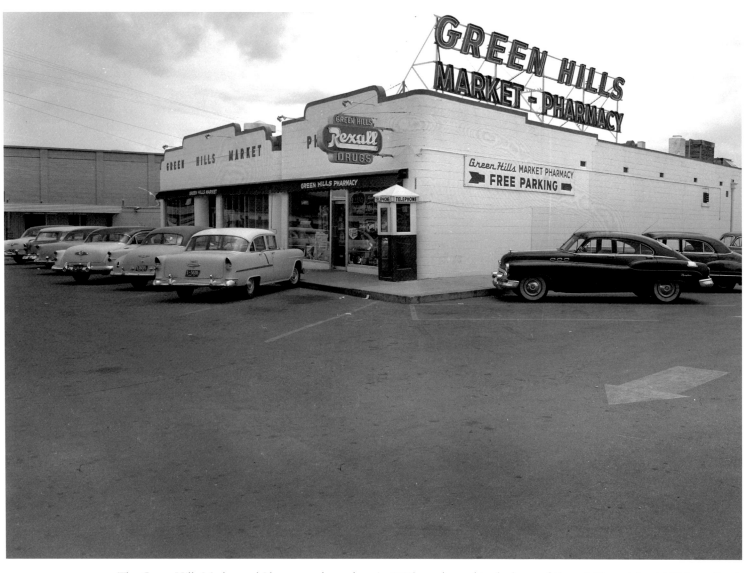

The Green Hills Market and Pharmacy, shown here in 1956, was located in the heart of Green Hills and faced Hillsboro Road. The site is now occupied by Trader Joe's food store.

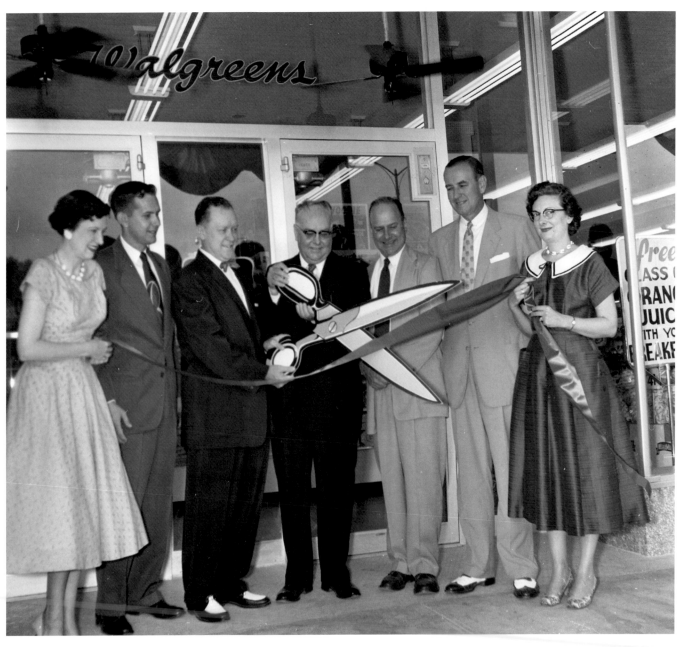

Ribbon-cutting ceremony at the new Walgreens located in Green Hills, around 1955. The site is now home to Carrabba's Italian restaurant.

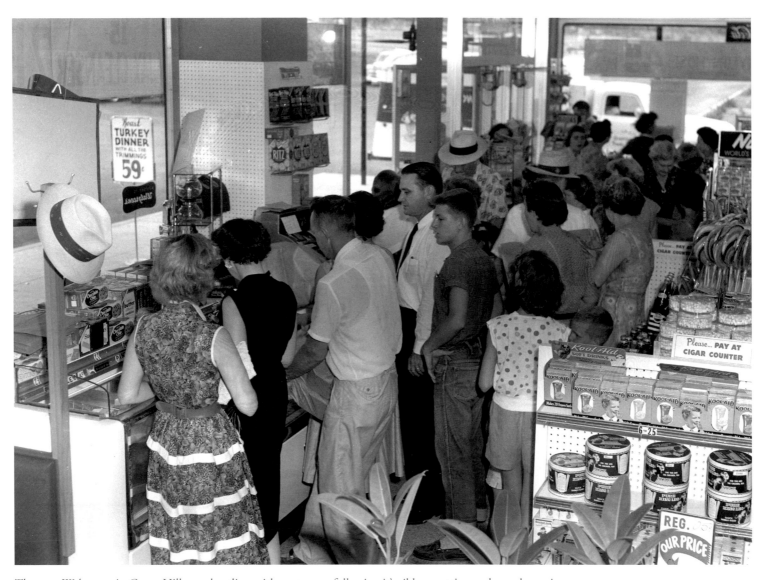

The new Walgreens in Green Hills was bustling with customers following it's ribbon cutting and grand opening.

Dury's camera and frame shop, shown here in 1955, was located in the Green Hills strip of stores. Mister Buford's was located next door.

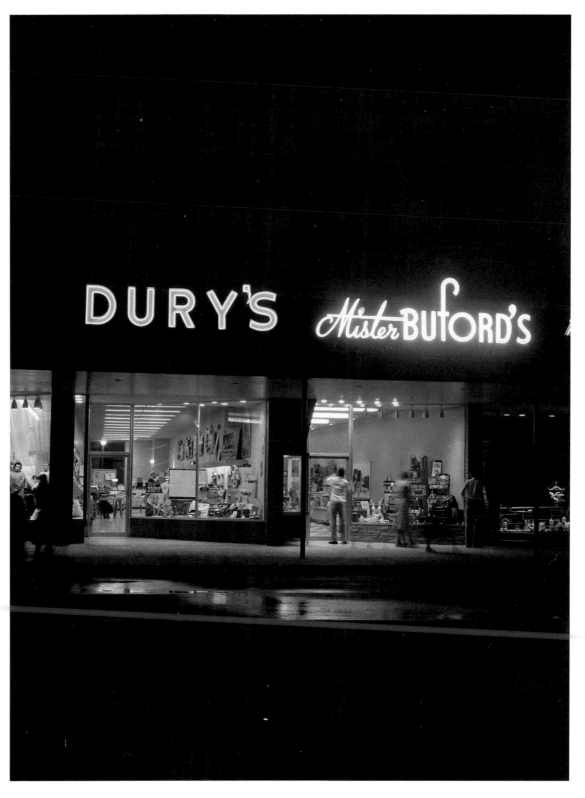

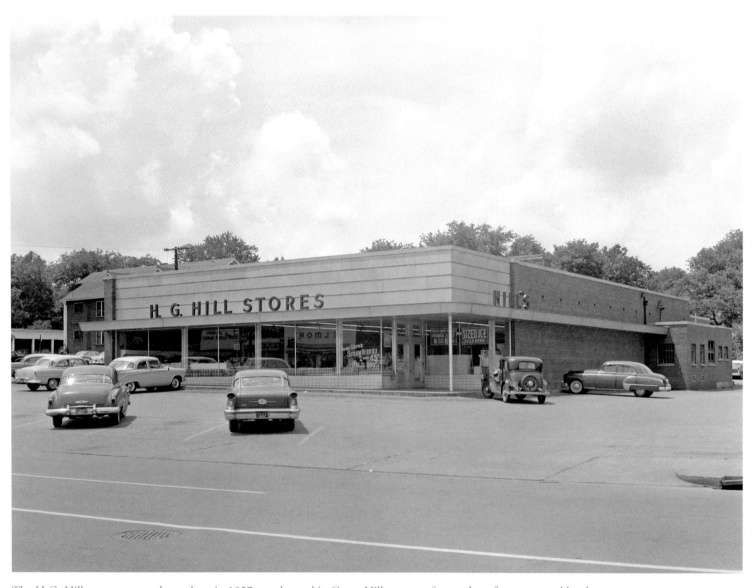

The H.G. Hill grocery store, shown here in 1957, was located in Green Hills as one of a number of stores owned by the local retailer. Hill opened its first store in downtown Nashville in 1895, becoming the dominant grocery retailer in the area by the 1920s, with stores throughout the Southeast. This store was razed in the early-twenty-first century to make way for the Hill Center, a high-end shopping development.

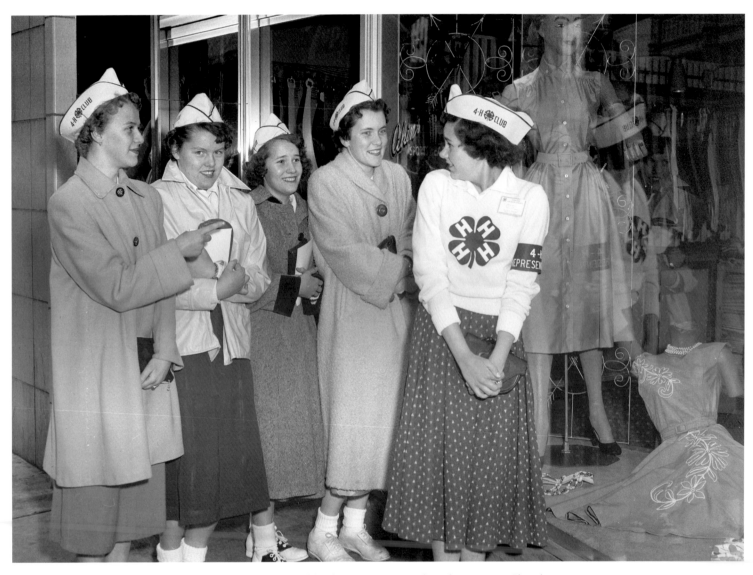

Members of the 4-H Club, in fashionable bobby sox and saddle shoes, are seen window-shopping on Church Street in December 1955.

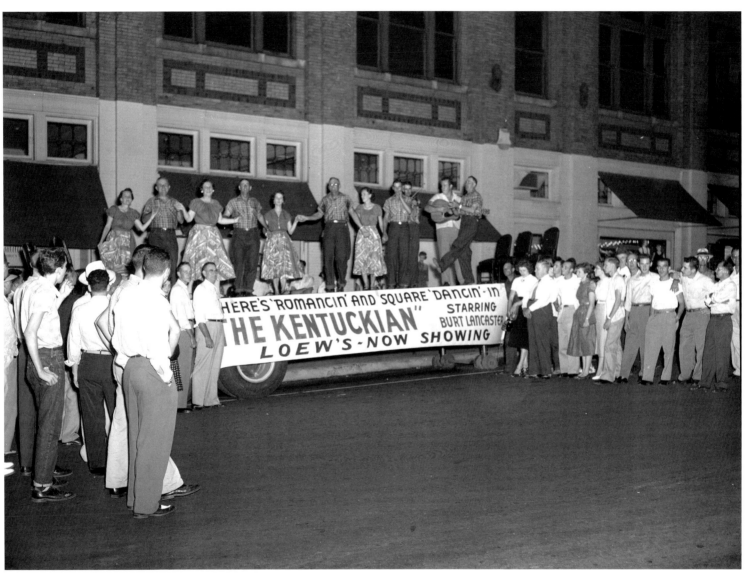

A crowd gathers for a rally celebrating *The Kentuckian,* a 1955 film starring Burt Lancaster. The film played at the Loew's Crescent on Church Street.

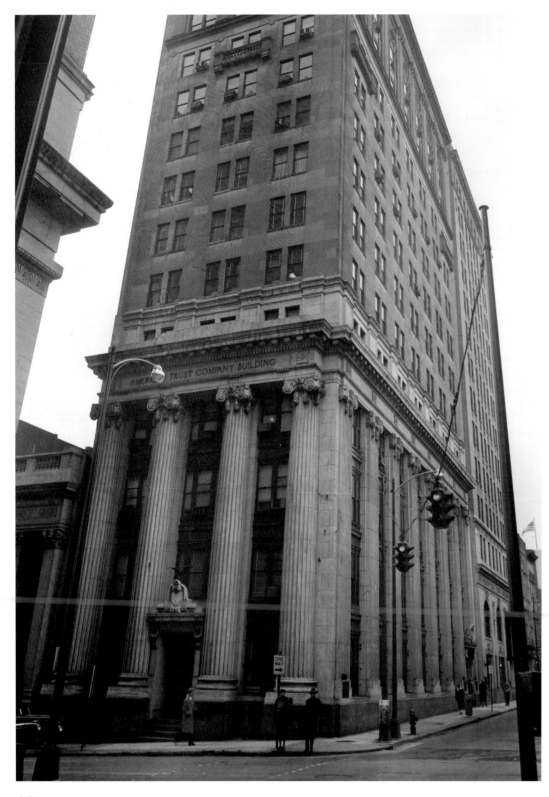

The American Trust Company Building, at Third Avenue and Union Street, as it appeared in 1955. Erected in 1925, the structure's four-story rows of Ionic columns create an imposing presence. The building is currently being refitted for condominiums.

The Baxter Building still stood at Third Avenue and Union Street in the 1950s. Street clocks like the one on the building's corner were once common in cities nationwide.

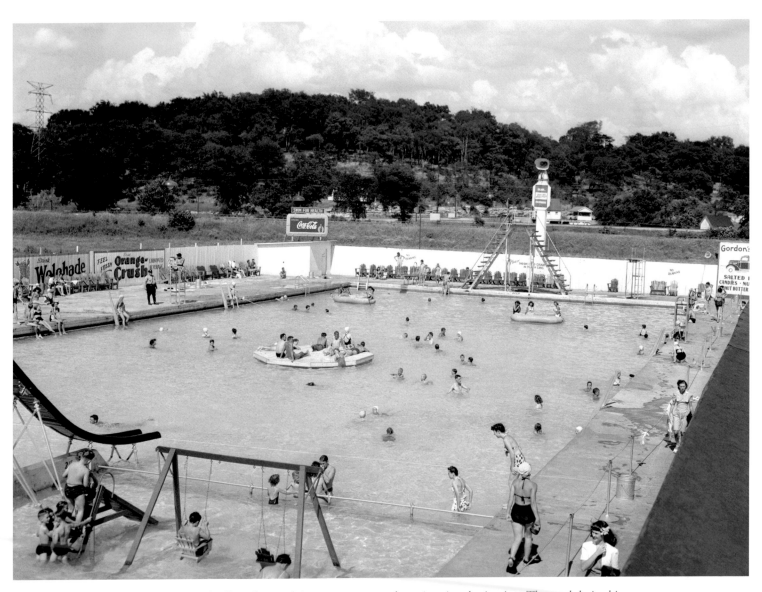

The Cascade Plunge, located at Fair Park off Wedgewood Avenue, was a popular swimming destination. The pool derived its name from the cascades of water that poured into it. Public pools, including the Plunge, Collins Pool off River Road, and others, would remain popular destinations into the 1970s.

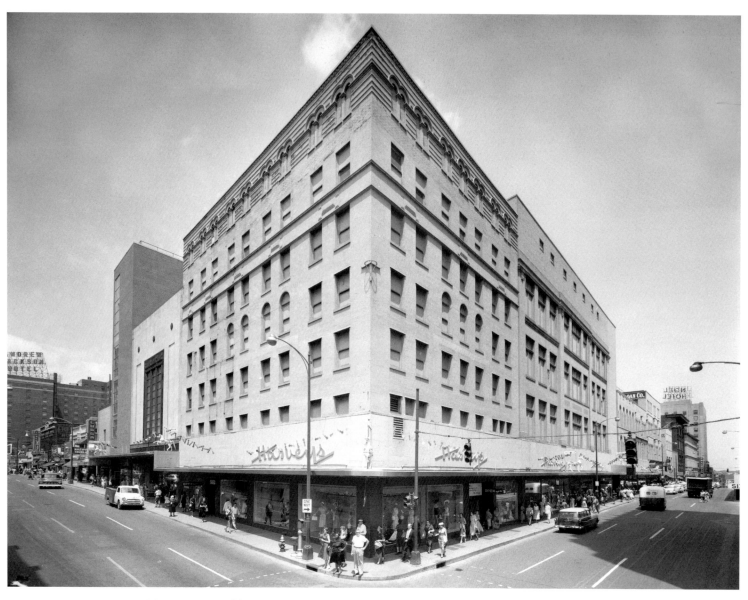

Harveys, pictured here in 1957, was a popular department store owned by local businessman Fred Harvey. The store was located at the corner of Sixth Avenue and Church Street.

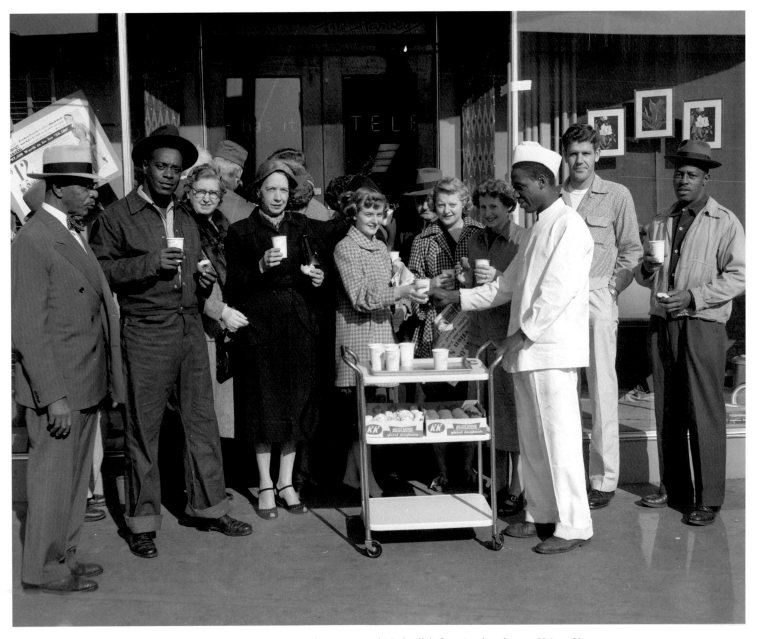

Shoppers waiting to gain entry to a Harveys sale enjoy warm beverages and Nashville's favorite doughnuts, Krispy Kreme.

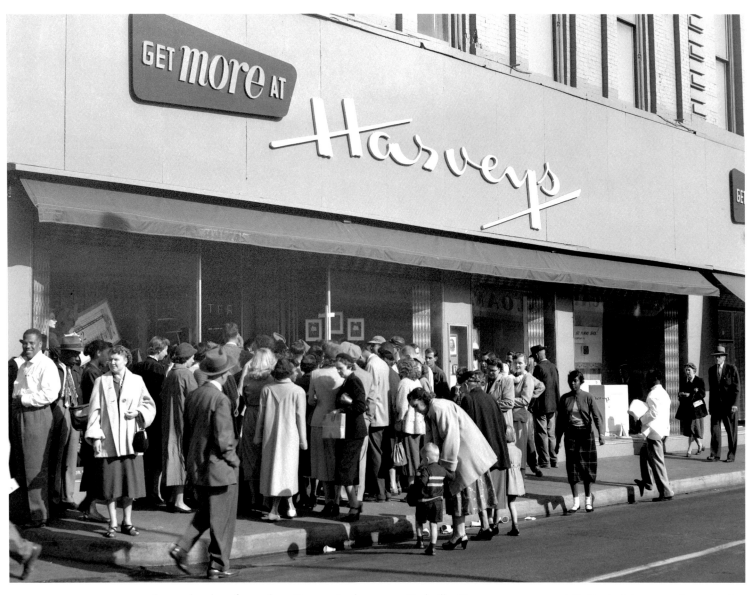

A crowd gathers for a sale at Harveys in downtown Nashville. Youngsters were especially fond of the store, always hoping that Mom would let them visit the carousel located upstairs.

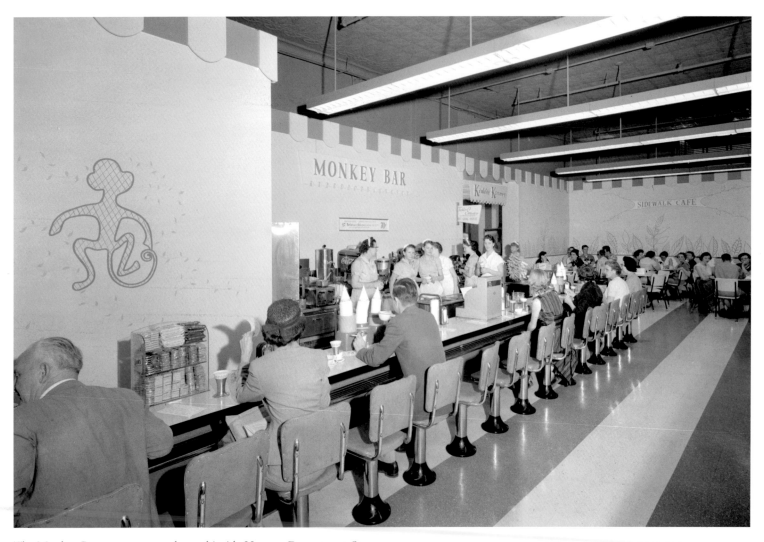

The Monkey Bar restaurant was located inside Harveys Department Store.

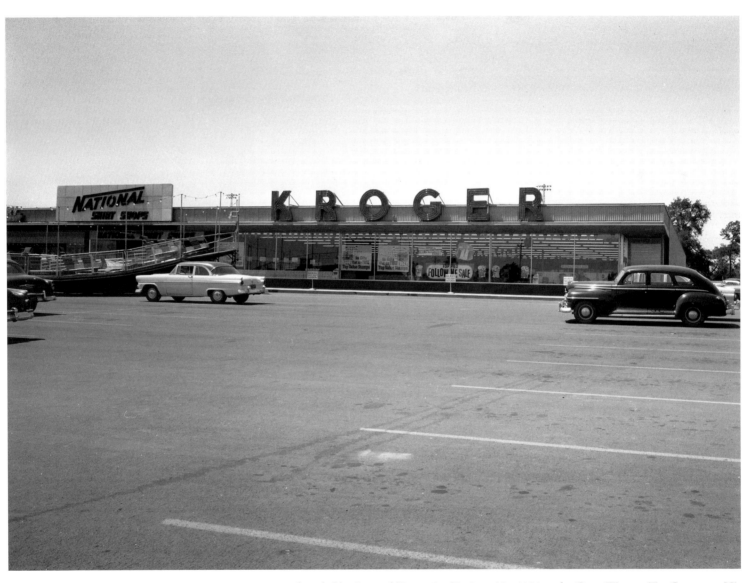

Kroger groceries was founded by Bernard Kroger in Cincinnati in 1883 as the Great Western Tea Company. His line of stores eventually expanded to other states and cities, including Nashville, becoming one of the largest grocery retailers in the nation.

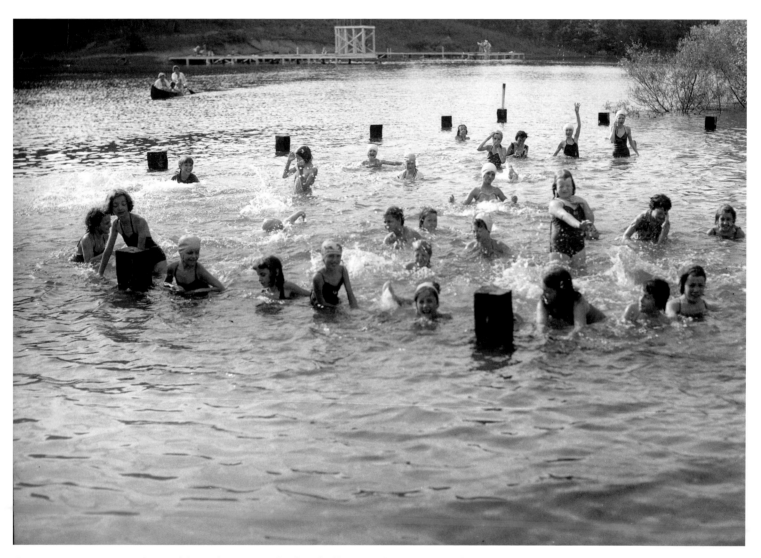

Camp Marymount opened in 1946 on 147 acres south of Nashville in nearby Fairview. Today the camp encompasses 340 acres, providing summer memories for hundreds of youth each year, some of them grandchildren of the first campers to experience the retreat.

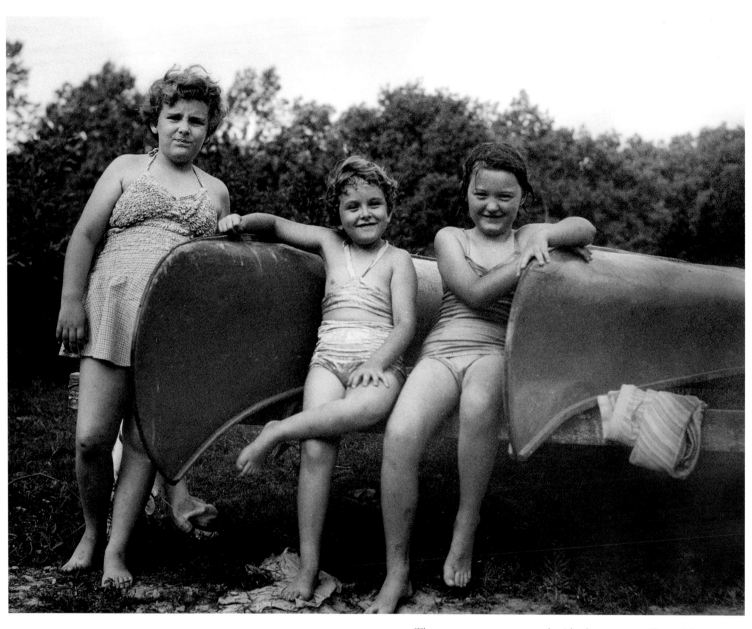

Three young campers pose beside the canoes at Camp Marymount.

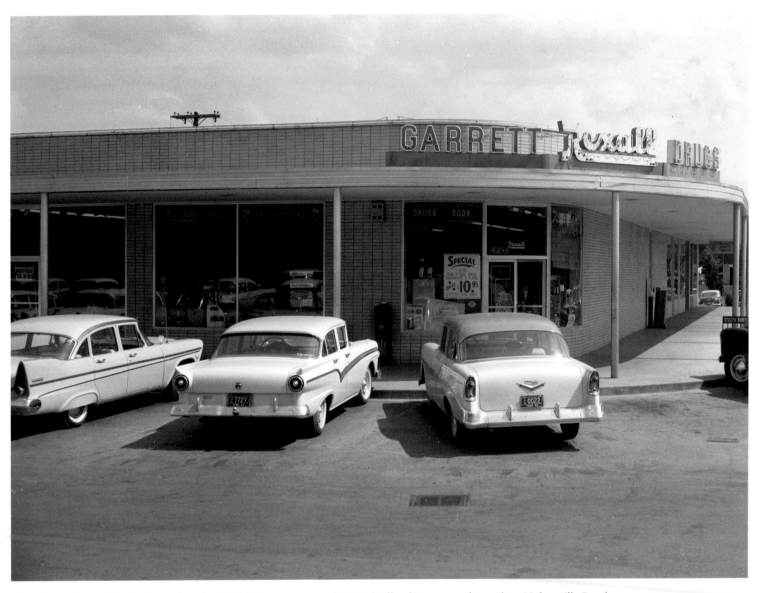

The Garrett Drugs Rexall, shown here in 1957. There were several in Nashville; this one was located on Nolensville Road.

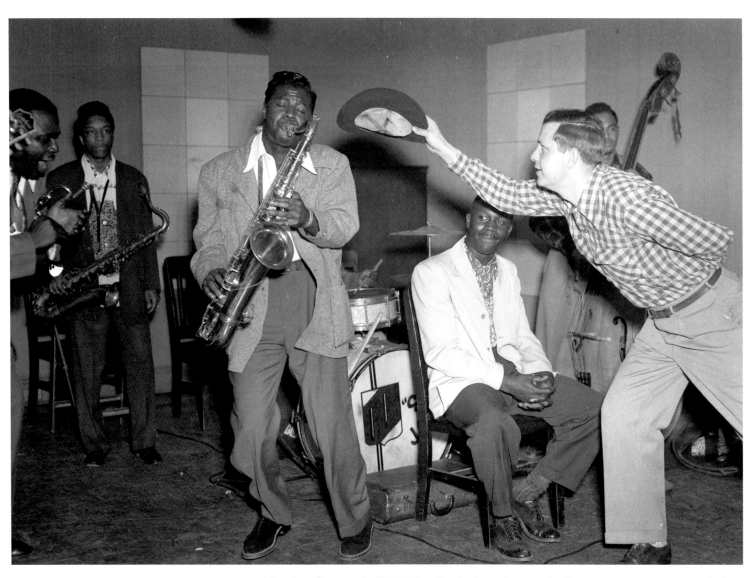

A band performs at the WMAK studio. In the early days of radio, programming was apt to be live.

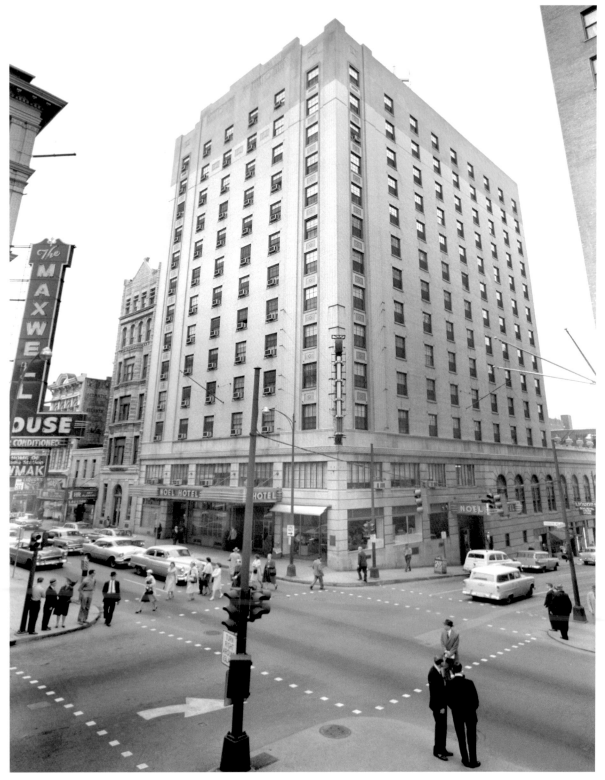

The posh Noel Hotel was located on Church Street at Fourth Avenue (formerly Cherry Street), across Fourth from the Maxwell House. The Noel opened in 1930, attracting celebrities that included Eleanor Roosevelt, Babe Ruth, and Roy Rogers. A kaffeeklatsch drew local businessmen, and a barbershop in the basement offered its services to patrons. The hotel closed its doors in 1972, but the Noel Building still shines elegantly as offices for attorneys, First Bank, and Turner Publishing Company.

The tower at Scarritt College, located on 19th Avenue South, was designed by Nashvillian Henry C. Hibbs.

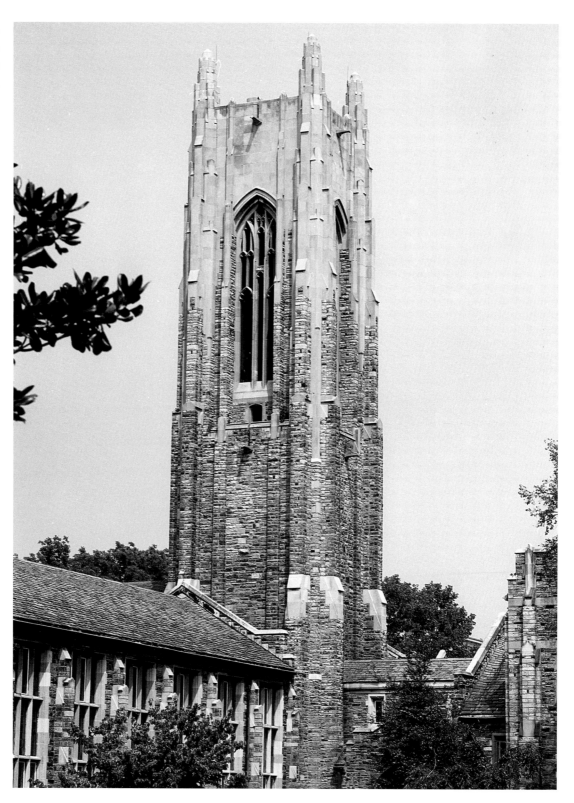

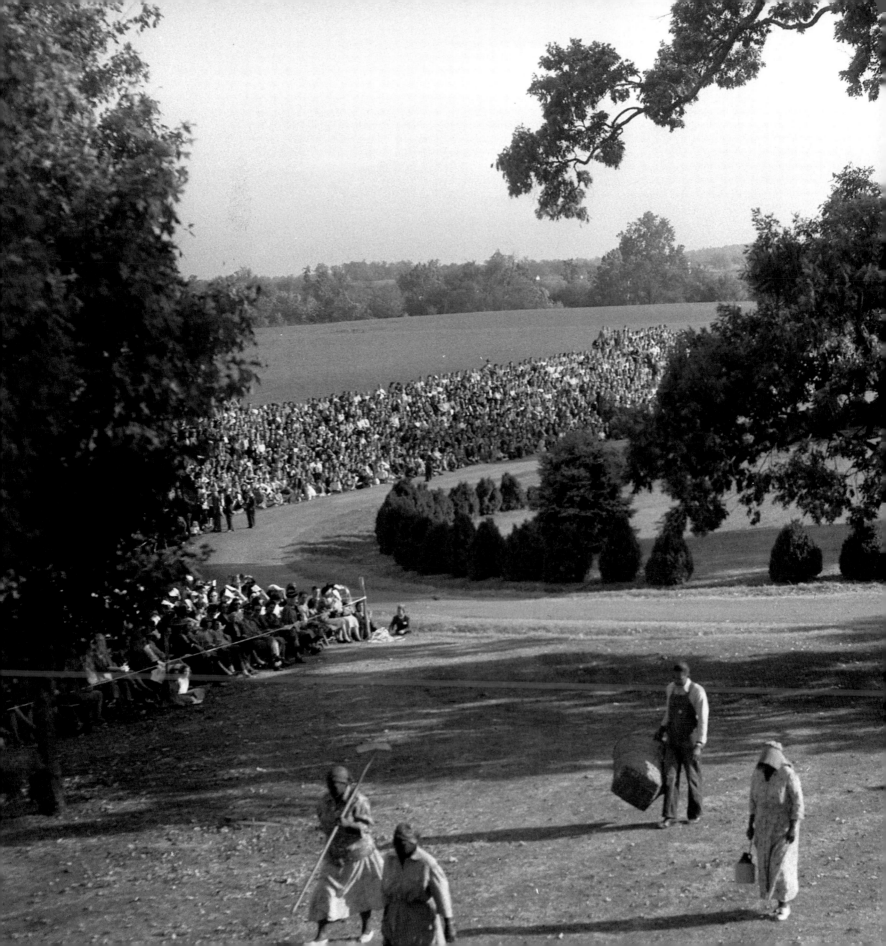

On October 5, 1952, more than 125 volunteers participated in the Sam Davis Pageant. In this photo, volunteers reenact the roles of plantation workers at Davis's home in Smyrna.

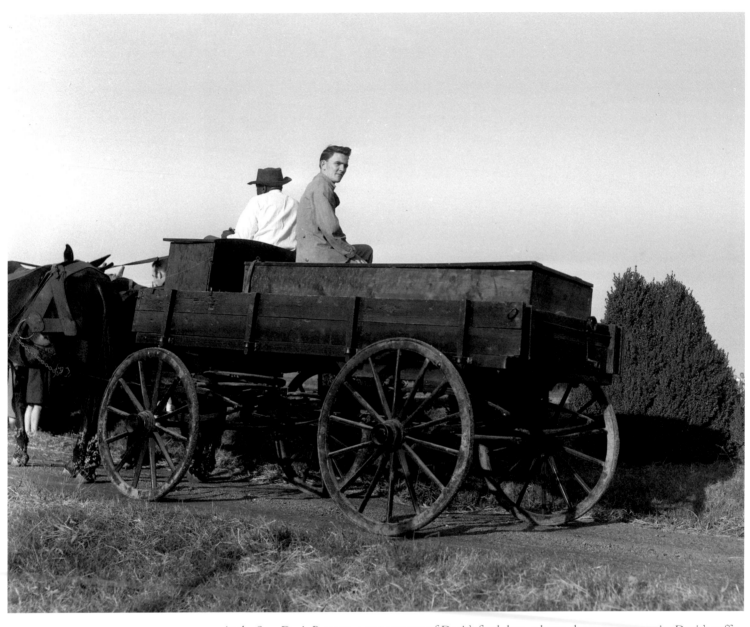

At the Sam Davis Pageant, a reenactment of Davis's final days, a horse-drawn wagon carries Davis's coffin.

Visitors enjoy a look at performers in period costume at the Sam Davis Home in Smyrna, October 5, 1952.

Pete "Bashful Brother Oswald" Kirby (on the left) and Roy Acuff entertain the audience at the Grand Ole Opry.

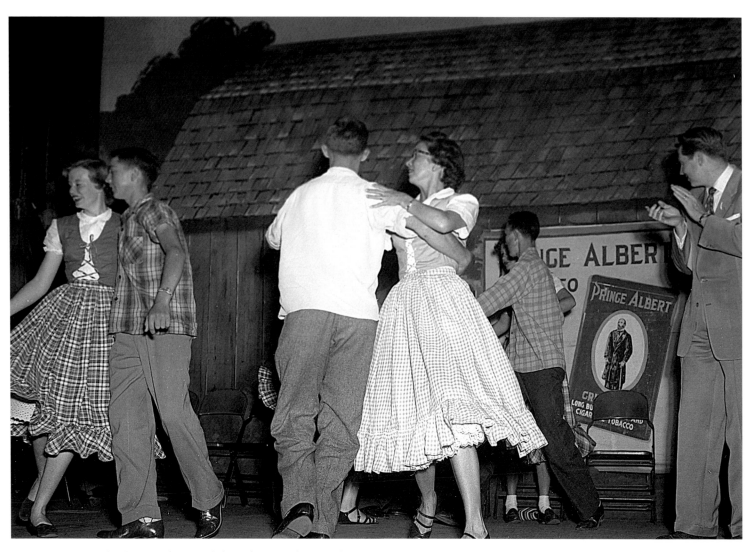

A local square dancing club performs at the Grand Ole Opry. Square dancing has long been a staple of Saturday night performances.

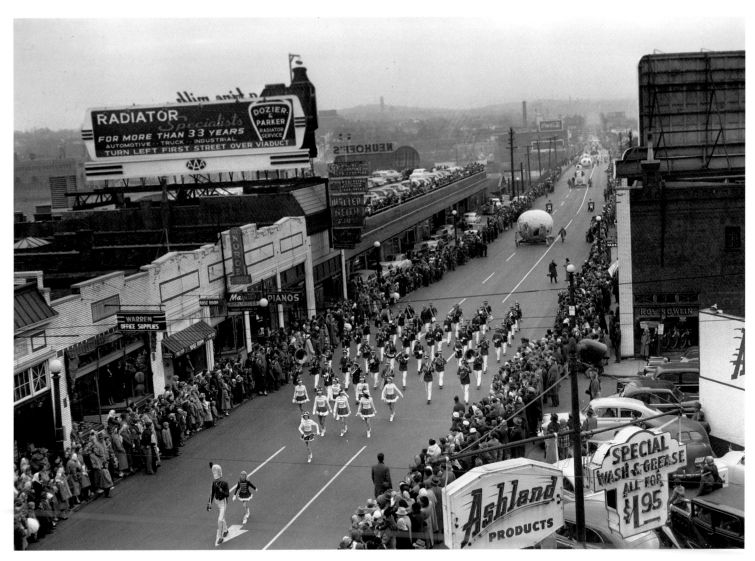

The 1952 Christmas parade travels along Church Street into downtown Nashville. The Church Street Viaduct over which the floats in the distance are traveling was rebuilt in the early 1990s, losing its distinctive wrought-iron railings which complemented those at Union Station along West End to the south. The Viaduct's early-twentieth-century cobblestone pavers, unusual for their small size and range of color, reportedly lie somewhere in a city dump.

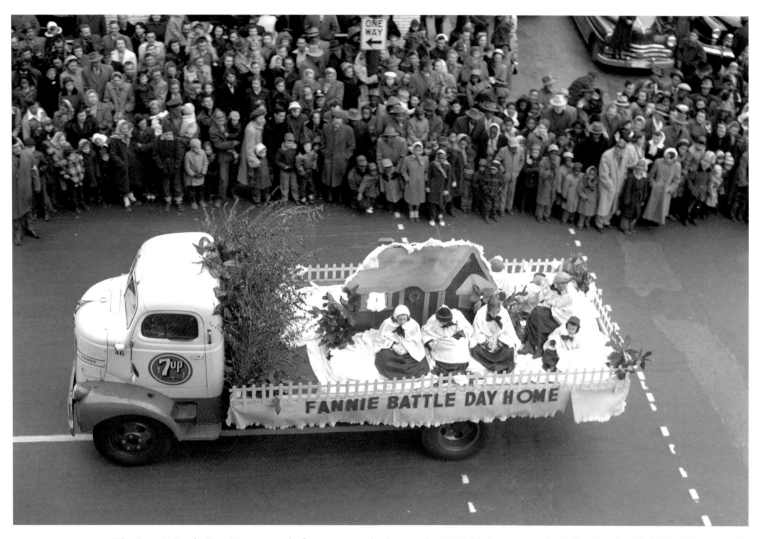

The Fannie Battle Day Home parade float passes onlookers at the 1952 Christmas parade. Following the Civil War, Fannie Battle taught at Howard School, organized relief for victims of the 1881 Nashville flood, and organized the Addison Avenue Day Home, Nashville's first daycare home for children. Fannie Battle died in 1924 and rests at Mt. Olivet Cemetery.

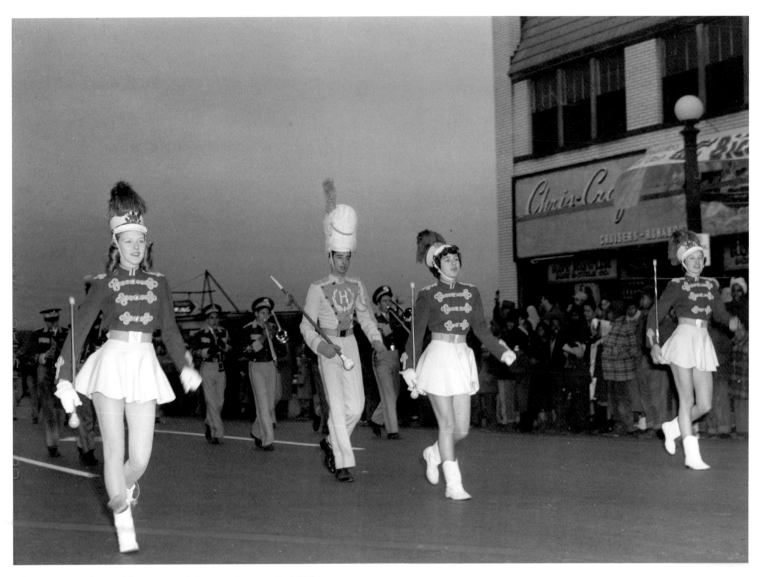

Christmas parade participants travel the parade route in 1952.

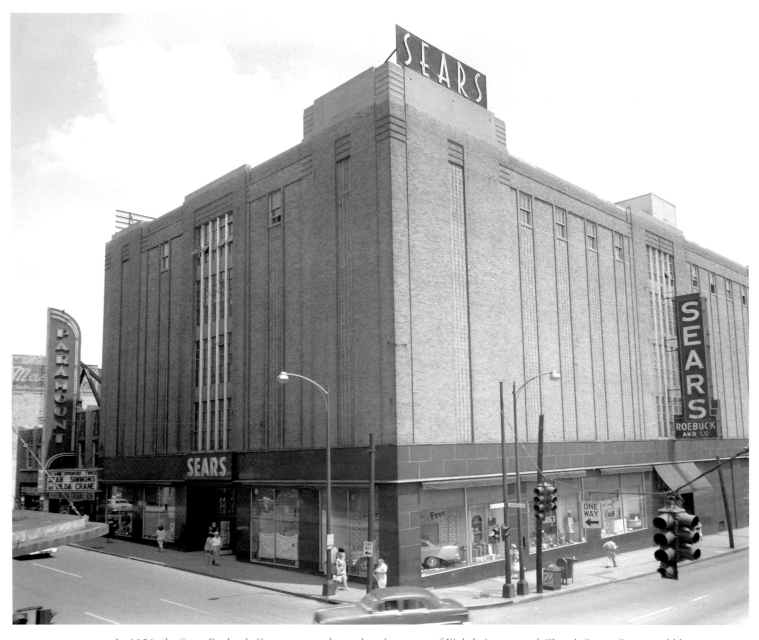

In 1956, the Sears Roebuck Company was located at the corner of Eighth Avenue and Church Street. Sears would later open at a location on LaFayette Street, and this building would house the Gold and Silver company, and still later, Service Merchandise. Next door is the Paramount Theater, where Jean Simmons is starring in *The Many Loves of Hilda Crane*.

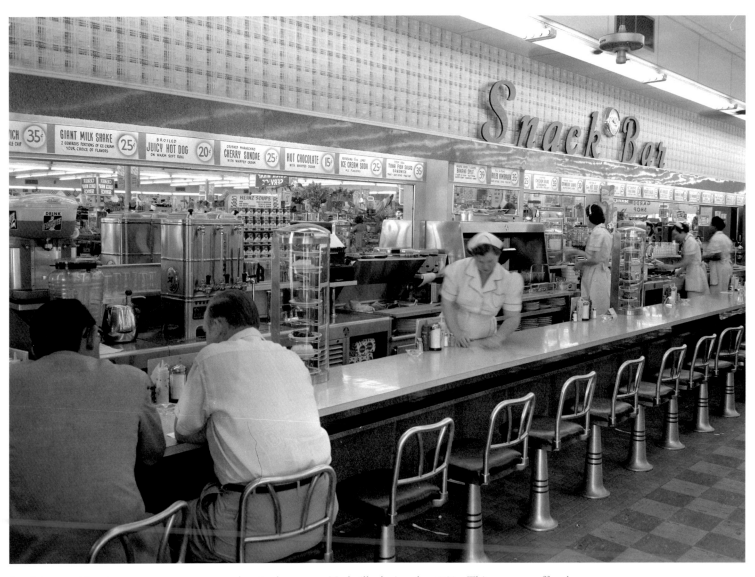

Snack bars and lunch counters were commonplace in downtown Nashville during the 1950s. This counter offered "giant milkshakes" for 25 cents.

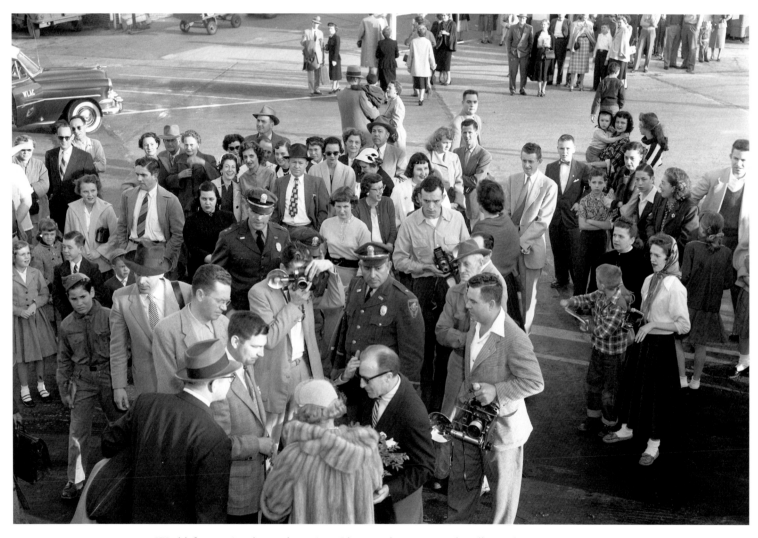

World-famous ice skater, three-time Olympic champion, and Hollywood screen actress Sonja Henie signs autographs for admirers during her stop in Nashville. Born in Oslo, Norway, Henie's associations with Hitler's Nazi Germany gave rise to controversy and criticism during and after the war.

Stephens Market in Green Hills was located on Hillsboro Road.

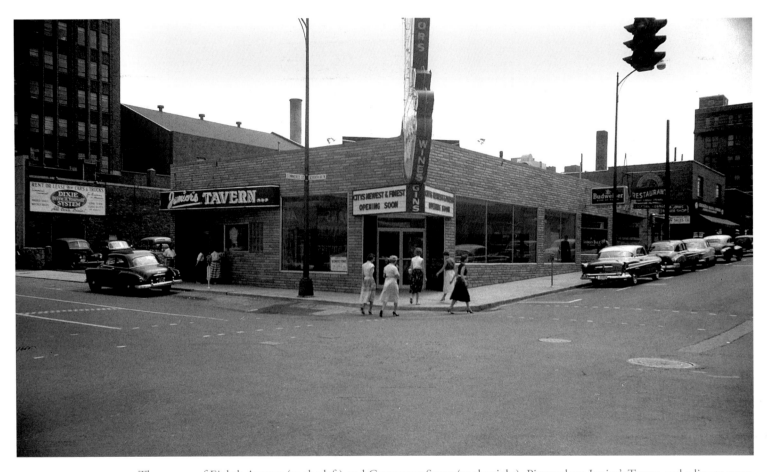

The corner of Eighth Avenue (to the left) and Commerce Street (to the right). Pictured are Junior's Tavern and a liquor store.

This shot of Sixth Avenue shows a thriving downtown Nashville in 1957. Pictured on the right is the Hermitage Hotel, and farther down is the Knickerbocker Theater. A taxi cab advertises "See Rock City and Lookout Mountain," words nearly ubiquitous in that era on the sides of barns along Highway 41 between Nashville and Chattanooga. Today the Hermitage Hotel is Tennessee's only 5-star hotel and the state's only example of Beaux-Arts architecture, rubbing elbows since 1910 with many of the rich and famous, including President Taft, Bette Davis, Sergeant York, FDR, and the Francis Craig Orchestra, which entertained radio audiences from the hotel's Oak Bar during the years 1929 to 1945.

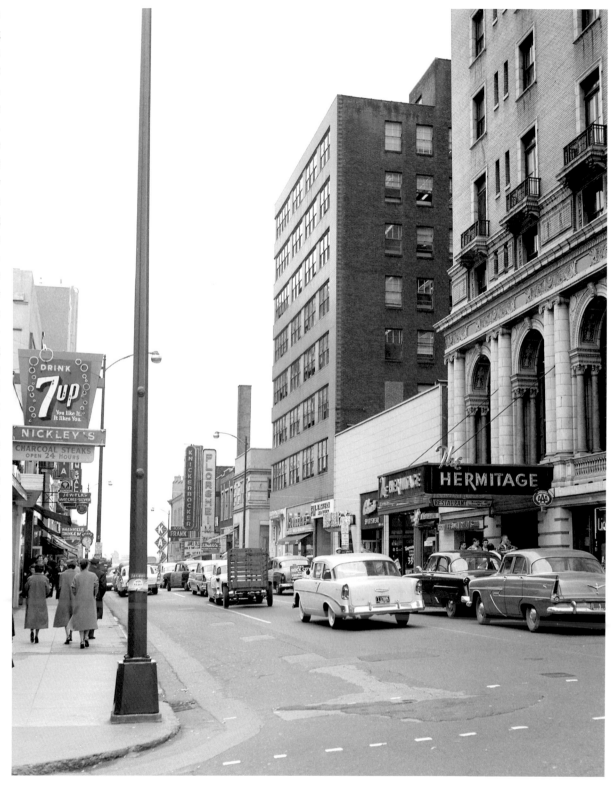

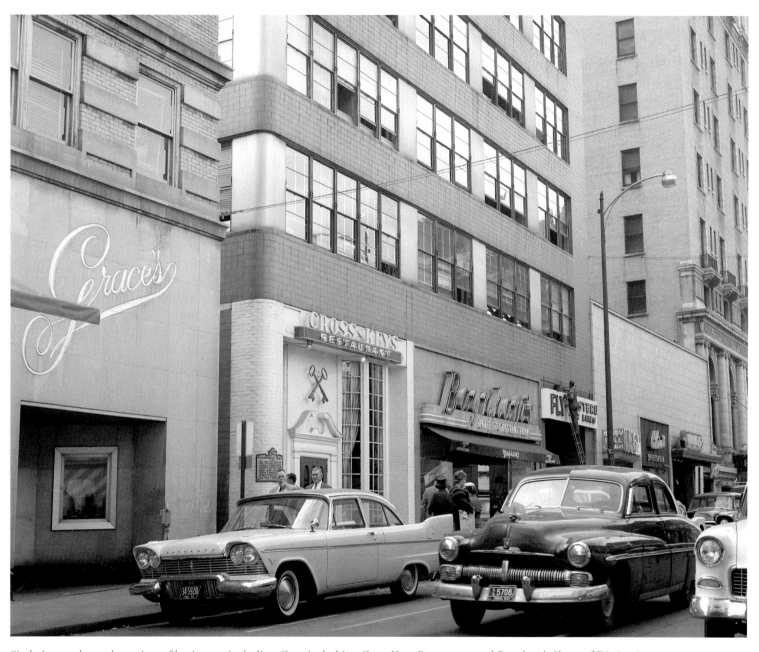

Sixth Avenue housed a variety of businesses including Grace's clothier, Cross Keys Restaurant, and Baynham's Shoes of Distinction.

Following Spread: A shot of Sixth Avenue as it appeared around 1957. The Knickerbocker Theater, Florsheim Shoes, and the Hermitage Hotel are visible at left.

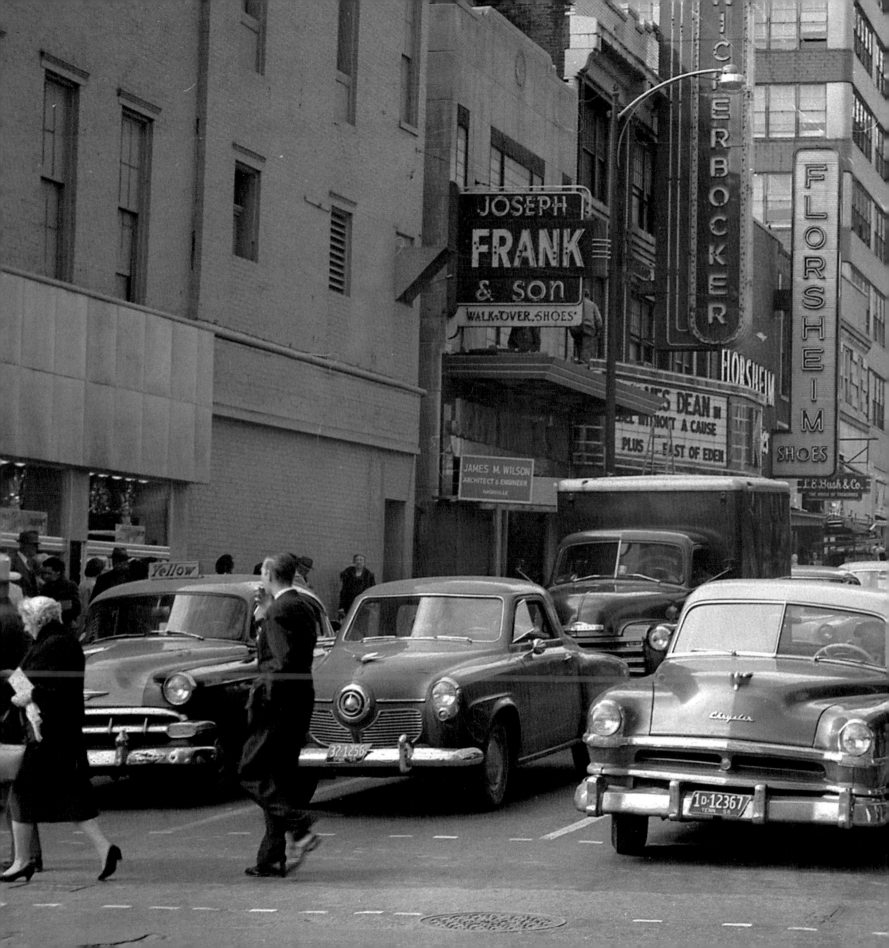

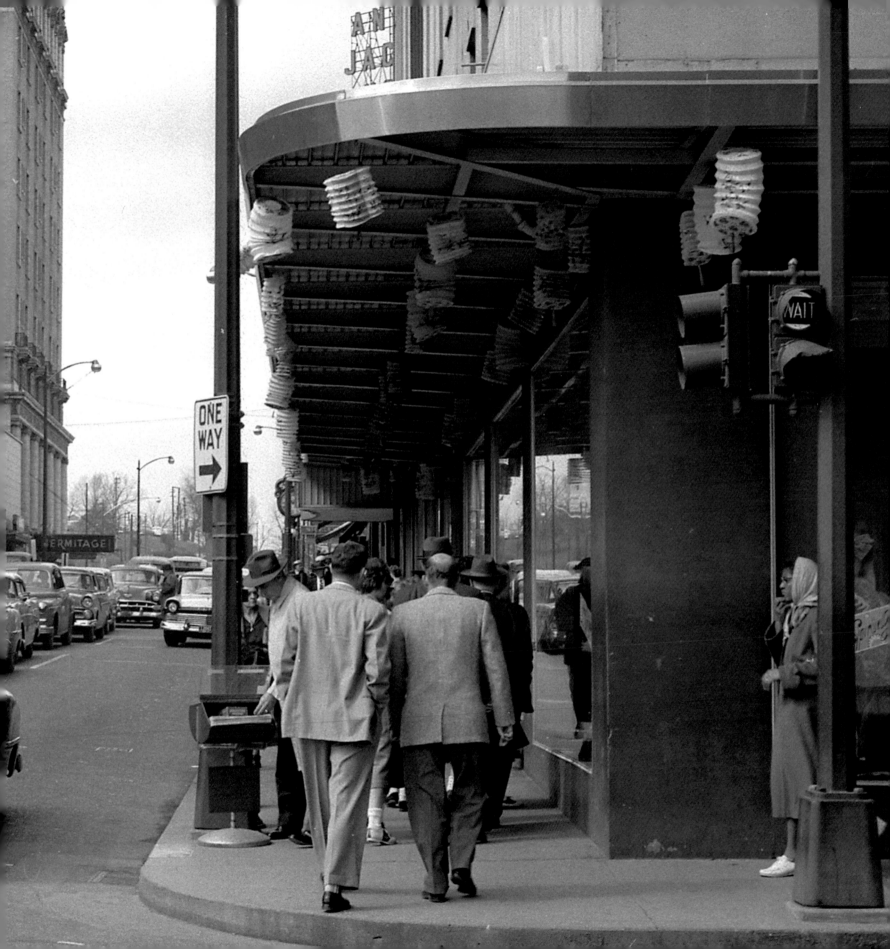

An overhead view of several Nashville landmarks in 1957, including the Hermitage Hotel (at right) and the Sudekum Building (top left). In the distance is the hill on which Fort Negley was built when Union troops occupied the city during the Civil War. This photograph was made from the Andrew Jackson Hotel, demolished in 1971 on the block where TPAC stands today.

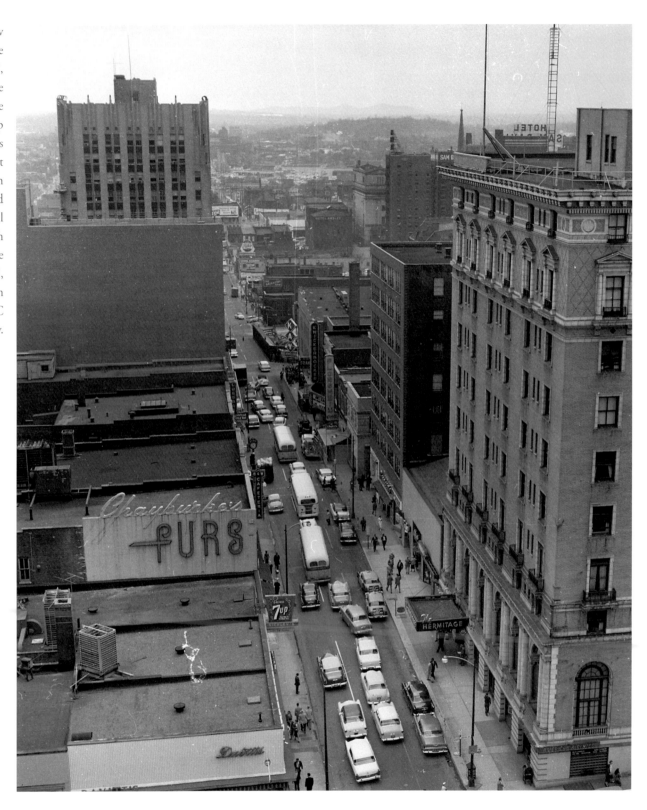

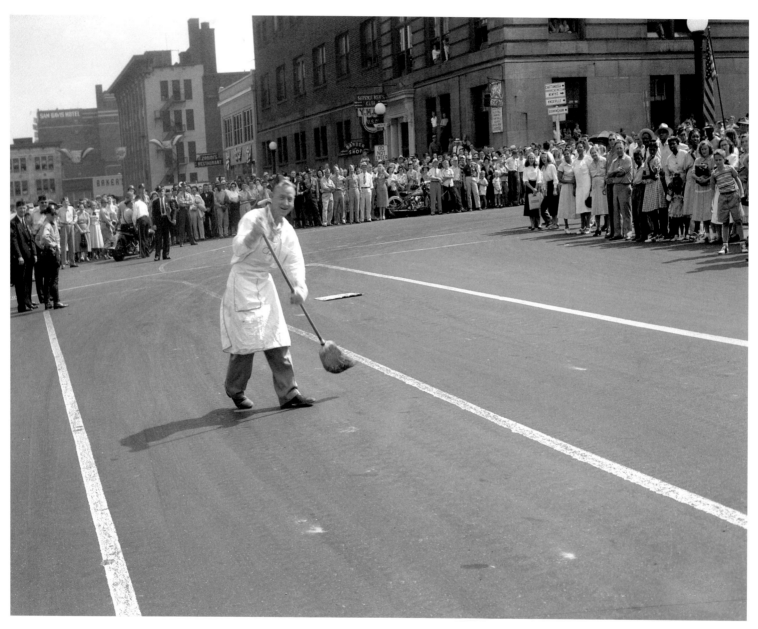

Paradegoers watch the "Chef" sweep the street at Union Street and Capitol Boulevard. In the background are Zanini's Restaurant and the Y.M.C.A. and U.S.O. for servicemen, on the site of today's downtown Sheraton Hotel. Down the street is the Sam Davis Hotel at Seventh Avenue and Commerce. The only structure still standing is the Castner-Knott Building at Capitol Boulevard and Church.

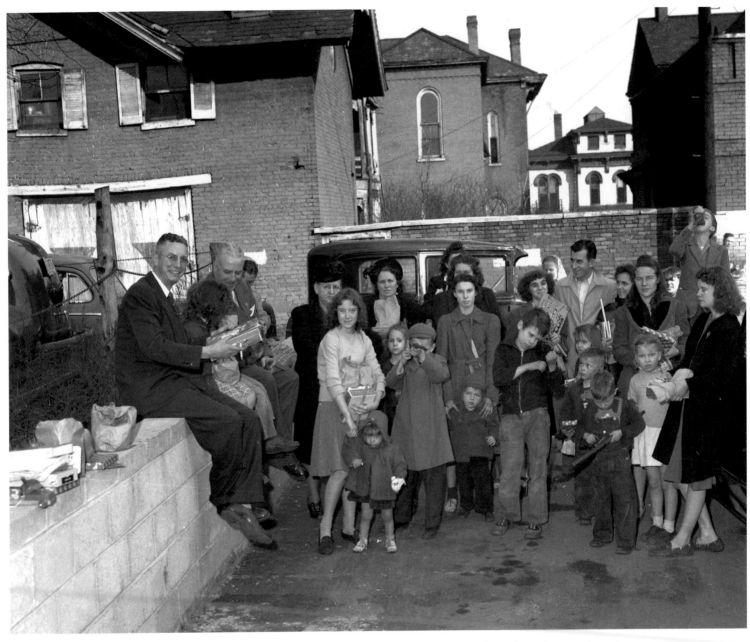

On a chilly Nashville day Bob Grannis' camera finds this group, some willing and some eager to have their photograph made.

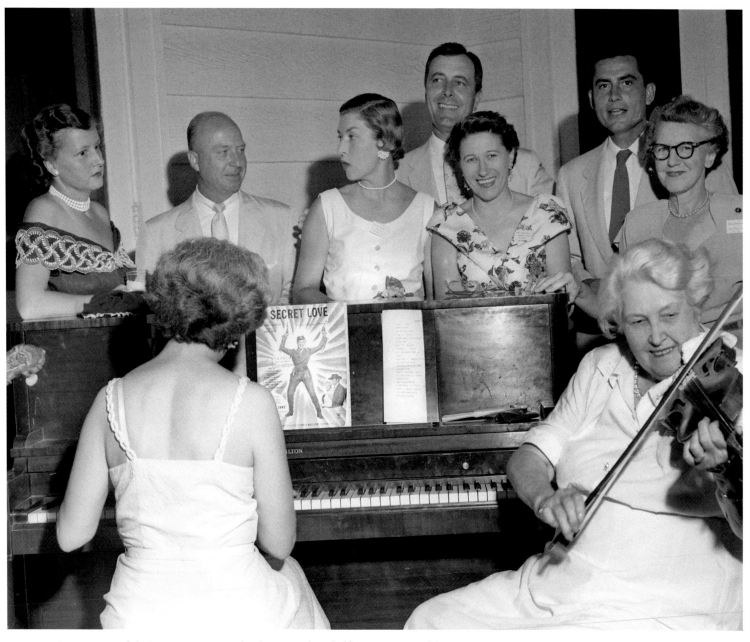

Participants of the Tennessee Women's Championship Golf Tournament celebrate the event at the Belle Meade Country Club in July 1954.

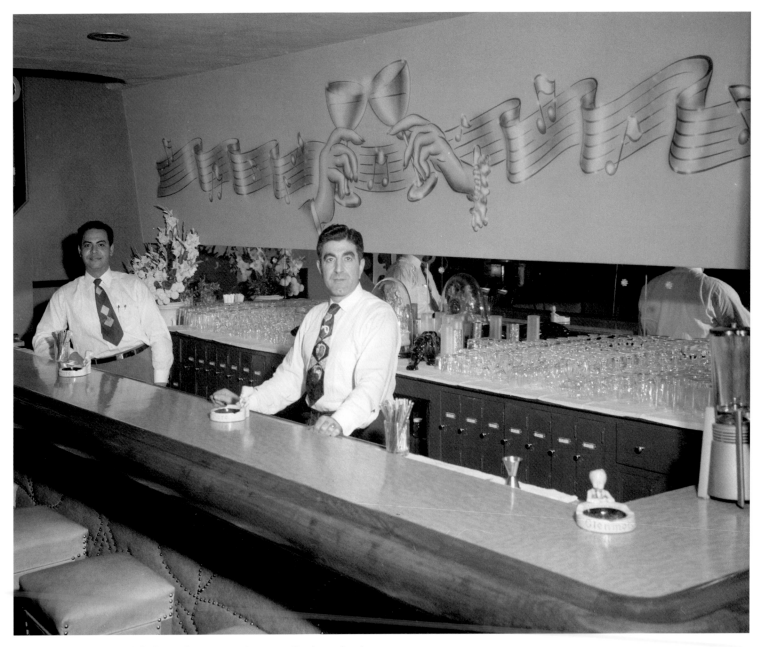

Bartenders at the Key Club, located on Union Street, smile cheers for the camera.

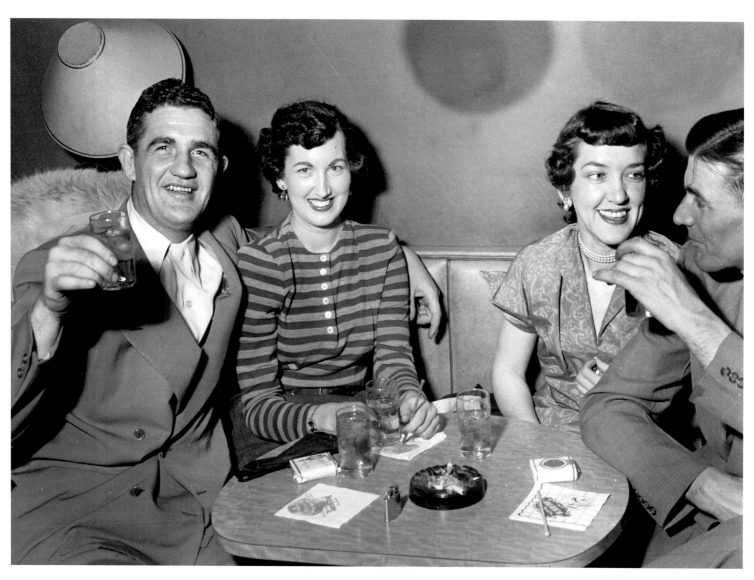

Patrons enjoy an evening at the Key Club in 1950.

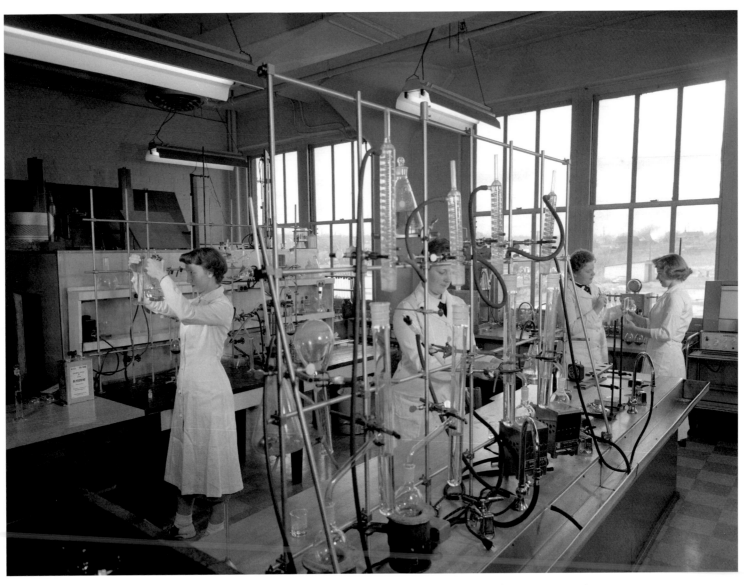

U.S. Tobacco employees work in the company laboratory. The facility, located several blocks north of the State Capitol, later housed a tobacco history museum, which has since closed.

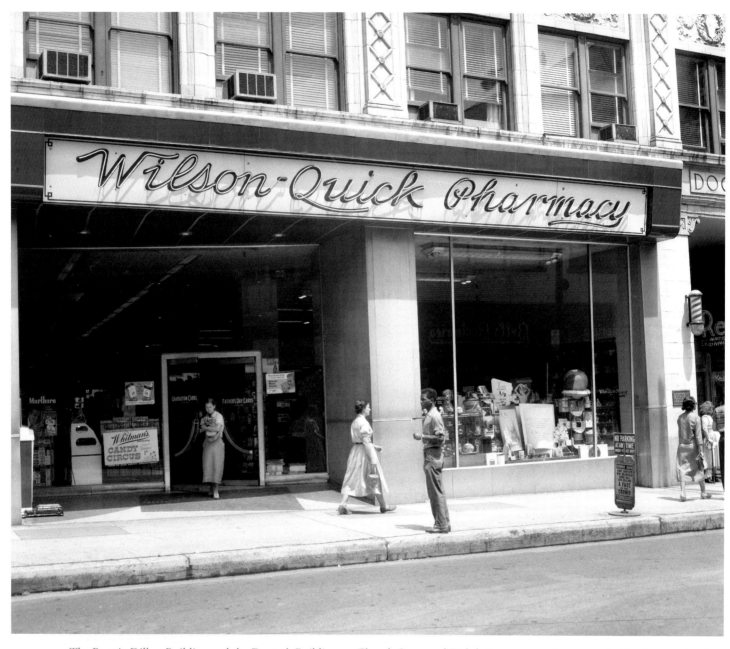

The Bennie Dillon Building and the Doctor's Building, at Church Street and Eighth Avenue, were long occupied by doctors, dentists, lawyers, and financial companies. At ground level was the Wilson-Quick Pharmacy. Today the Bennie Dillon Building, which is on the National Registry of Historic Buildings and has been restored several times, houses residential lofts.

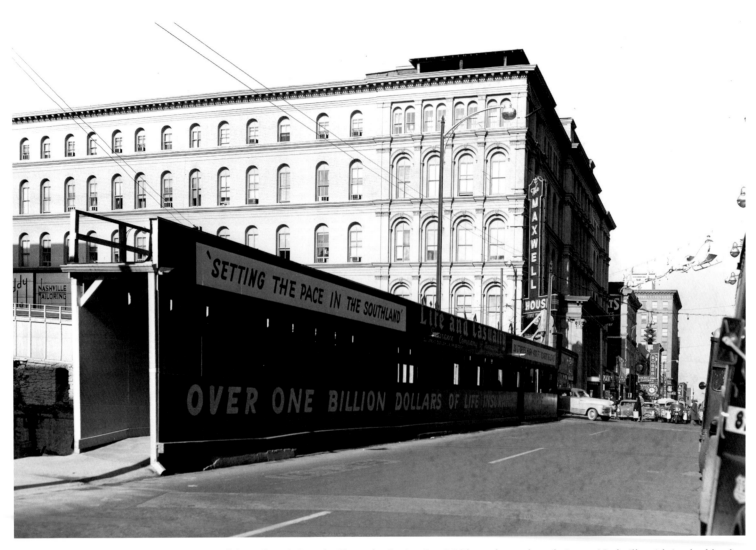

The erection of the Life and Casualty Tower beginning in 1956 brought modern design to Nashville with its double-glass windows, elevators, and an electronically filtered air system. The sign reads, "Setting the pace in the Southland." Next door is the landmark Maxwell House Hotel.

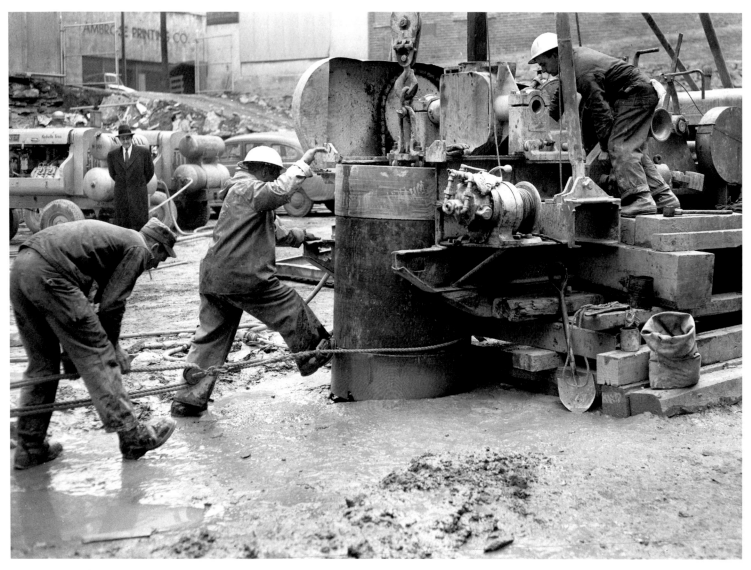

Construction of the Life and Casualty Tower is shown in progress. The $7 million, 31-story structure was for a while the tallest building in the Southeast.

Members of this church on Carroll Street in downtown Nashville congregate for services in the 1950s. Today, although many nineteenth-century houses of worship have been lost, others remain standing and are home to worshiping congregations, including the Lindsley Avenue Church of Christ near Rutledge Hill and the Russell Street Methodist church in East Nashville.

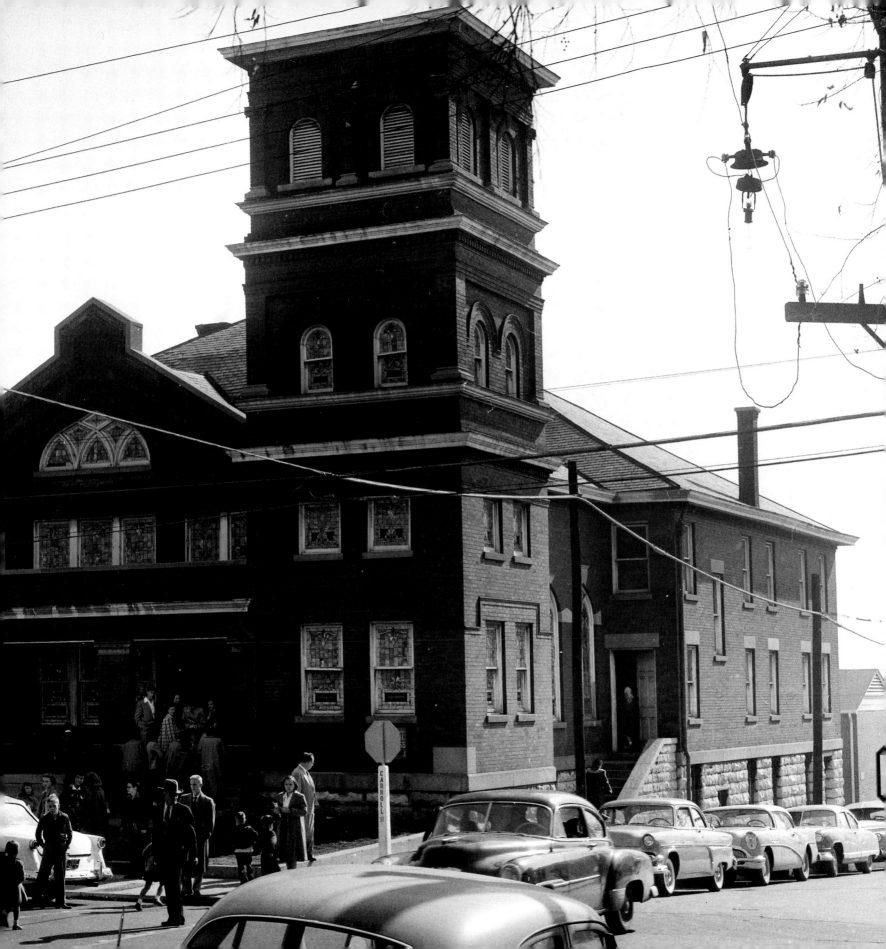

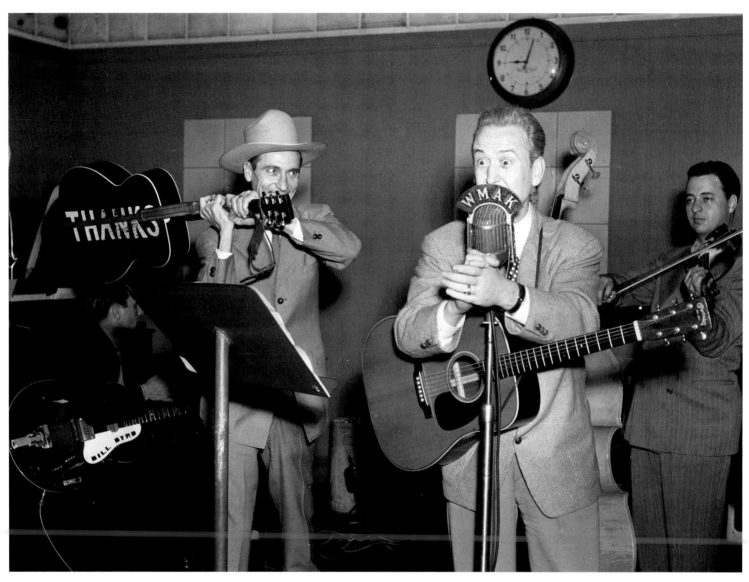

From left to right are Billy Byrd (seated), Ernest Tubb (with one thankless guitar), Red Foley (on the microphone), and Hal Smith (on fiddle) performing at the WMAK studio.

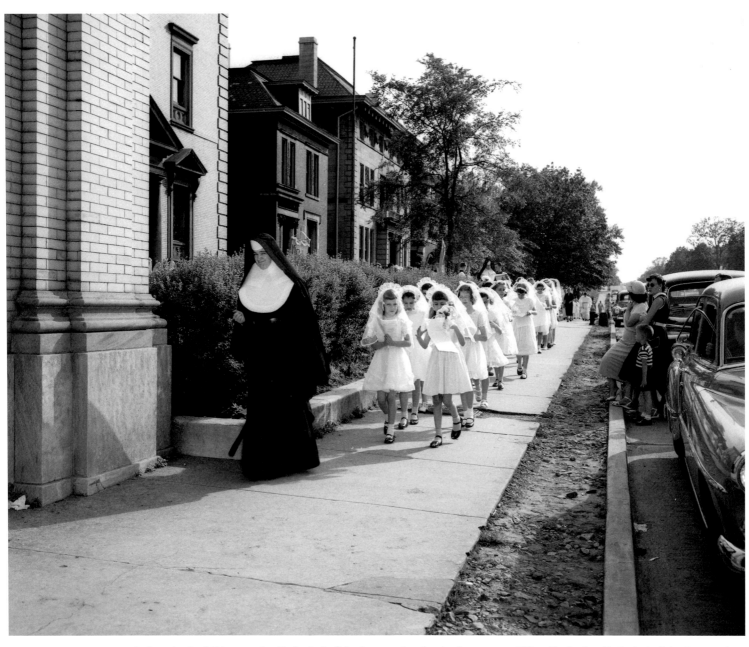

A sister leads children to the Cathedral of the Incarnation for the Sacrament of First Eucharist. Cathedral of the Incarnation, located on West End Avenue near Vanderbilt University, was built in 1914 on plans modeling St. Martin's on the Hill in Rome. With its towering campanile, the structure remains a landmark on the skyline today.

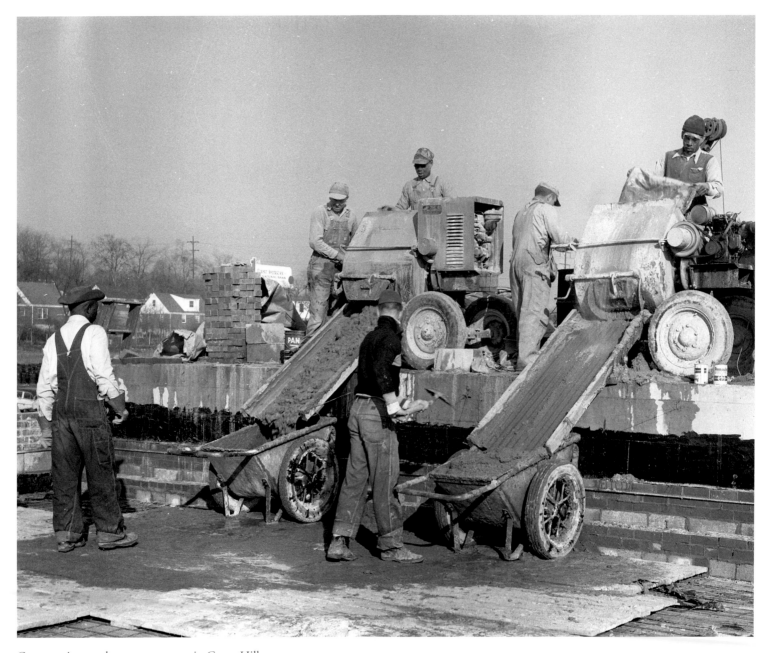

Construction workers pour cement in Green Hills.

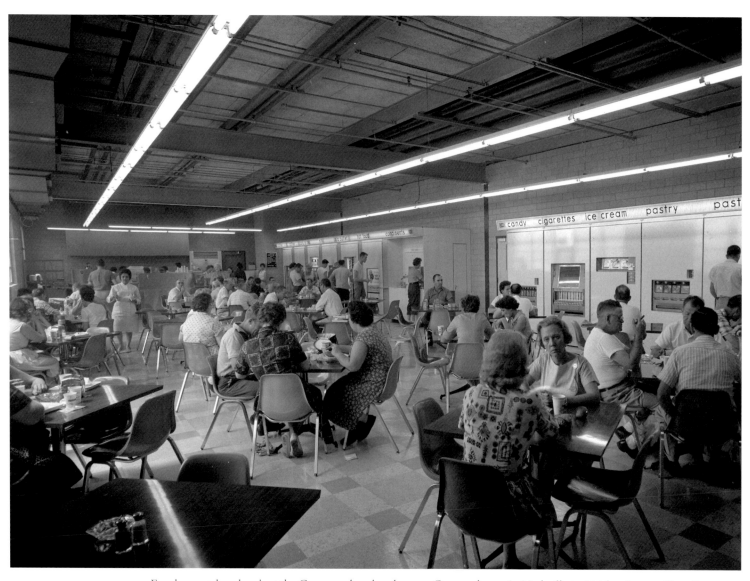

Employees take a break at the Genesco plant lunchroom. Genesco began in Nashville in 1924 as Jarman Shoe Company, founded by James Jarman. His son Maxey, at one time branded too shy to succeed in management, greatly expanded the company. By 1962, Genesco was operating 80 factories in 17 states and manufacturing 51 brands of shoes.

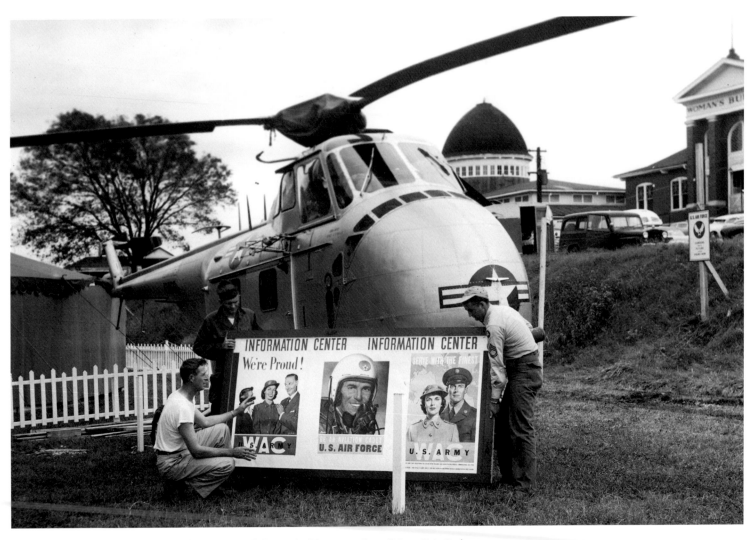

Armed Forces recruitment personnel set up an exhibit at the Tennessee State Fair at Fair Park.

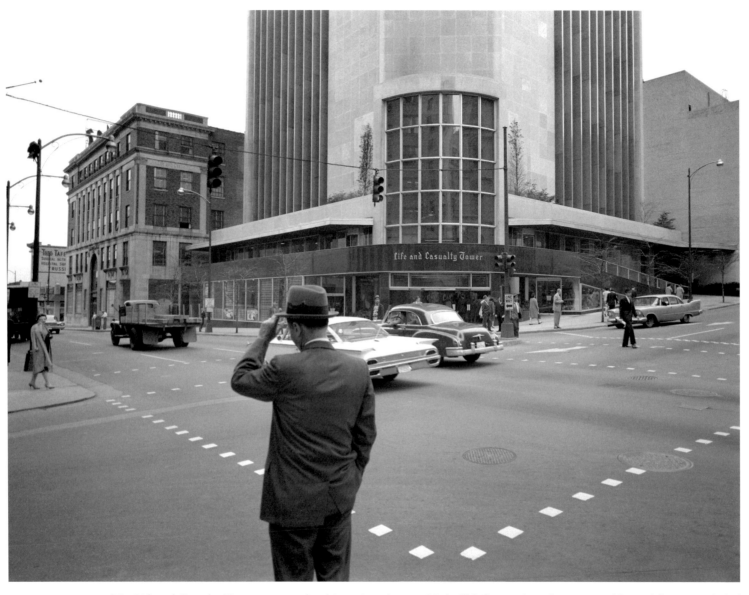

The Life and Casualty Tower was completed in 1957 to become Nashville's first modern skyscraper. Additional features included an observation deck and a three-story penthouse.

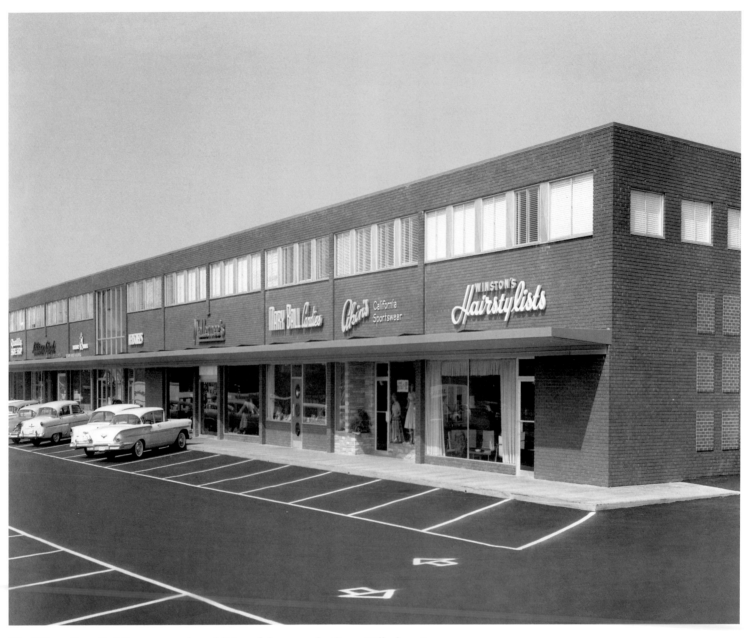

The Wilson Bates Building was another addition of the era to the Green Hills shopping scene.

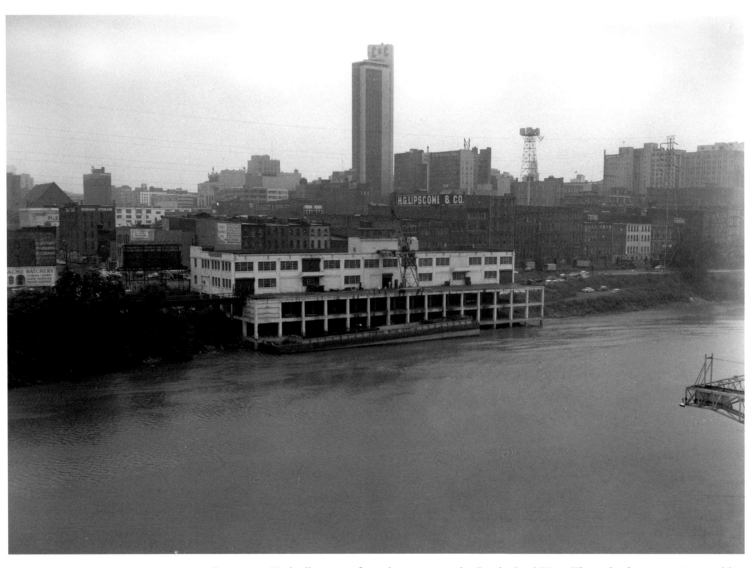

Downtown Nashville as seen from the east across the Cumberland River. The embankment in view would in later years become Riverfront Park.

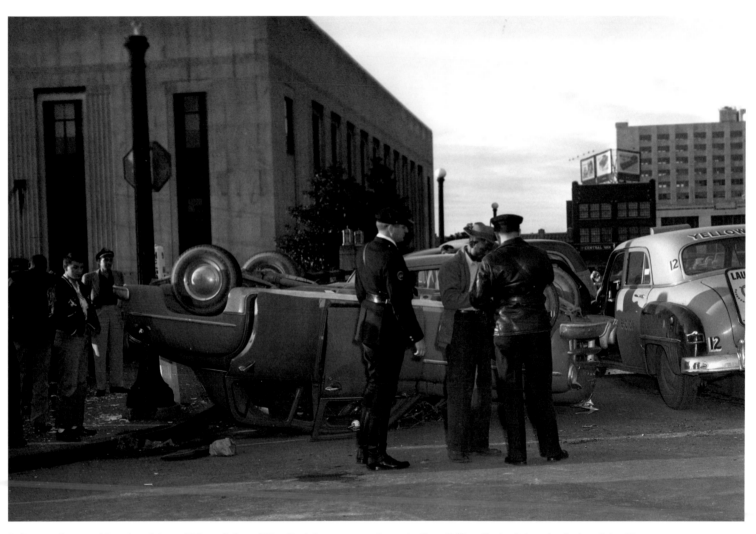

Police work an accident involving a Yellow Cab on West End Avenue near the main Post Office. Embodying classical and Art Deco architectural features, the Post Office was completed in 1934 on monies appropriated by Congress during the Hoover Administration. Today the structure houses the Frist Center for the Visual Arts.

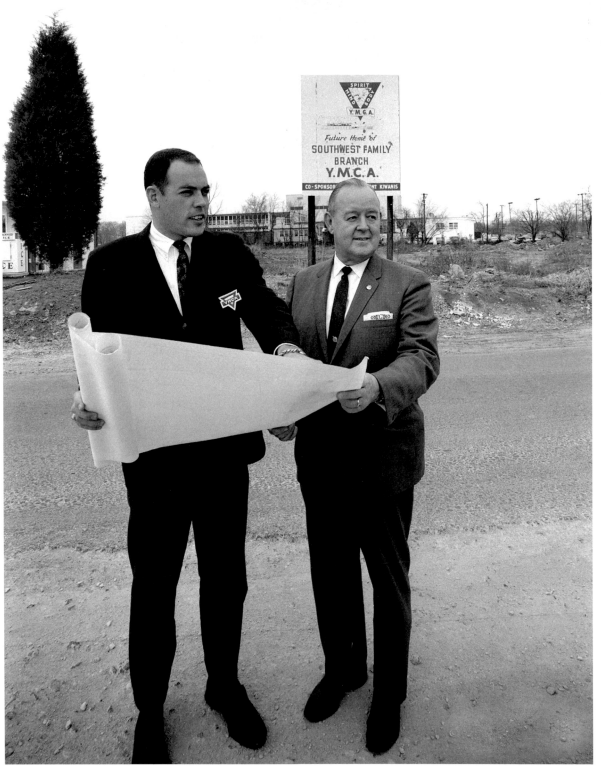

Mayor Ben West, at right, with a Y.M.C.A. executive. The pair are reviewing plans for the new Southwest Family Branch Y.M.C.A. on Hillsboro Circle in Green Hills.

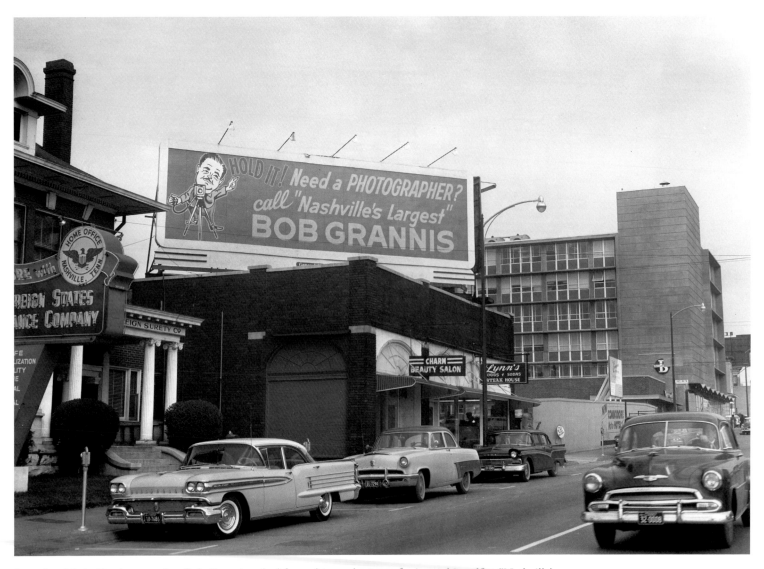

Longtime Nashville photographer Bob Grannis poked fun at his portly size, referring to himself as "Nashville's largest photographer" on his billboard, seen here around 1959.

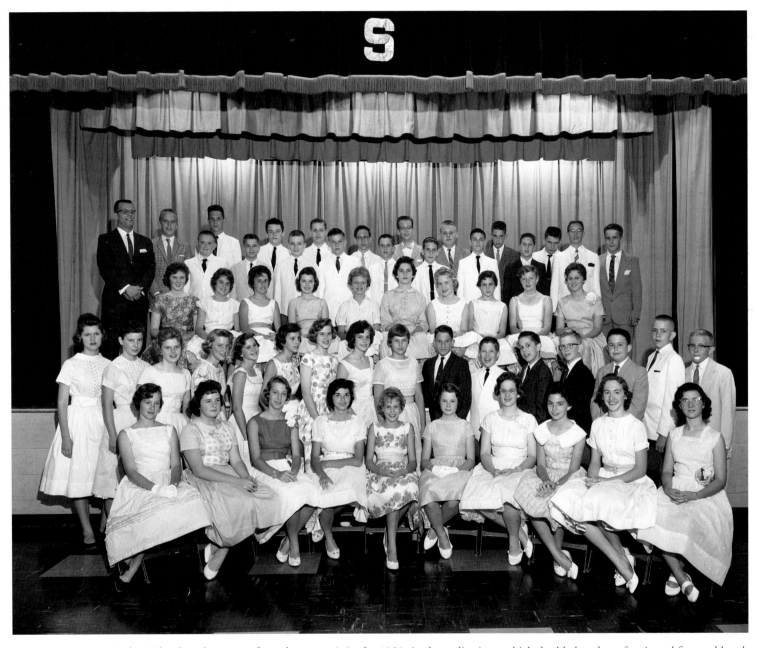

Stokes School students pose for a class portrait in the 1950s in the auditorium, which doubled as the cafeteria and featured lunch tables that could be folded into the walls. In the 1960s, Mr. Harris would serve as principal, and Mrs. Palmer, Mrs. Alsup, and Mrs. Brothers would teach kindergarten through second grades. Their former students are grateful, including the little boy who fretted too much and the little girl who was partial to white glue—mostly for licking. The school is located near David Lipscomb University off Woodmont and Belmont boulevards.

An evening view of downtown. In the distance is the L&C Tower and Harveys Department Store. At left is the Andrew Jackson Hotel and at right is the Hermitage Hotel. The area in the foreground would become Legislative Plaza.

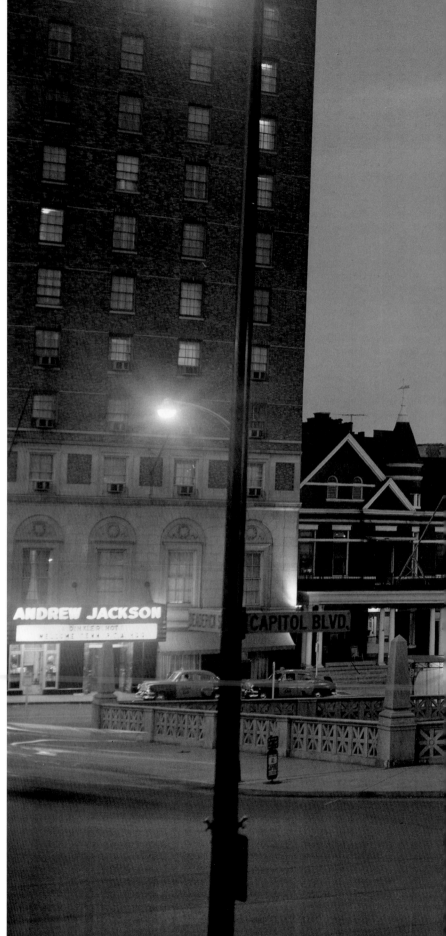

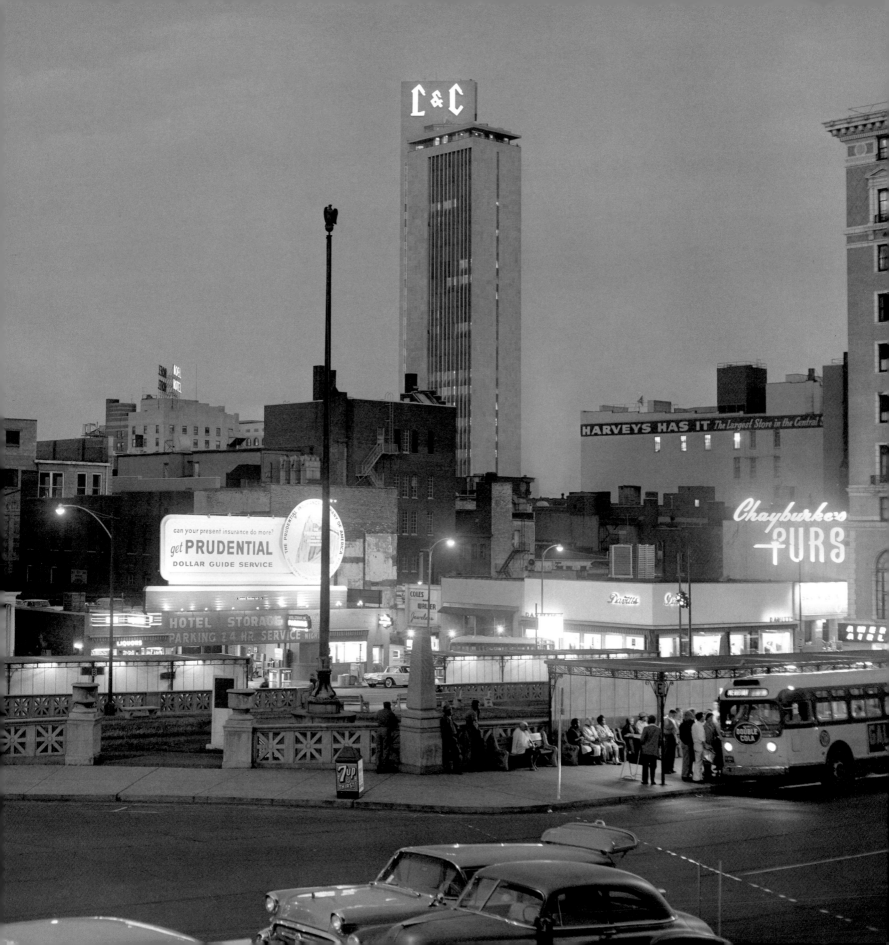

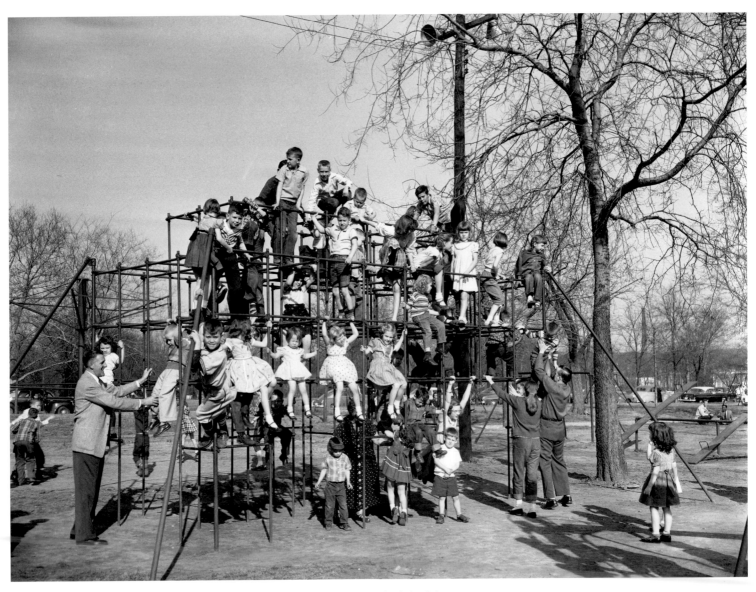

Children climb on the jungle gym at Centennial Park. The Parthenon is to the left of the structure.

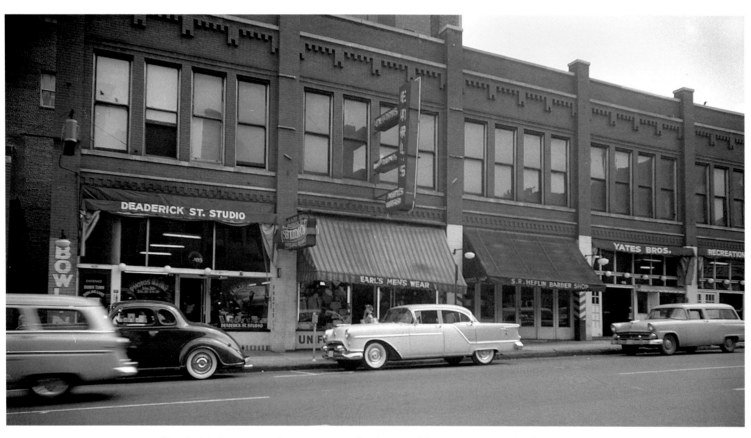

Deaderick Street, once home to many family-owned businesses, is now landscaped with many office buildings and the Tennessee Performing Arts Center.

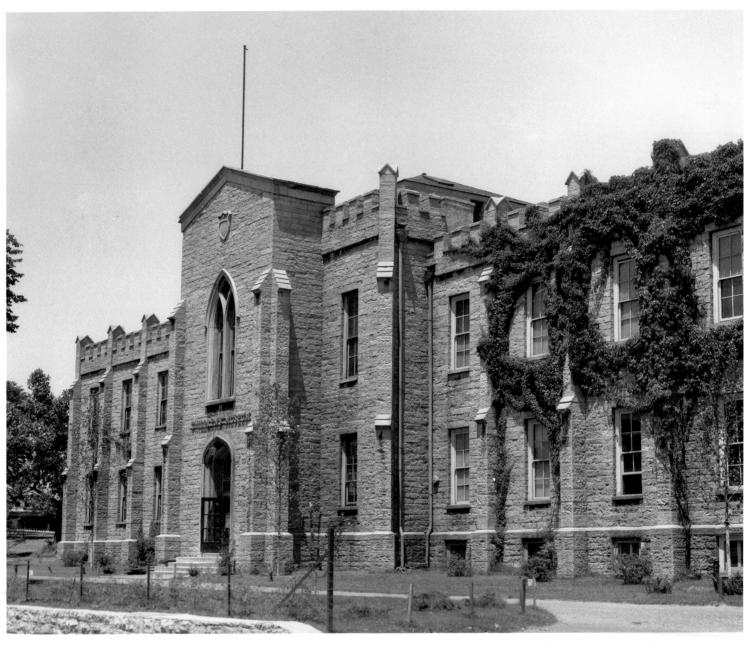

The Children's Museum, housed in the castlelike Peabody Building once visited by Teddy Roosevelt, was founded by John Ripley Forbes in 1945 and enjoyed by Nashville youth throughout the 1950s and 1960s. The museum featured displays of flora and fauna habitats worldwide, but much more. A creaky wooden staircase led past a pair of shrunken heads to a model railroad three or four flights up, where trains crisscrossed a scale model of Nashville. Live turtles and alligators inhabited a cove on the first floor, reached through another nook filled with mounted displays of the world's butterflies and moths. Field trips to local rock quarries and other destinations departed the museum from the front entrance shown here, on school buses filled with young paleontologists carrying rock hammers, collecting sacks—and sack lunches prepared by Mom.

POISED FOR GROWTH AND CHANGE

(1960–1969)

As the 1950s drew to a close, Nashville was poised to become the next great place to live and do business. The city burgeoned with promise, and yet already had much to offer. Each Christmas, Nashvillians enjoyed a life-size nativity scene made possible by Harveys Department Store and set up in front of the Parthenon at Centennial Park. Lit softly at night, it was truly a one-of-a-kind experience. The airspace was crowded over the model airplane field at the Warner Parks, another preferred outdoors destination. The Children's Museum offered young paleontologists field trips to local rock quarries, where expedition leader Mr. Webster might offer a cup of hot chocolate to chilled youngsters hot on the trail of a trilobite. Passenger trains still departed Union Station from beneath a disheveled Train Shed, and well-wishers could wave good-bye to loved ones out-of-doors at Berry Field airport. TV weatherman Bob Lobertini enthralled viewers with his weather map artistry, and Nashvillians watched entranced in 1969 as Neil Armstrong set foot on the moon.

At the forefront of controversy were the civil rights movement and the Vietnam War. Unresolved racial questions and anti-war sentiments led to tension and unrest. In 1960 the Nashville Student Movement paved the way for minority rights by staging sit-ins at local lunch counters, a move that was largely supported by city leaders. Another notable change was the consolidation of government in 1963, when city and county governments joined together to create Nashville's Metropolitan Government. A unified government was seen as a bigger draw for potential businesses.

In 1967, the sale of liquor by the drink was made legal. Opposing the move were the unlikeliest of allies. Liquor stores sided with the Baptist Sunday School Board, one fearing a drop in sales, the other concerned about the city's moral standards. Those in favor hoped the change would entice more hotels and restaurants to call Nashville home. It was also a matter of image. A city that sold liquor by the drink was held to be more progressive, a place that would draw people who wanted to see and be seen. Businesses settled here, and hotels and restaurants began opening doors to patrons ready to pay. Nashville was seeking to shed its "Old South" image in hopes of becoming a thriving metropolis, and a metropolis it would become. New businesses and a shopping mall, the birth of the city's Interstate system, and other changes ultimately brought Nashville into line with the direction of the nation at large.

The Frost Building, pictured here in 1960, was erected by the Baptist Sunday School Board on Eighth Avenue in 1913.

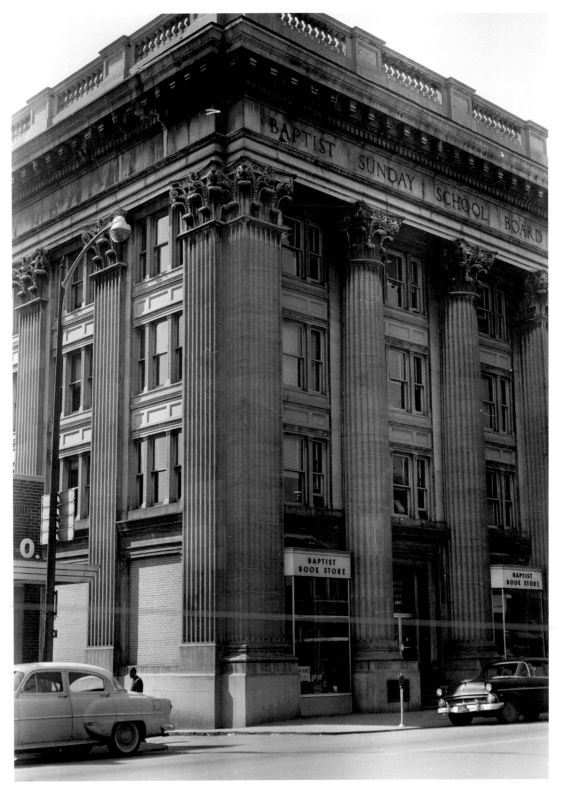

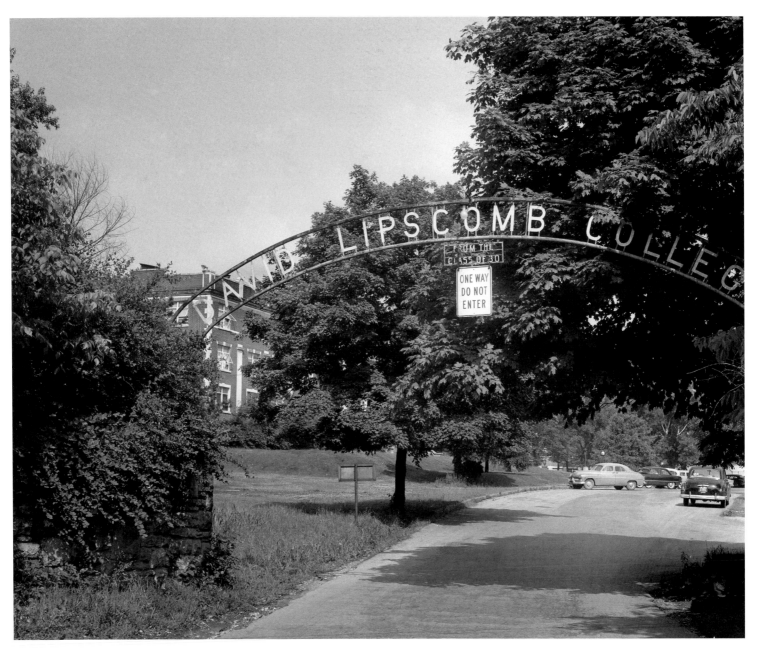

David Lipscomb University off Woodmont Boulevard and Granny White Pike was founded by David Lipscomb and James Harding in 1891, prominent leaders of the conservative branch of a movement spearheaded by frontier revivalist Alexander Campbell. Campbellites and their inheritors the Church of Christ preached a return to authentic Christianity, which they believed had been corrupted over the centuries with accoutrements unrelated to the faith. The school offers a wide range of majors, including an art department that in the twentieth century produced the widely noted local talents Michael Shane Neal, Dawn Whitelaw, and Charles T. Cox.

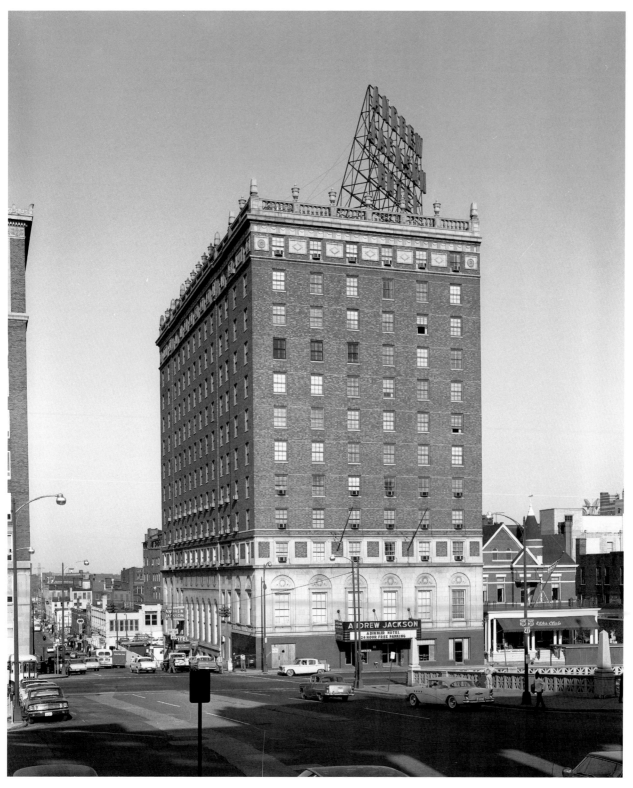

The Andrew Jackson Hotel opened in August 1925 at the corner of Sixth Avenue and Deaderick Street. In 1971, the building was demolished and the James K. Polk State Office Building, home to the Tennessee State Museum and the Tennessee Performing Arts Center, was erected.

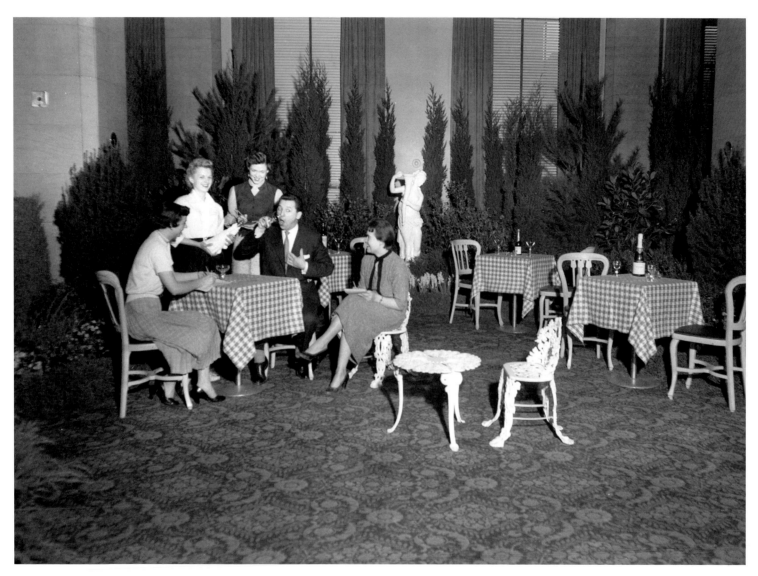

Patrons enjoy a glass of wine in the Hickory Room at the Andrew Jackson Hotel. Liquor by the drink would become a hot-button issue during the decade and was voted into law in 1967.

An exterior close-up of the Andrew Jackson Hotel and vicinity around 1960. The marquee welcomes legionnaires.

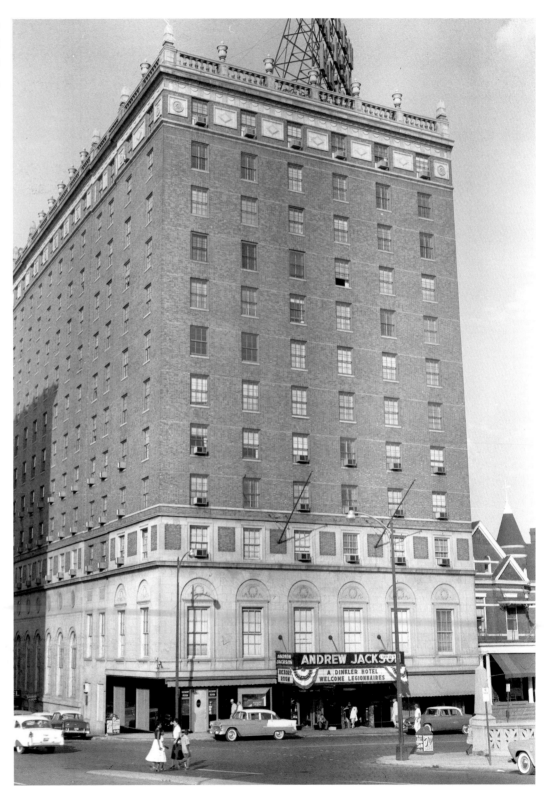

Nashville's General Hospital, which opened in 1890 with 60 beds, 1 physician, and 7 nurses, served Nashvillians into the 1990s. Three of the historic buildings on site, which overlooks the Cumberland River, are currently undergoing revitalization as residential and commercial properties.

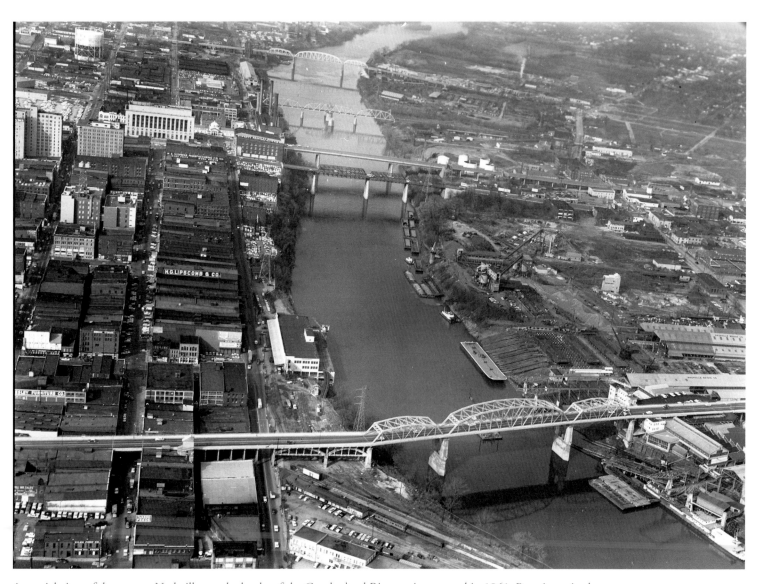

An aerial view of downtown Nashville, on the banks of the Cumberland River, as it appeared in 1961. Prominent in the image are Second Avenue and the Shelby Street Bridge. The bridge opened for vehicular traffic in 1909 and would reopen as a pedestrian bridge in 2003, much owing to the success of Chattanooga's historic Walnut Street Bridge, revitalized for pedestrian use sometime earlier.

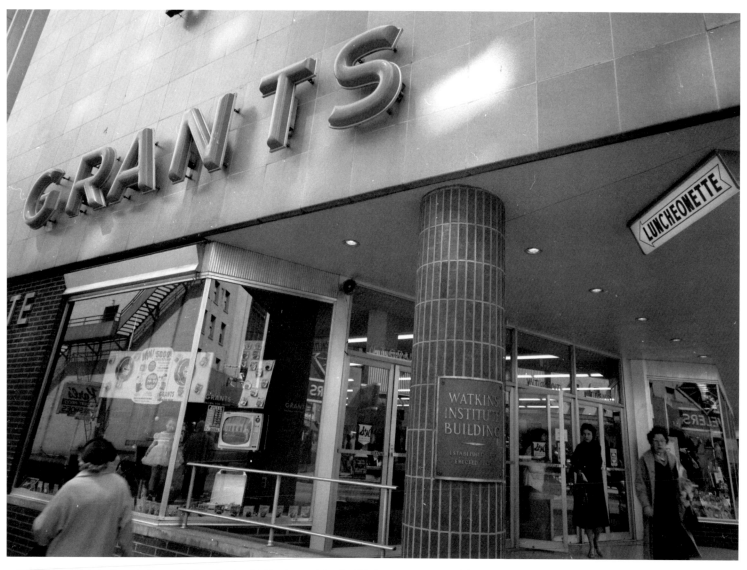

Shoppers exit Grant's five-and-dime in the 1960s, located in the Watkins Institute Building downtown on Church Street. The original Watkins Institute building, a handsome multi-story Victorian-era edifice which stood on this site, was demolished in 1958.

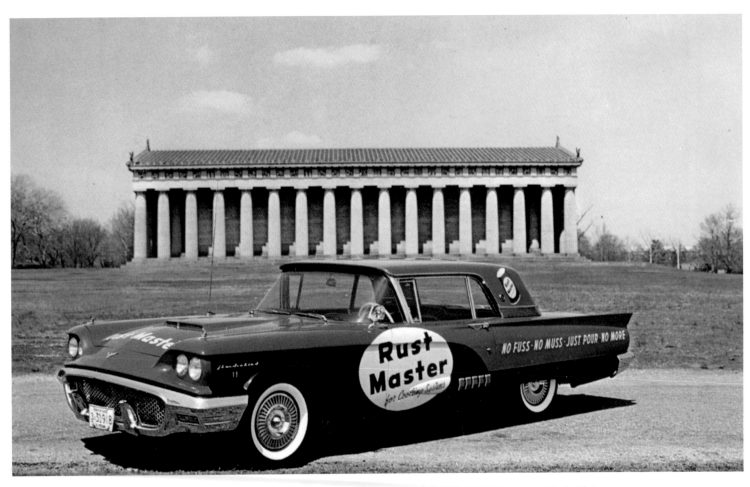

A Ford Thunderbird advertising Rust Master, an automotive radiator fluid, rests in front of the Parthenon in Nashville's Centennial Park in the early 1960s. Had this been December, Harvey's nativity scene would be visible in the background, extending the length of this side of the Parthenon, which faces West End Avenue.

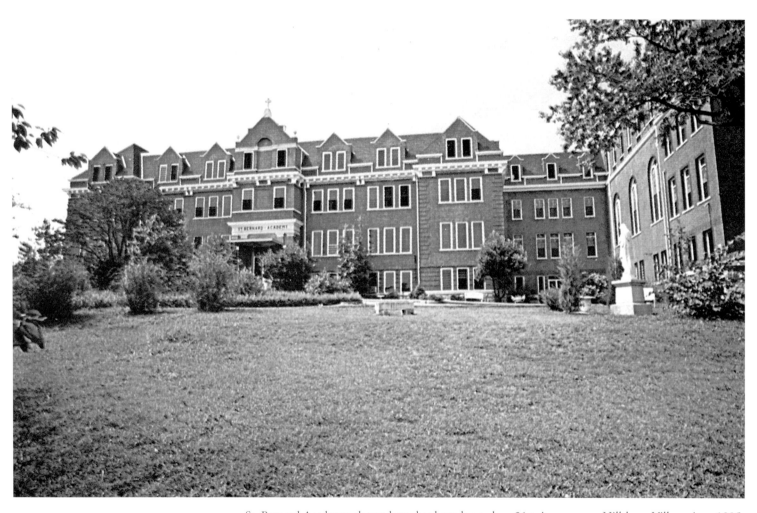

St. Bernard Academy, shown here, has been located on 21st Avenue near Hillsboro Village since 1905.

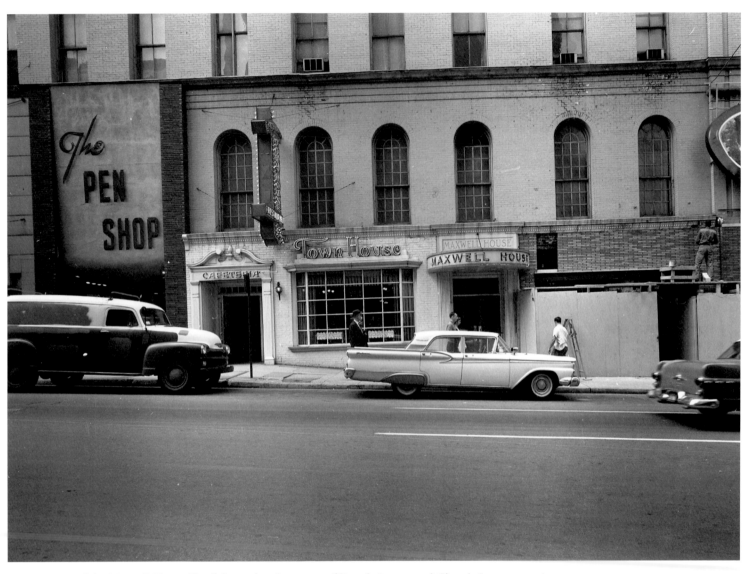

Exterior view of the Maxwell House Hotel, located at the corner of Fourth Avenue and Church Street, opposite the L&C Tower and the Noel Hotel, early in the decade.

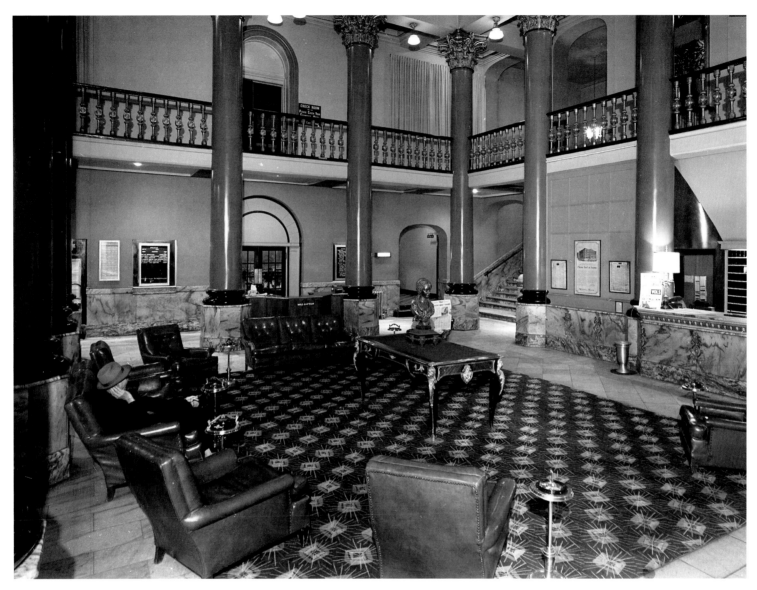

The scene around 1961, in the Maxwell House Hotel lobby. Nashville's best-known and greatly lamented hotel—known to many only for the famous brand of coffee that originated there—the Maxwell House began construction on the eve of the Civil War and was completed in 1869 following the war. Luminaries who paid the grand hotel a visit include Sarah Bernhardt, Thomas Edison, Henry Ford, William Jennings Bryan, Buffalo Bill, Enrico Caruso, and eight presidents, among them Teddy Roosevelt. Whether Teddy actually uttered the immortal phrase "good to the last drop" after imbibing a cup of the house's now-famous blend remains a favorite subject for conjecture.

Mickey's Restaurant was one of several dining options associated with the Maxwell House Hotel. Other restaurants included Court of Kings and Copper Kettle. The entrance to the Maxwell House is on the far right.

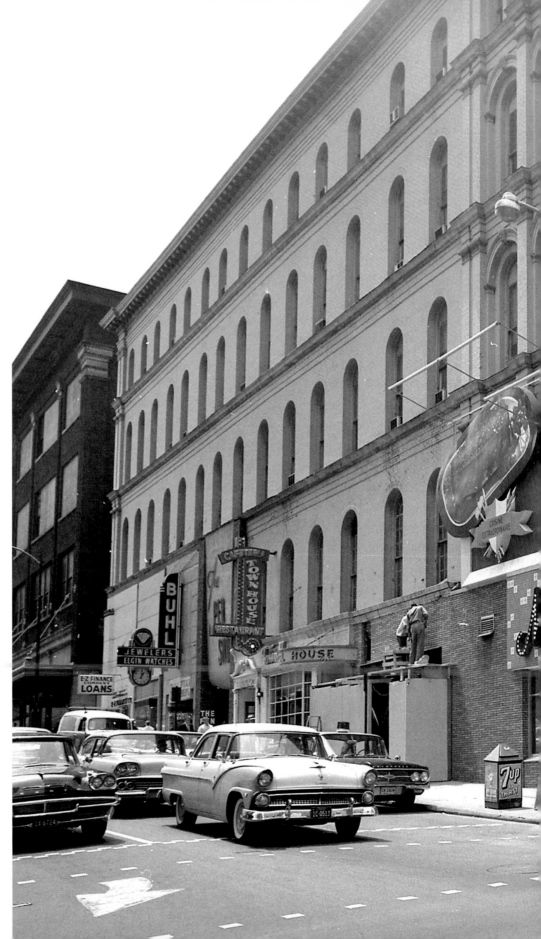

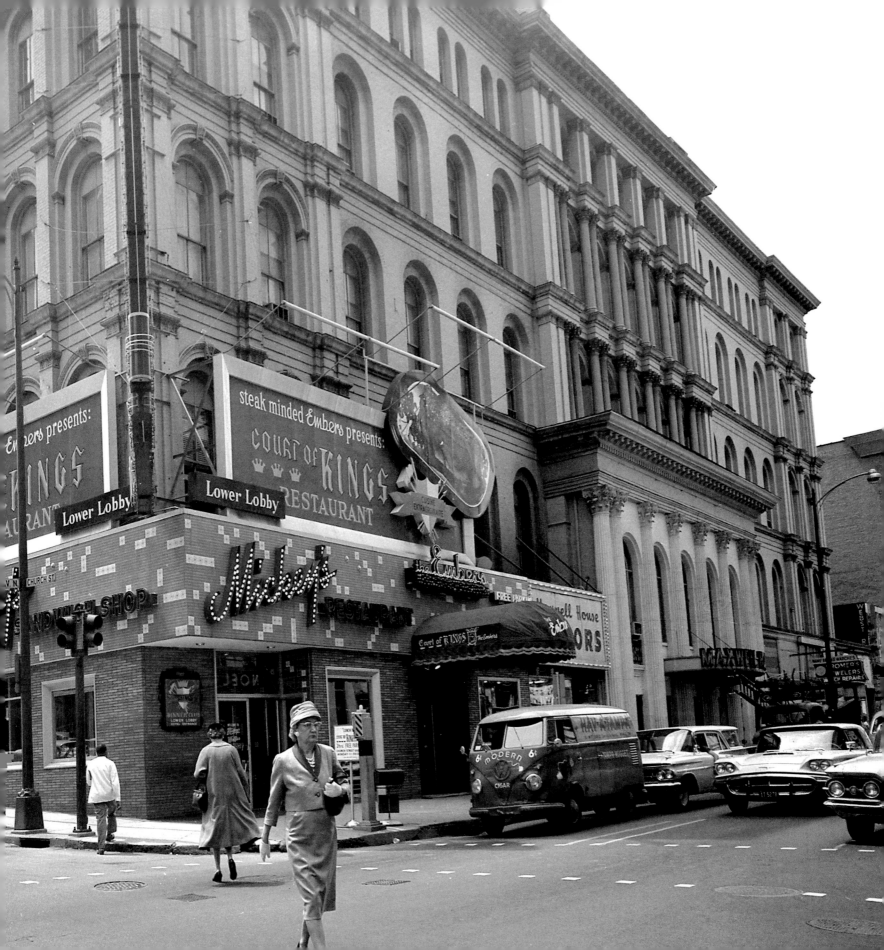

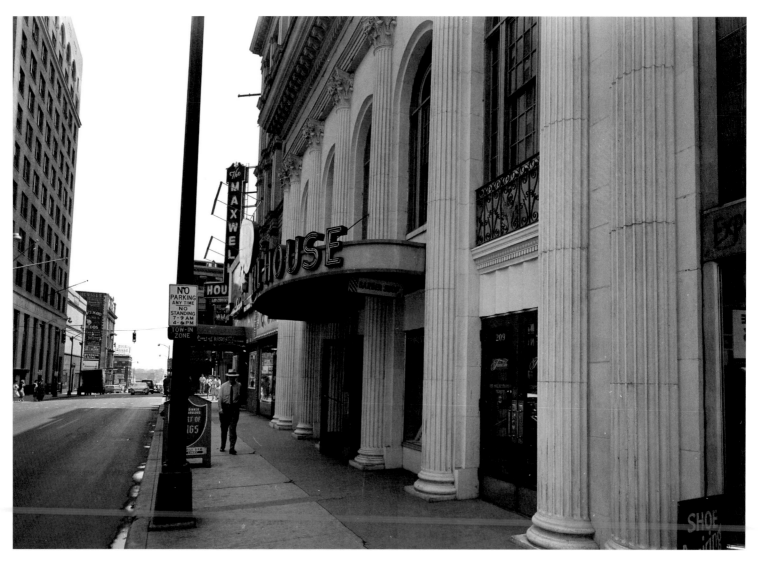

The Fourth Avenue entrance of the original Maxwell House Hotel, for which Maxwell House coffee is named, on a day in 1961. Open for business nearly a century, the hotel's days were now numbered.

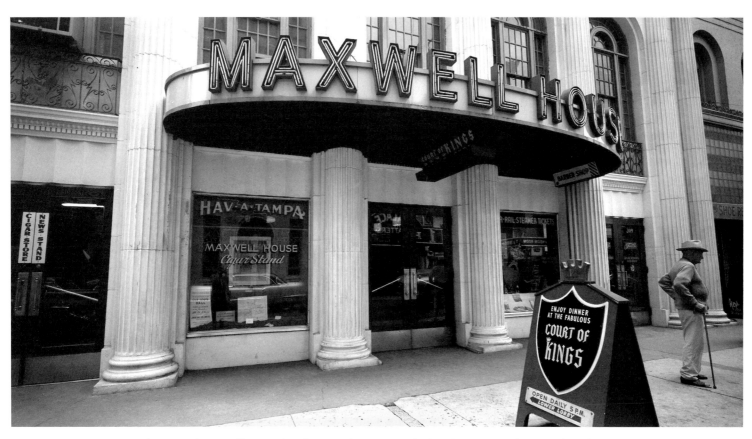

The original Maxwell House hotel at Fourth Avenue and Church Street was destroyed by a fire on Christmas night 1961. It lives on, in name only, at the Millennium Maxwell House in MetroCenter.

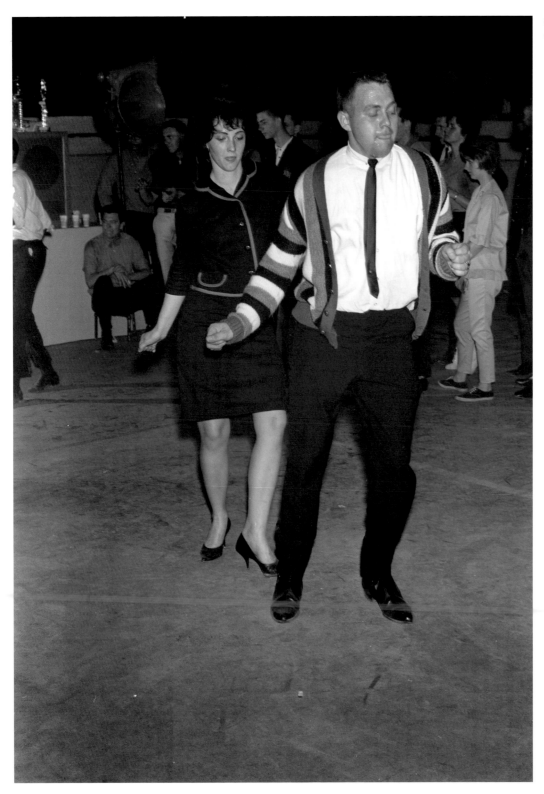

One couple twists the night away in the WKDA Radio Twist Contest in 1962.

All ages were doing the twist in the WKDA contest.

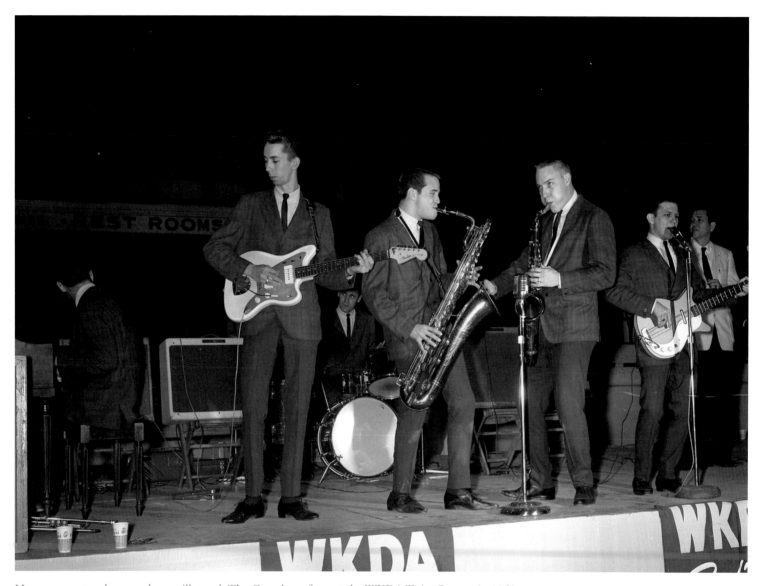

Have crew cut and pompadour, will travel. The Casuals perform at the WKDA Twist Contest in 1962.

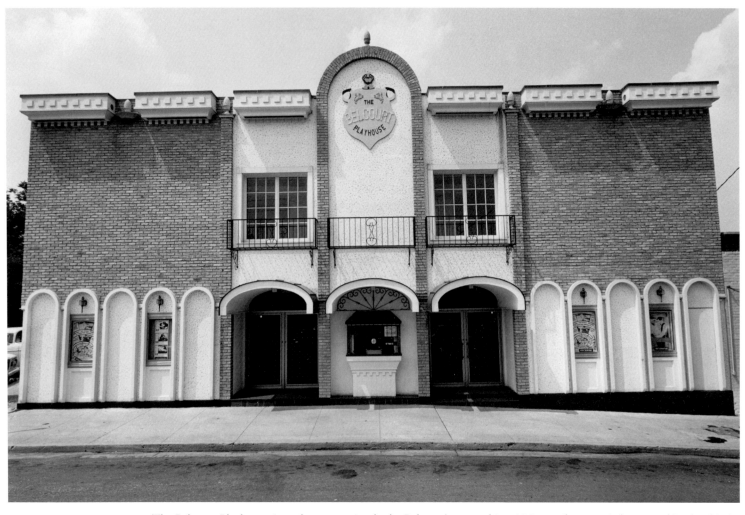

The Belcourt Playhouse (now known as simply the Belcourt), opened in 1925 as a silent-movie house and in the thirties became home to Nashville Children's Theatre and the Grand Ole Opry. The building is still an entertainment venue and remains in its original location on Belcourt Avenue off 21st Avenue in Hillsboro Village.

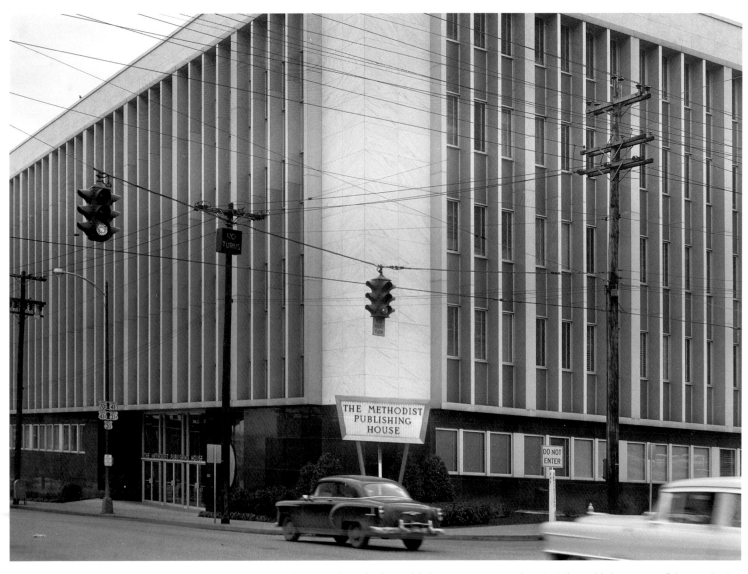

The Methodist Publishing House became the United Methodist Publishing House around 1968. The publishing arm of the Methodist Church was founded in 1789 to supply John Wesley's traveling frontier preachers with Christian literature for distribution to early Americans. From the 1960s forward, much of the focus of house publications shifted to activist causes. Membership in all mainline denominations, with United Methodist churches experiencing some of the steepest drops, has continued to decline since 1970.

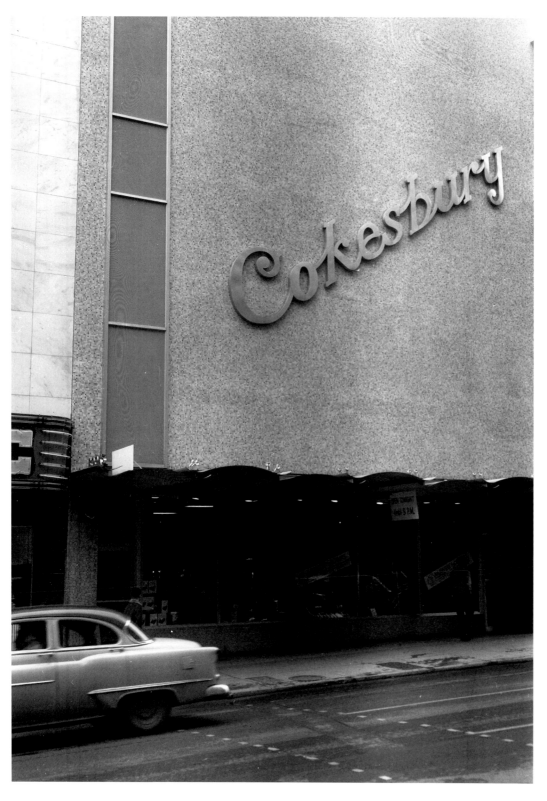

Cokesbury, the retail outlet for publications of the United Methodist Publishing House, is pictured here at its Eighth Avenue location in 1960.

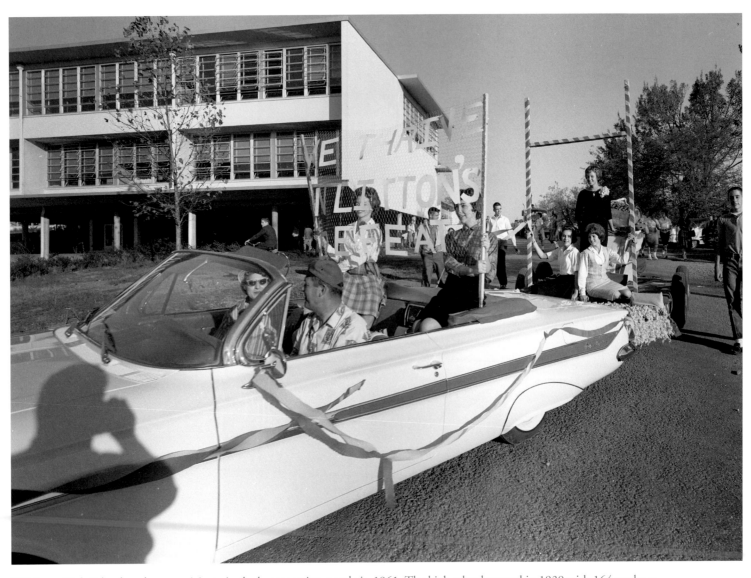

Hillsboro High School students participate in the homecoming parade in 1961. The high school opened in 1939 with 164 students.

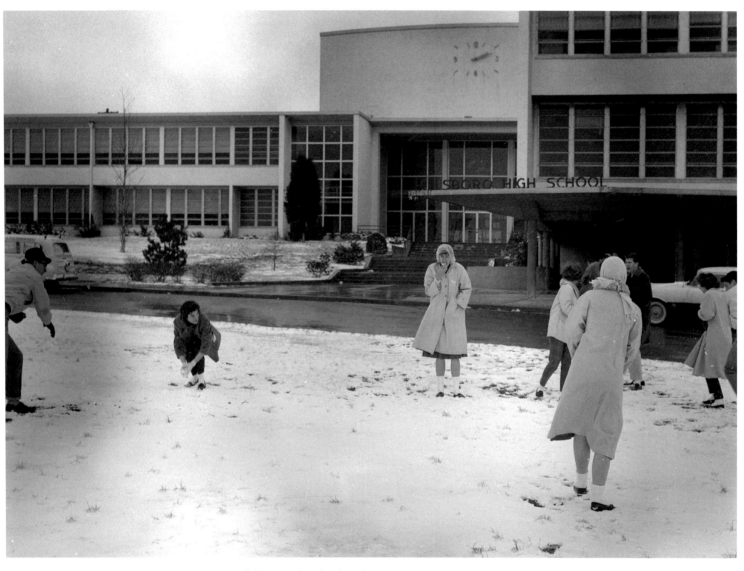

Hillsboro High School students enjoy some snow play in front of the school, still located in the heart of Green Hills facing Hillsboro Road.

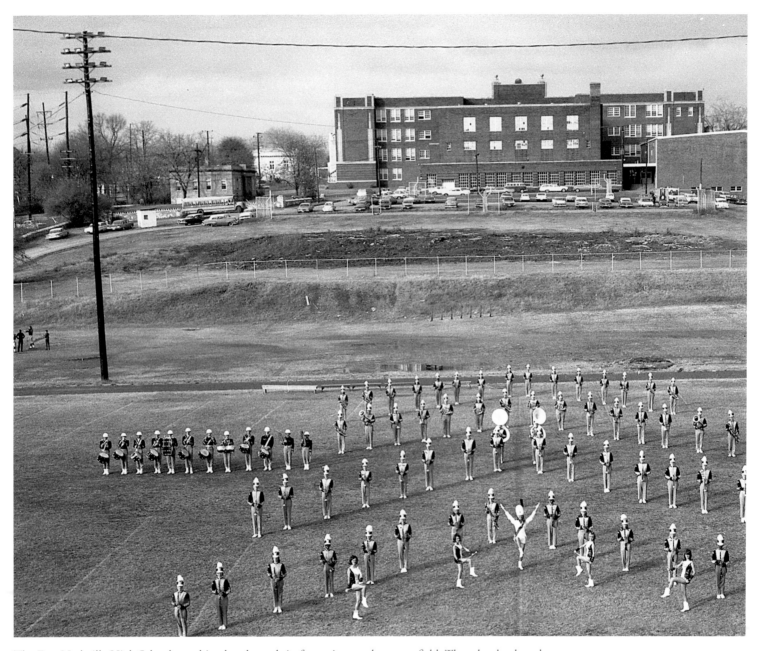

The East Nashville High School marching band stands in formation on the sports field. The school, whose best-known alumna was Oprah Winfrey, is today East Literature Magnet School, which operates out of the same building located on Gallatin Road in East Nashville. The Frozen Castle located nearby, once a purveyor of ice cream confections, was in former days a favored hang-out among students.

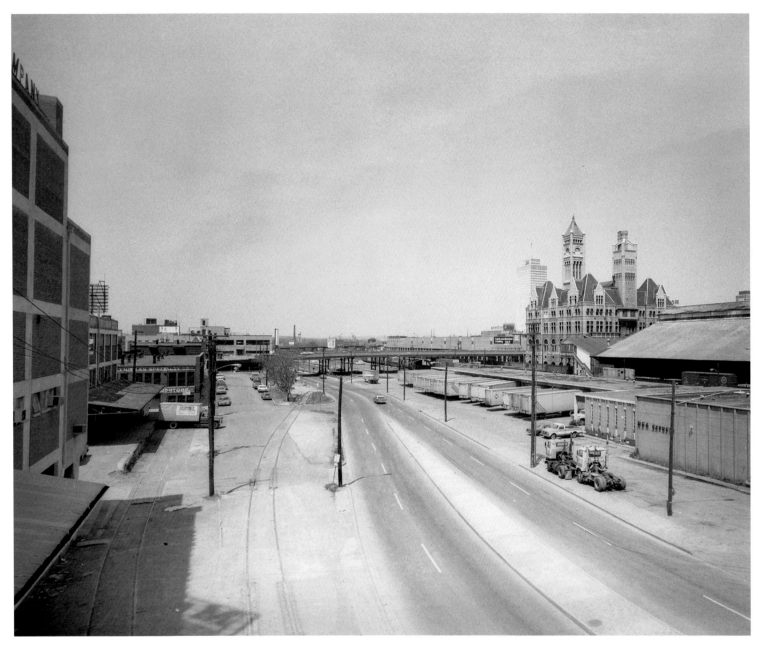

Union Station, the Train Shed, and the Concourse are shown to the right in this image of the railroad gulch from the 1960s. The station's passenger trains would continue competing with the airlines, buses, and the automobile until the 1970s, when passenger service was discontinued. Although the station would be resurrected as a luxury hotel 20 years later, the Baggage Building and architecturally unique Train Shed were left by city leaders to pigeons, transients, and the elements. When the Shed was set afire in 1996, reportedly the result of a turf war among the transients living beneath the structure, the Fire Department branded the Train Shed a fire hazard. It would be razed in early 2001.

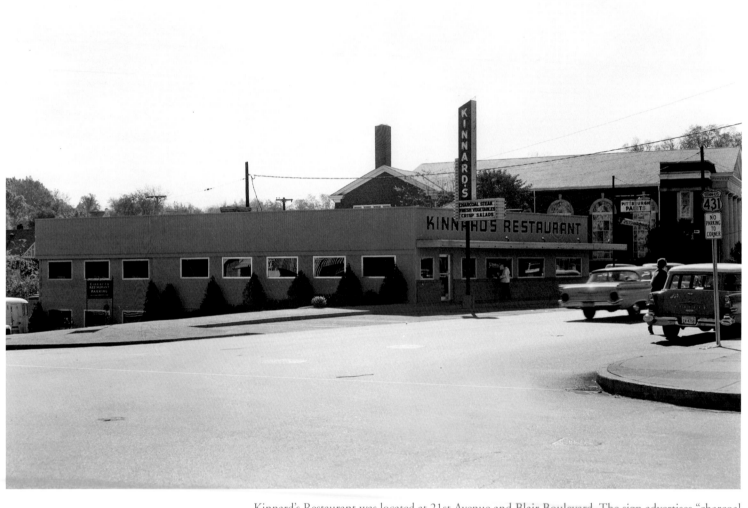

Kinnard's Restaurant was located at 21st Avenue and Blair Boulevard. The sign advertises "charcoal steaks, fresh vegetables, crisp salads."

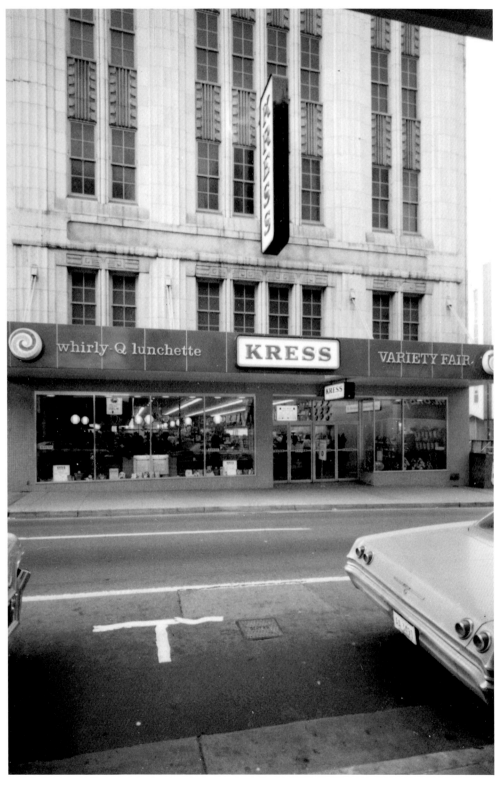

The Kress five-and-dime was located on Fifth Avenue near Grant's, Woolworth's and McLellan's, across the street from the Arcade. Samuel Kress founded the chain of department stores in 1896 in Nanticoke, Pennsylvania, eventually opening locations in most cities across the nation. Kress stores, which were noted for their distinctive architecture, continued in operation up to 1981. Although the Whirly Q Lunchette is long since gone, Nashville's Kress building stands tall, refitted for condominiums.

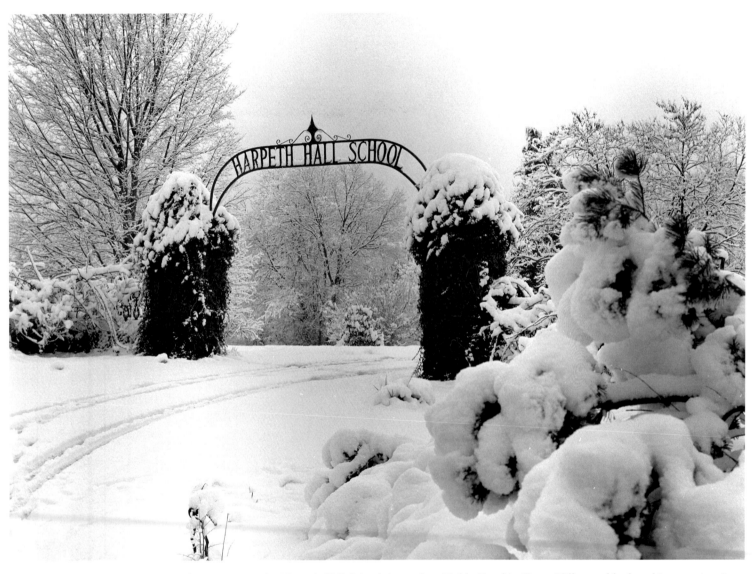

The entrance to the Harpeth Hall School, located on Hobbs Road in Green Hills, was blanketed in snow in winter 1968. The all-girls' school was founded in 1951.

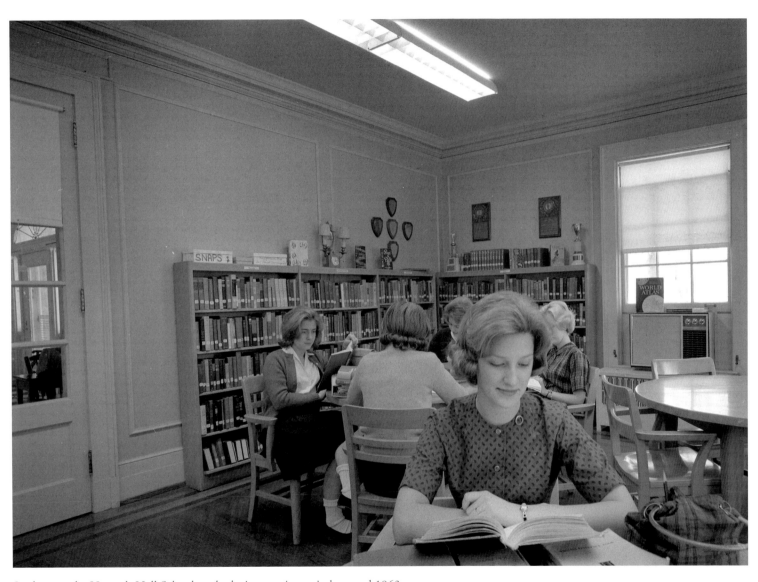

Students at the Harpeth Hall School study during a quiet period around 1963.

The students at Harpeth Hall all-girls' school perform at the annual Washington Day in 1963.

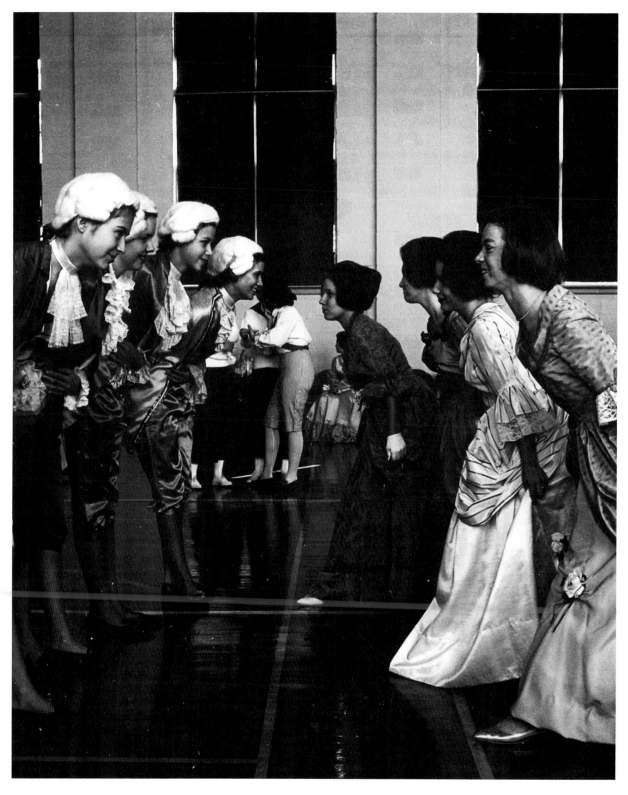

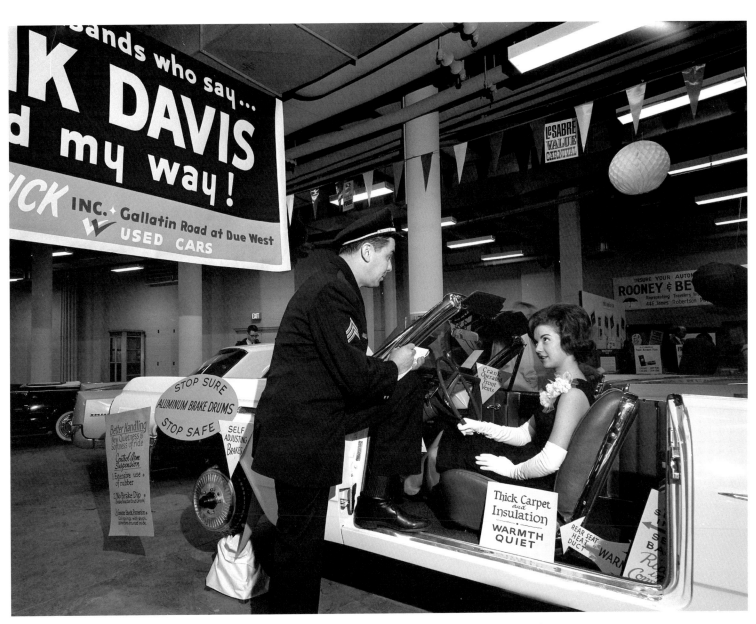

Antics abound at the Bob Osiecki car show in January 1963. The hanging sign advertises Frank Davis Buick.

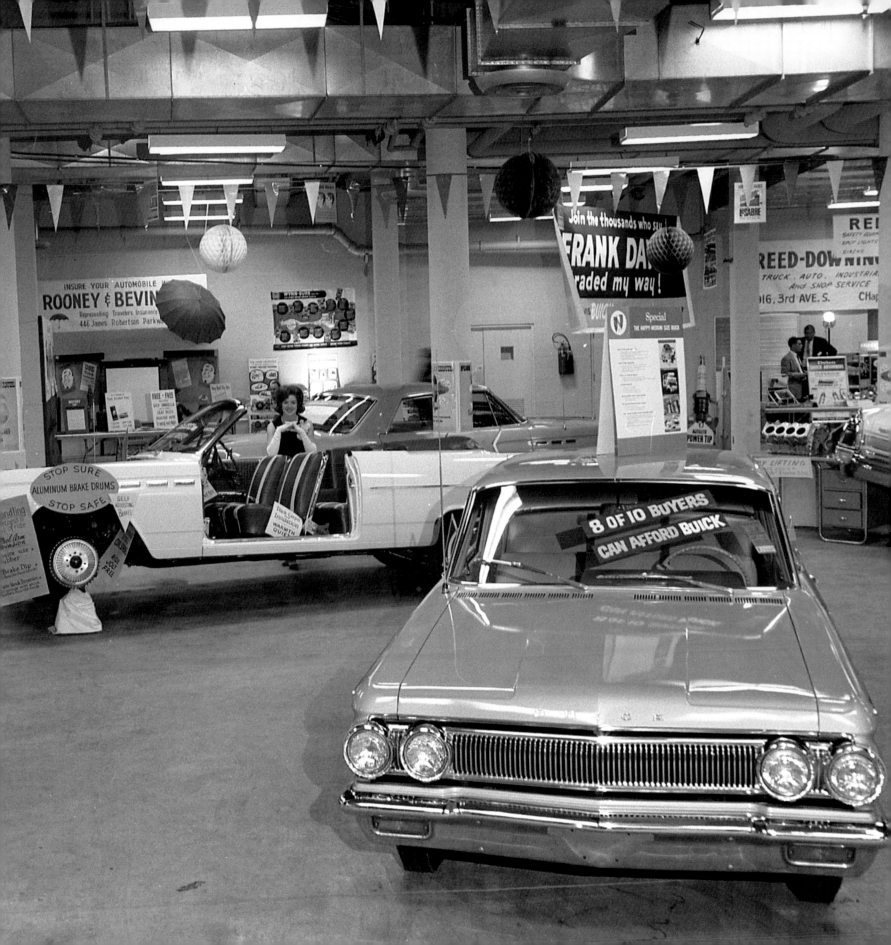

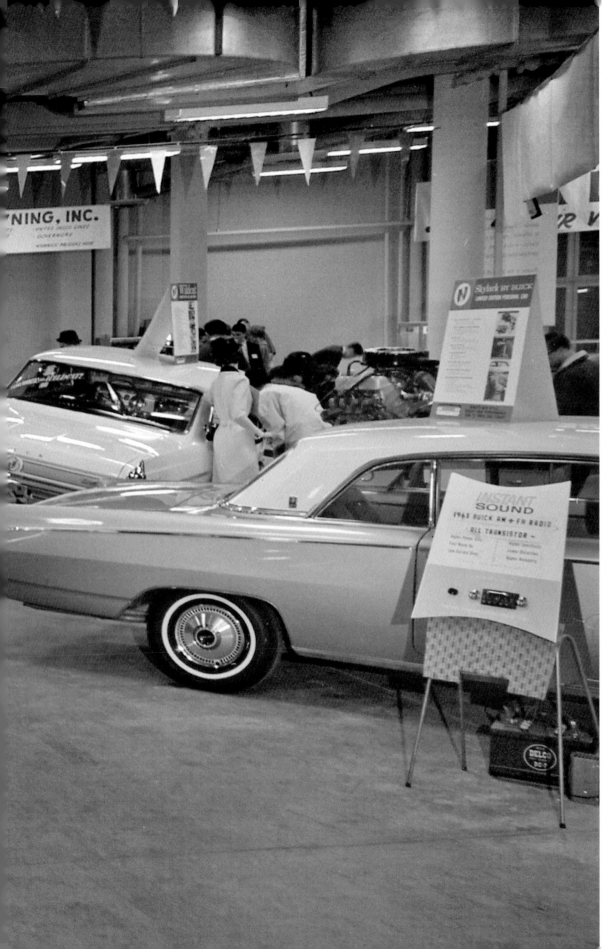

A wide range of automobiles are on display at Bob Osiecki's Auto Show at the fairgrounds in January 1963.

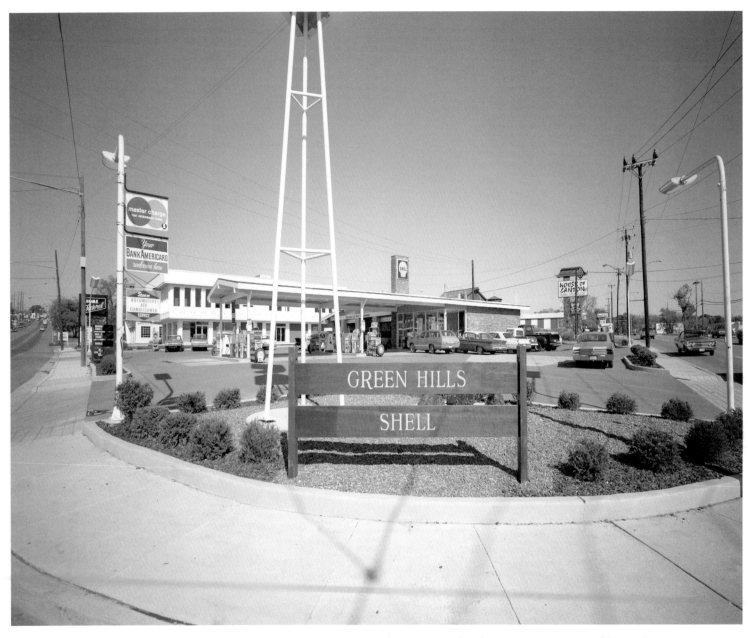

The Green Hills Shell station was located on the corner of Hillsboro and Richard Jones roads. The space is now occupied by Men's Warehouse. A new Shell station is located down the street at the corner of Hillsboro Road and Warfield Drive.

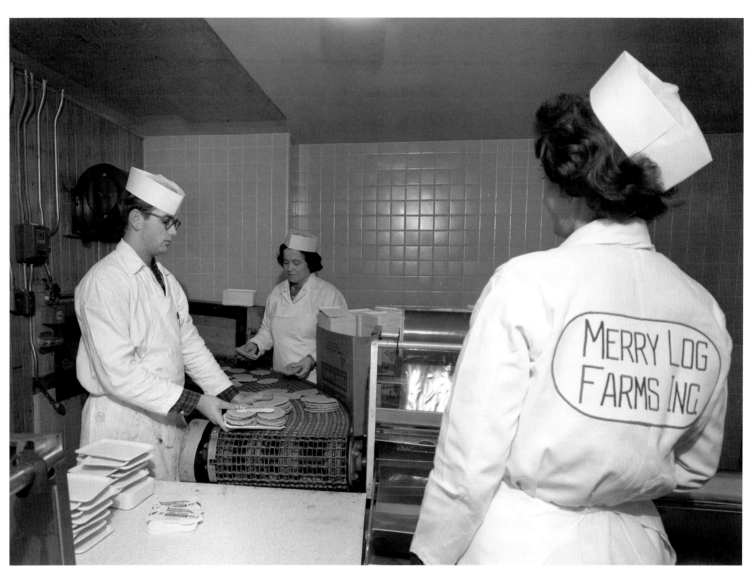

Merry Log Farms employees package hamburgers for sale in 1966.

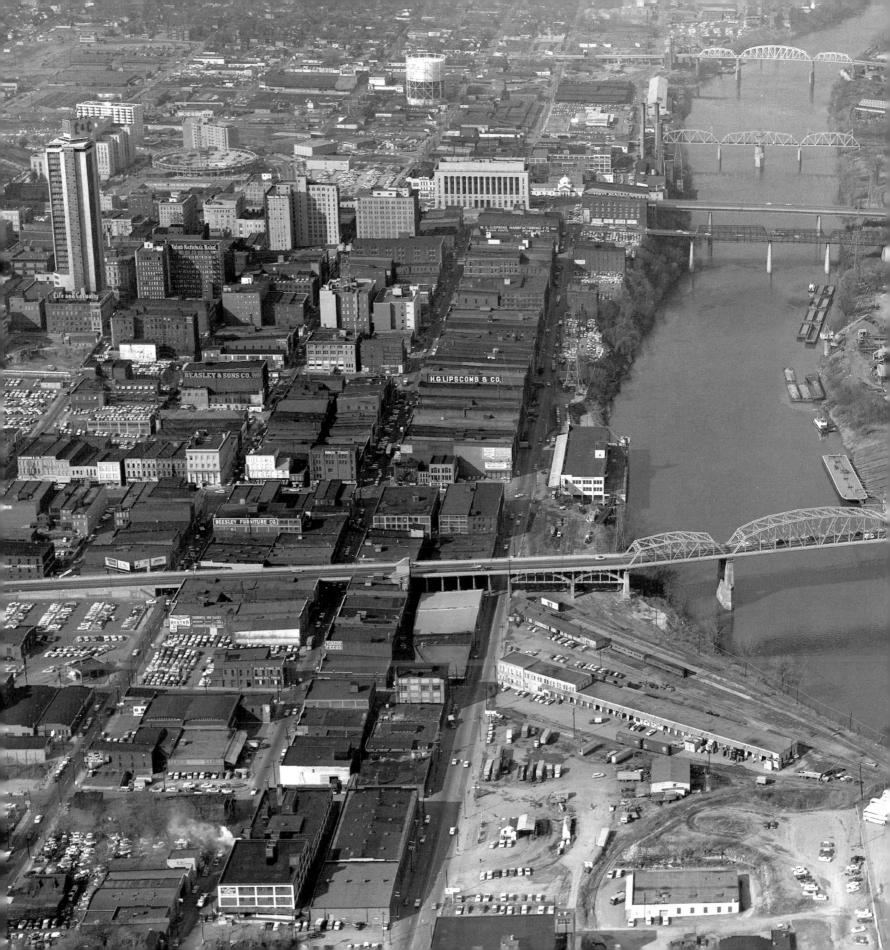

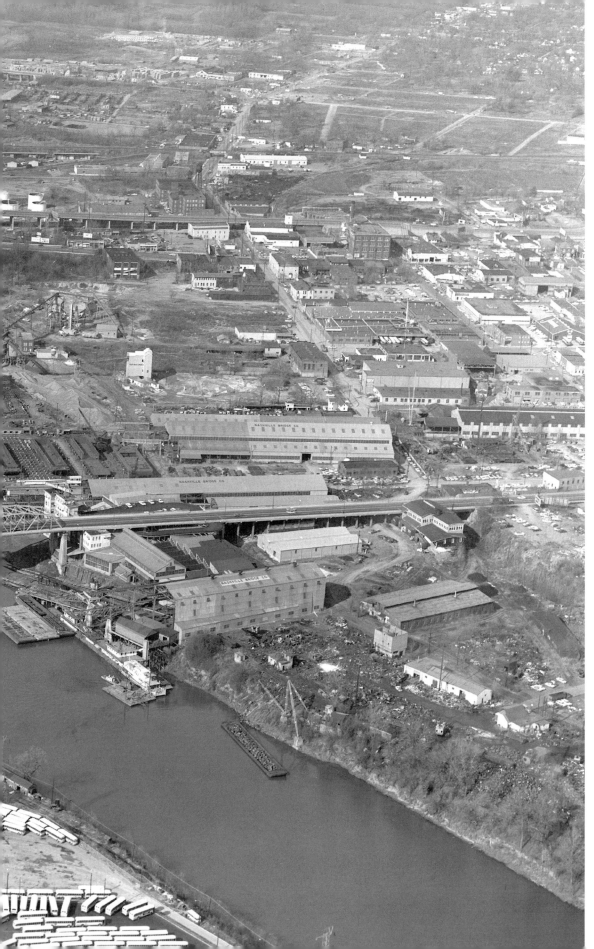

An aerial view of midcentury Nashville shows a thriving city coming into her own.

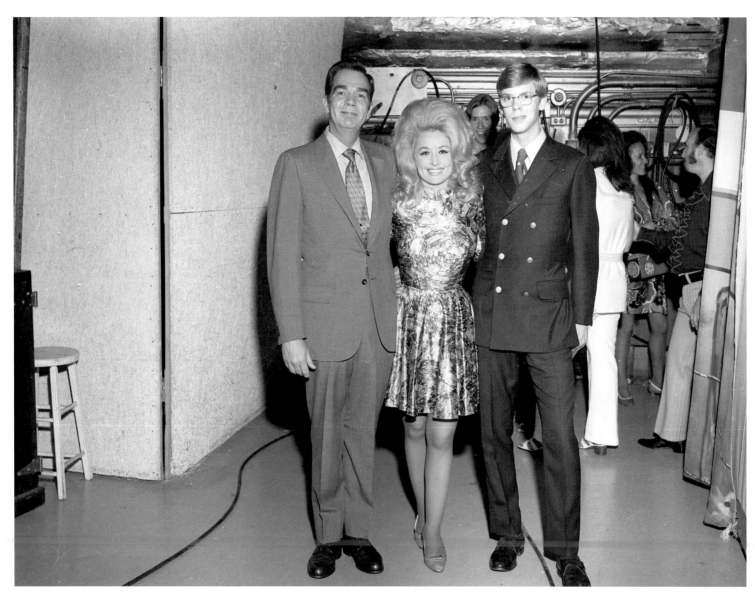

Country legend Dolly Parton began performing as a child in east Tennessee, making an appearance on the Grand Ole Opry at the age of 13. Parton moved to Nashville in 1964 and rose to fame after joining the Porter Wagoner Show in 1967.

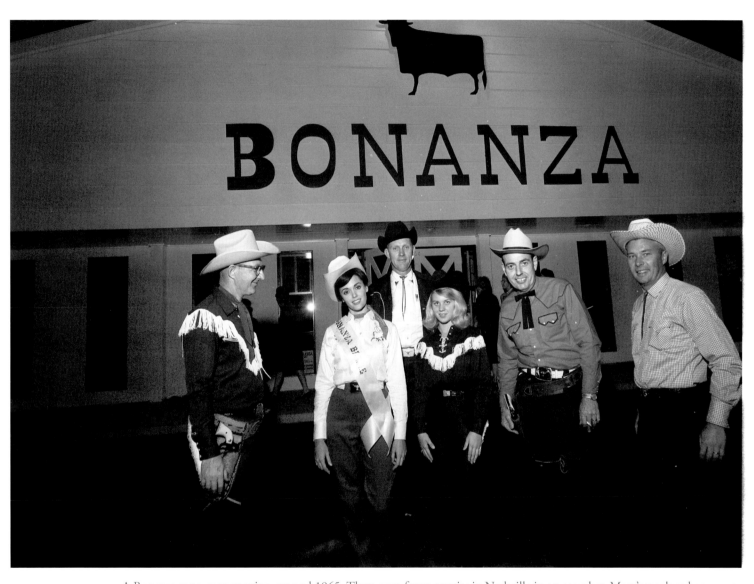

A Bonanza restaurant opening, around 1965. There were fewer eateries in Nashville in an era when Mom's meals at home were still the norm. Favorite venues for a meal on the town included Bonanza, Shakey's Pizza, Shoney's, the Iris Room at Cain-Sloan's downtown, Melfi's Italian on Division Street, the Elliston Place Soda Shop, Cross Keys, and Candyland.

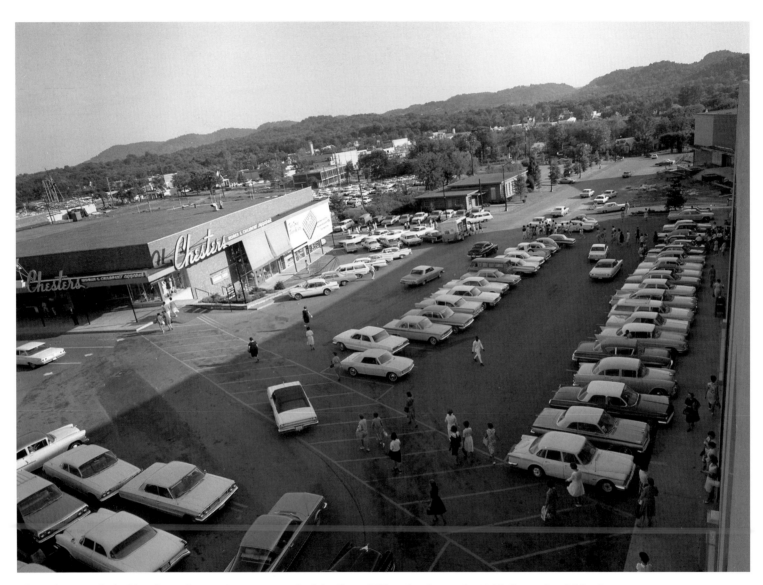

Chester's women's clothier, shown here at the western end of the Green Hills strip of stores in 1965, featured a children's playground for tagalong tots. At the other end of the row, facing Hillsboro Road, stood a small house visited by Santa each year at Christmastime. Cain-Sloan and Castner-Knott, two of the three leading local department stores, had opened stores at the Green Hills site, and many shoppers in the 1960s were choosing these stores over the downtown locations. Chester's had a whistling mynah bird that got everyone's attention.

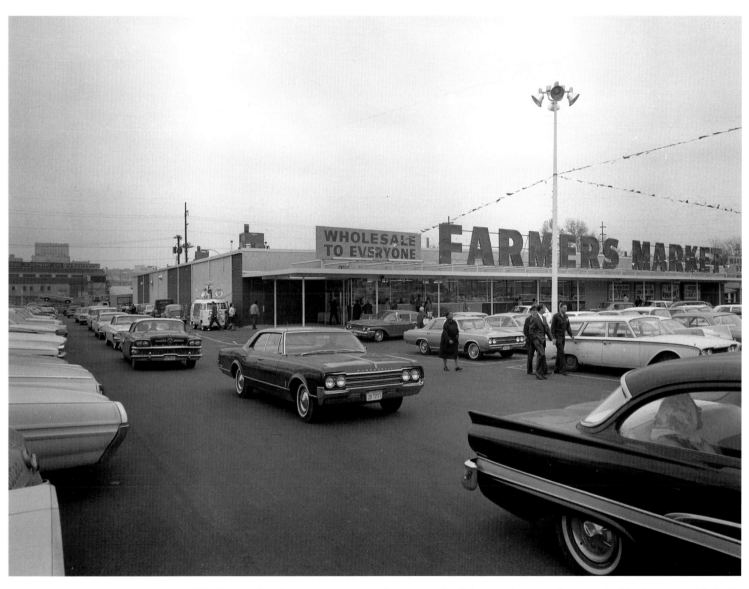

The Farmers Market grocery store was located north of the courthouse and state capitol in downtown Nashville adjacent the Farmer's Market. Today's market is located on the same site, and Smiley's fruits and vegetables available there are still homegrown on a farm thirty miles north near Greenbrier.

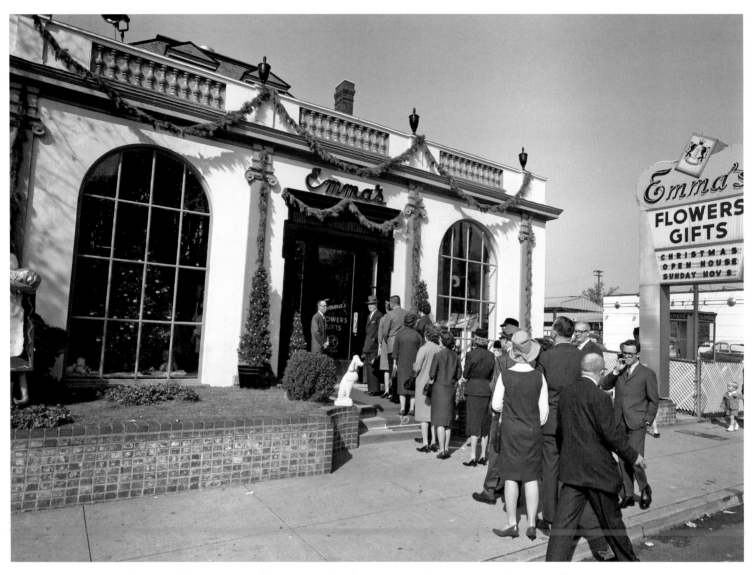

Emma's Flowers and Gifts, Nashville's "superlative florist," hosted a Christmas open house in November 1964. The flower shop still operates at this location on West End Avenue.

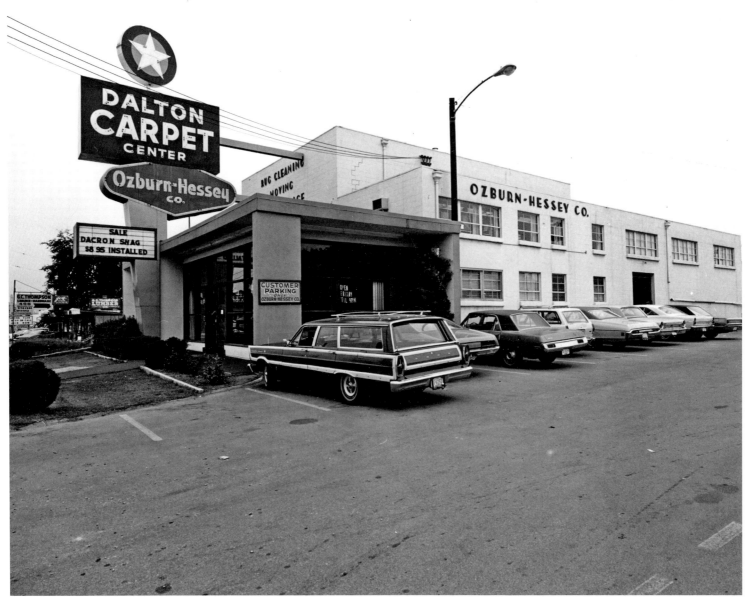

The Dalton Carpet Center and Ozburn-Hessey Company on Murfreesboro Road. Ozburn-Hessey was founded in 1951 as a moving and storage company and continues to offer moving and logistics services today.

Ray Price and his band perform at the Grand Ole Opry birthday party in 1966. At the age of 83, Price still performs, making an appearance in 2009 on TV's *Huckabee* show.

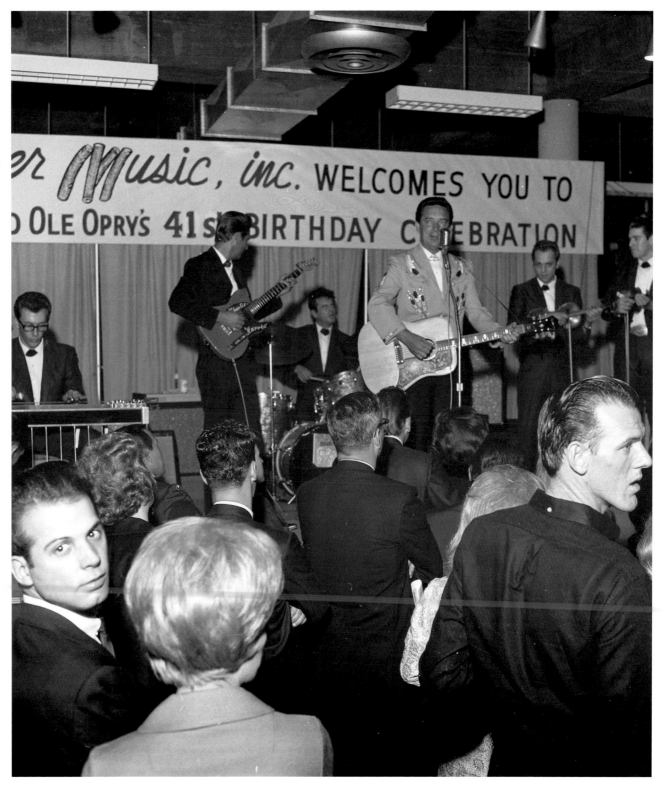

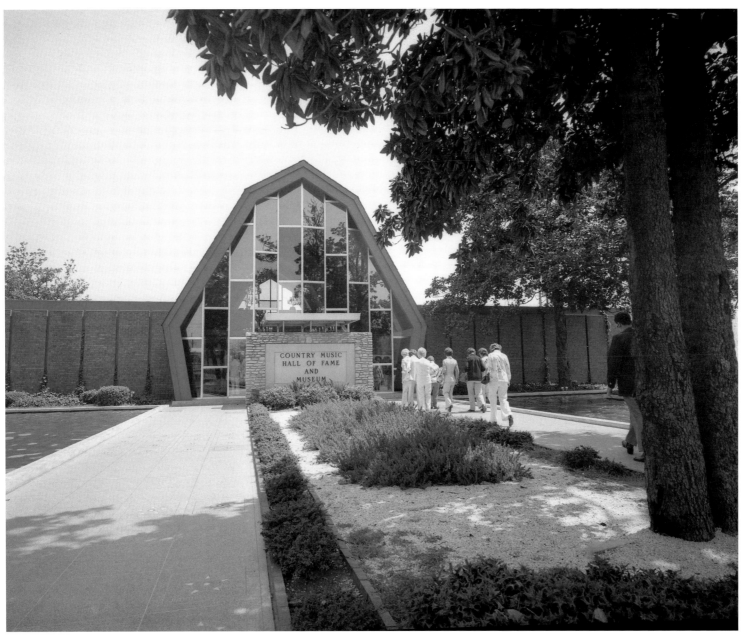

The Country Music Hall of Fame and Museum, which opened in 1967, was originally located on 16th Avenue at the end of Nashville's famous Music Row. The new Hall of Fame was built on Fifth Avenue, opening to the public in 2001.

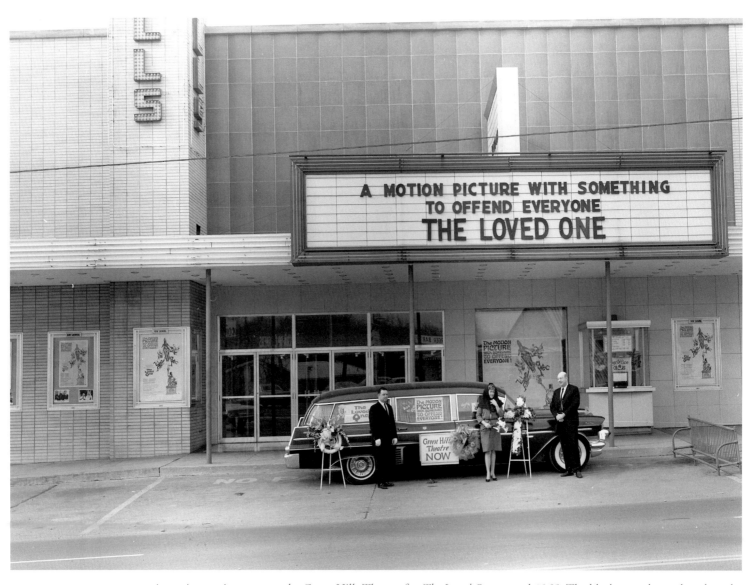

A movie premiere stunt at the Green Hills Theater for *The Loved One* around 1965. The black comedy was based on the novel by Evelyn Waugh and starred Jonathan Winters and Robert Morse. The Green Hills Theater was among the several downtown and suburban theaters that would succumb to the "bigger is better" habits of theatergoers, who were soon to be lured to multi-screen venues in which the screens themselves would grow ever smaller.

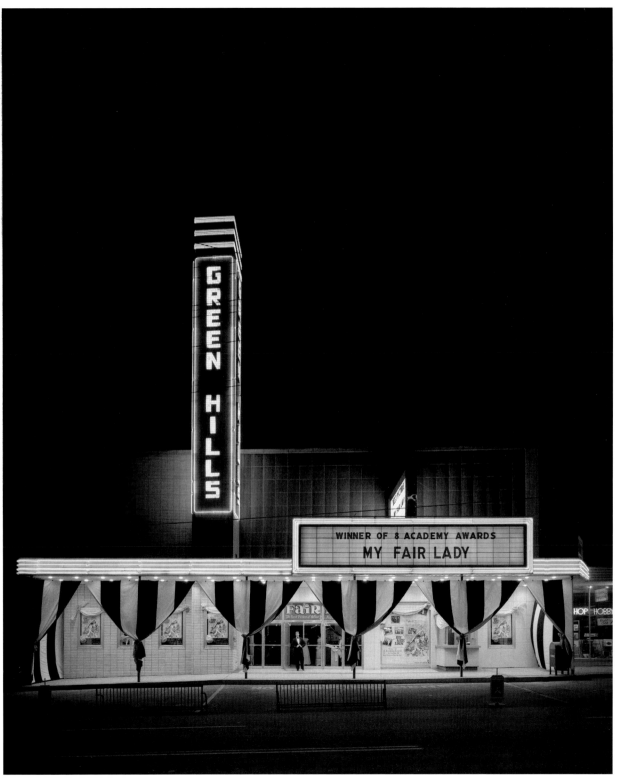

The Green Hills Theater, located in the heart of Green Hills on Hillsboro Road, offers a showing of *My Fair Lady.* Starring Rex Harrison and Audrey Hepburn, the film version of the hit Broadway musical was released in 1964 and won eight Academy Awards.

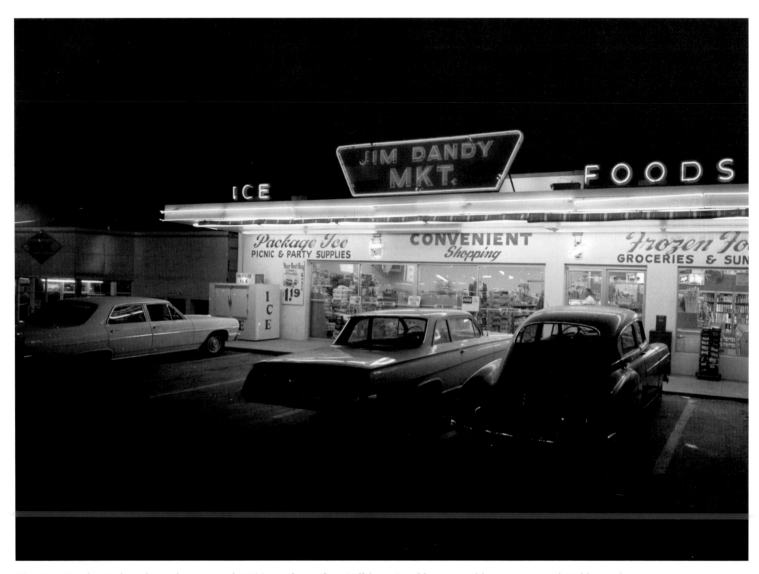

This Jim Dandy Market, shown here around 1966, was located on Hillsboro Road between Abbott Martin and Hobbs roads in Green Hills. Jim Dandy, Bi-Rite, Martin's Food Town, and Stop-N-Go were among the leading small grocery and convenience markets serving the Nashville area.

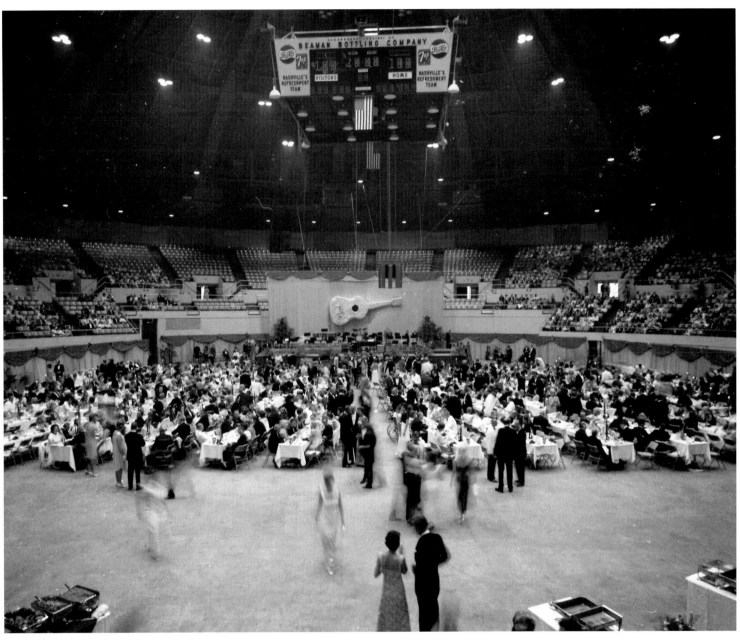

Guests gather in the Municipal Auditorium for a Chet Atkins tribute in May 1967. The futuristic multipurpose auditorium opened in 1962, hosting a Church of Christ revival as its first event. Circuses, hockey, rodeos, country music's Fan Fair, concerts, and many other events have entertained Nashvillians beneath its circular roof. Performances by Ted Nugent, John Denver, the Isley Brothers, Natalie Cole, the Rolling Stones, and countless other celebrities have been staged here, and the Dixie Flyers hockey team scored for local hockey fans here from 1962 to 1970. In 1972, Mayor Beverly Briley hosted a dinner celebrating the 10th anniversary of the auditorium.

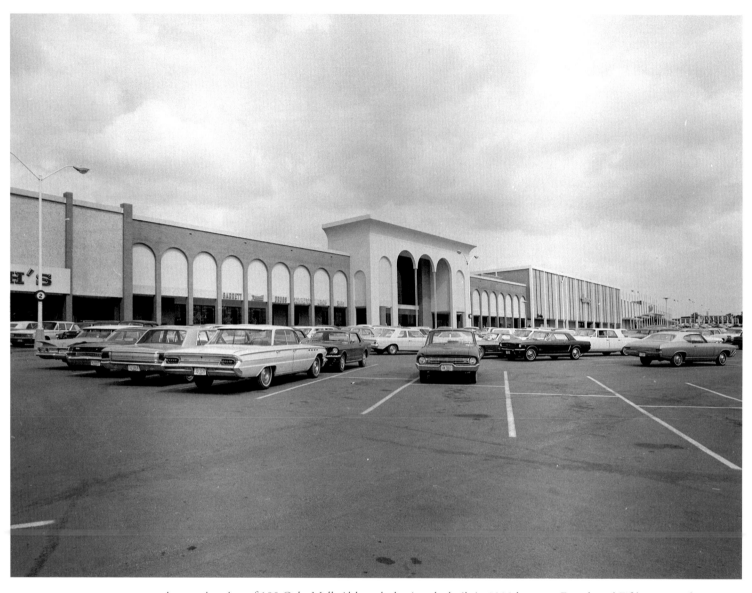

An exterior view of 100 Oaks Mall. Although the Arcade, built in 1903 between Fourth and Fifth avenues downtown, will always be Nashville's first "enclosed" shopping mall, 100 Oaks Mall became the city's first mall as they are built today. In its early years, every Nashvillian shopped here. The rise of other malls in the surrounding suburbs would lead to stiff competition, but 100 Oaks has reemerged more than once over the years as a key shopping destination.

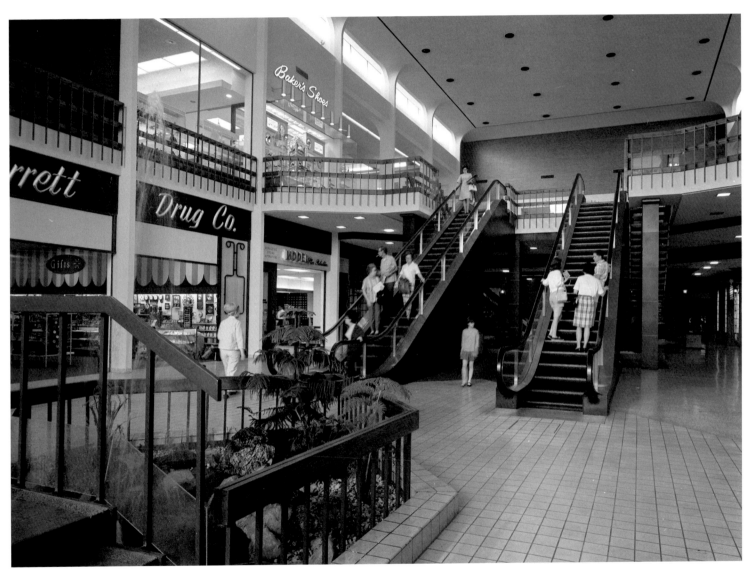

When 100 Oaks Mall on Powell Avenue opened in 1968, it quickly became Nashville's premier enclosed shopping destination. Penney's and Harveys served as anchor stores, and the mall included a Morrison's Cafeteria, the Collector's Shop for coin and stamp collectors, Games Imported for board game enthusiasts, a Woolco, and many other venues. Shown here is the lower level, located along the mall's midpoint.

An exterior shot of the Ryman Auditorium on Fifth Avenue. The Ryman, built in 1892 by riverboat captain Thomas Ryman, was originally used as a religious meetinghouse, becoming home to the Grand Ole Opry in 1943 where the show was broadcast for 31 years.

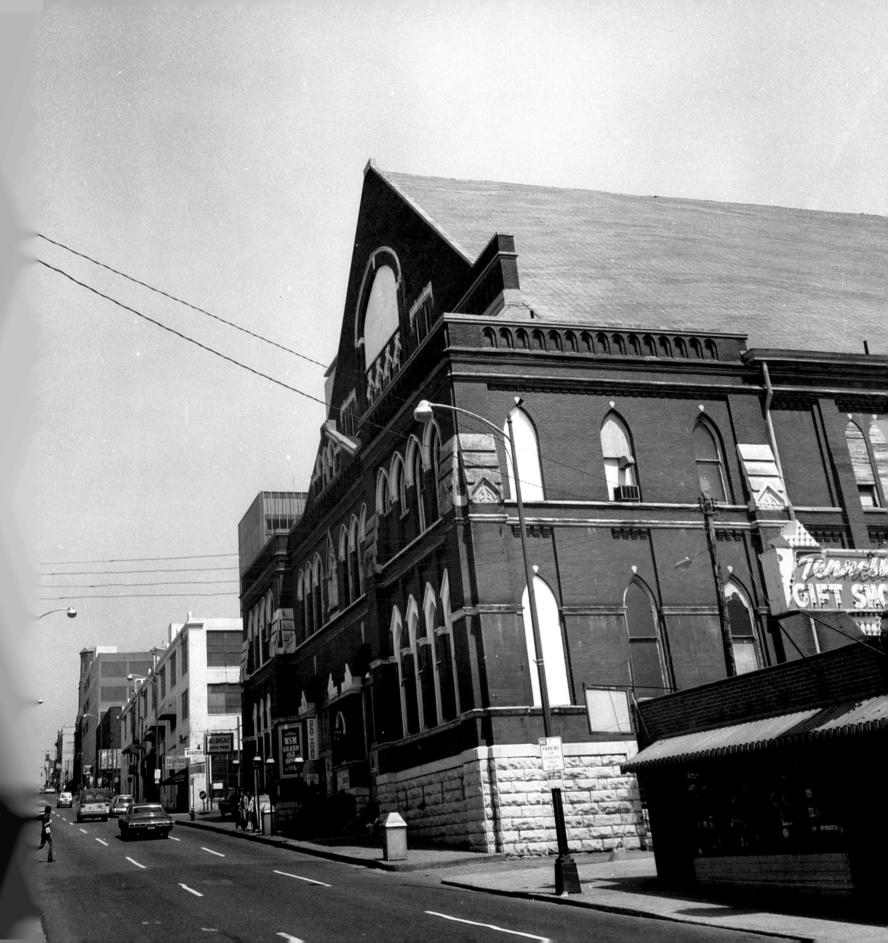

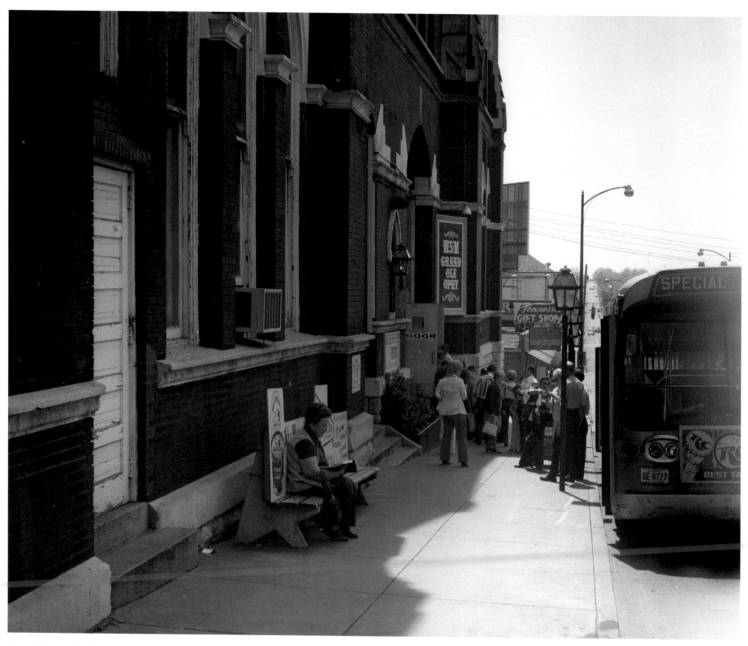

A small crowd of visitors gathers outside the Ryman Auditorium. For fans at home, the Opry broadcast one of two shows Saturday evenings on television, along with its WSM radio program, which still airs as the longest-running program in broadcast history.

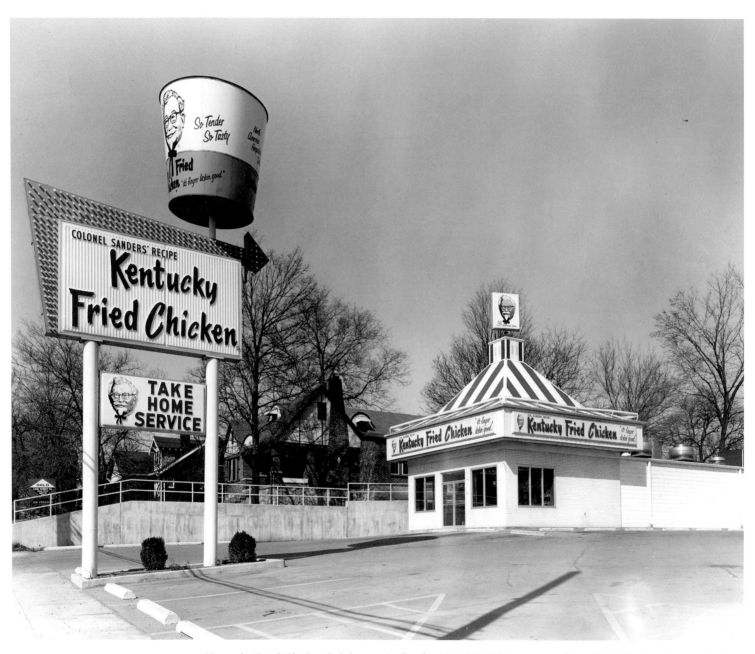

Kentucky Fried Chicken led the way in fast food in 1969. This was one of two Nashville locations at the time.

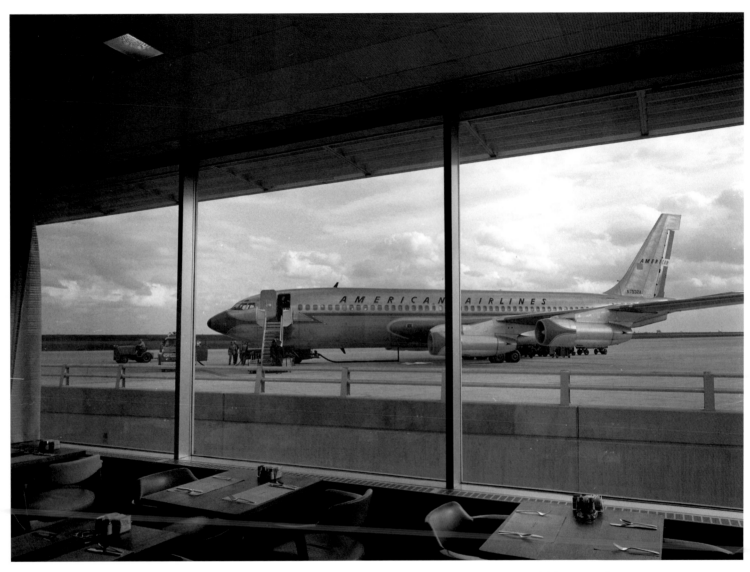

An American Airlines jet is refueled at Berry Field, later known as Nashville International Airport. Berry Field first opened in 1937, followed by a larger terminal in 1961. A government-sponsored facility, the airport continues to expand.

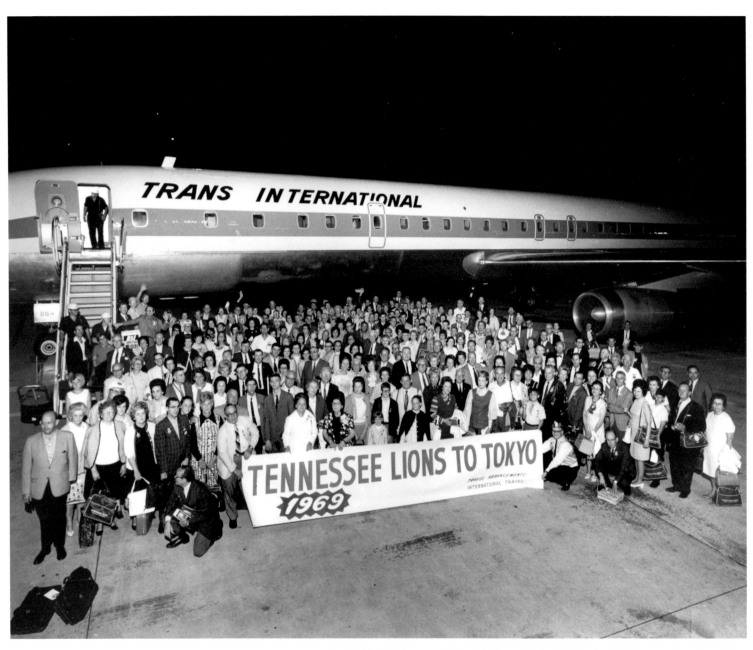

In 1969, the Tennessee Lions Club traveled to Tokyo for their international meeting.

David "Stringbean" Akeman was a regular at the Grand Ole Opry as both a banjo player in company with Grandpa Jones and a comedian. His attire was his hallmark— an extra-long shirt, which played up his height, and a pair of blue jeans, which Akeman wore belted at his knees. Stringbean was also a founding member of the popular variety show *Hee Haw,* which aired nationwide. In November 1973, Akeman and his wife returned home to their Ridge Top cabin following an Opry performance and were shot to death. The double murder alarmed the public. Two years later, young Marcia Trimble was murdered while en route to deliver Girl Scout cookies in a Green Hills neighborhood. In the years to come, Nashvillians would begin to realize that, although it is always the best of times and the worst of times, sometimes the worst gets the upper hand.

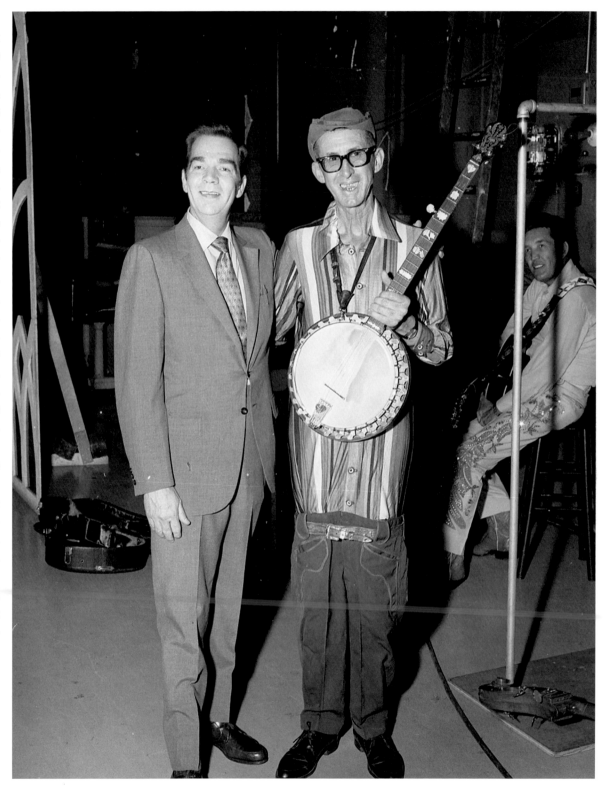

TOWARD THE FUTURE

(1970S)

The growth spurt of the sixties left Nashville ready to burst at the seams, and in the 1970s it did just that, while spending the balance of time acclimating to its new circumstances. While city youth delivered the *Nashville Banner* to doorsteps everywhere, whole families left the city for suburbia. Interstate connectors were built, malls replaced downtown five-and-dimes, cross-town busing came to the public schools, and Nashville proper became a less centralized destination.

During the 1970s, the State Capitol enjoyed another facelift, and St. Thomas Hospital built a new state-of-the-art medical facility in Belle Meade. Vanderbilt University continued its own expansion, razing entire blocks of old homes along 31st and Blakemore. Another neighborhood along Park Avenue and row of stores that included Austin's Electric Shop, purveyor of model trains for the hobbyist, was felled to dig a canyon for I-440, which remained snarled on the Tennessee Department of Transportation drawing board until 1986. Rivergate Mall and Hickory Hollow Mall joined 100 Oaks Mall as destinations of choice among shoppers, and the Green Hills strip of stores underwent a continual state of commercial development, eventually to emerge as the Mall at Green Hills. As the Andrew Jackson Hotel came down in the early seventies, the James K. Polk State Office Building and the Tennessee Performing Arts Center went up. First American Bank built a 28-story tower on Deaderick Street, creating a sensation during excavation when the remains of a saber-toothed cat were found 30 feet below ground level inside an ancient limestone cave. The Children's Museum moved out of the venerable Peabody Building, leaving behind its aura of nooks and crannies that had fascinated youngsters for a generation. The last train departed Union Station, leaving the station's cavernous Train Shed a rookery for pigeons, and a tornado toppled Giuseppe Moretti's *Battle of Nashville* Monument, which had presided over Franklin Road since 1927.

Opryland opened in 1972 as a theme park on the banks of the Cumberland River east of the city, attracting Americans from far and wide to music and rides. The nation's countercultural movement took root in local fashions as long hair, short skirts, and bell-bottom trousers pushed the envelope of respect and respectability. Robert Altman came to town to film *Nashville* in 1974, an award-winning but not-so-flattering look at the world of music and politics and those who make it. Nashville was on the map and emerging as a city more recognizable as the place Nashvillians today call home.

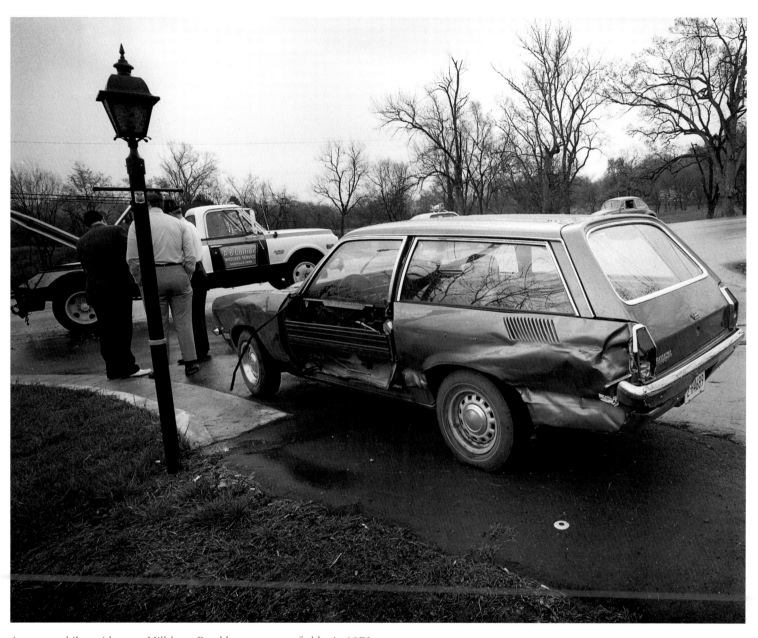

An automobile accident on Hillsboro Road becomes news fodder in 1972.

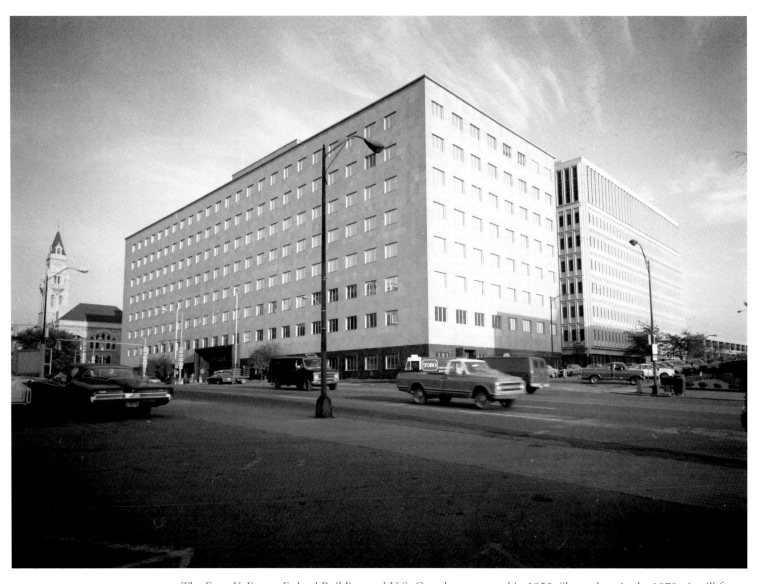

The Estes KeFauver Federal Building and U.S. Courthouse opened in 1952. Shown here in the 1970s, it still fronts Broadway, along with the 1877 Customs House, in view to the left, and the 1934 downtown post office, out of view at right, now home to the Frist Center for the Visual Arts.

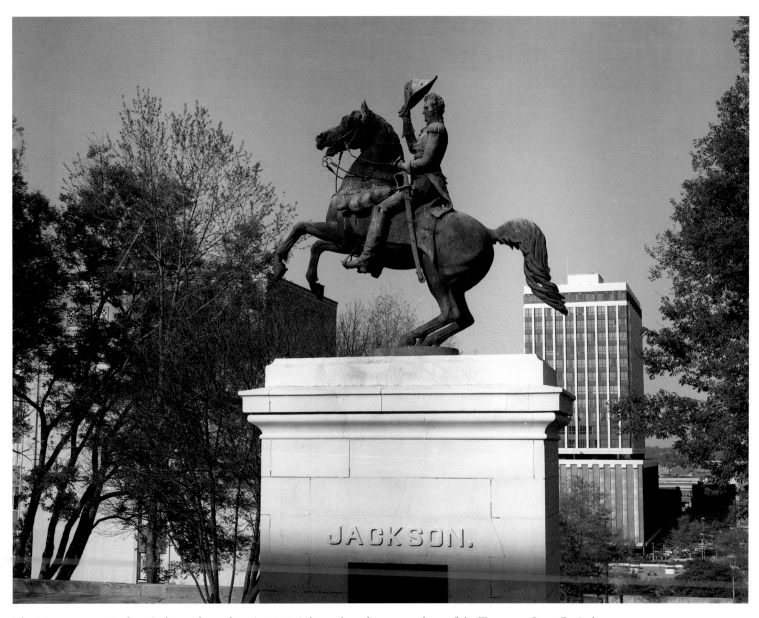

The Monument to Andrew Jackson, shown here in 1977, is located on the eastern slope of the Tennessee State Capitol grounds. One of three in existence, it joins another at New Orleans and a third in Washington, D.C., in tribute to the former president. The monument was dedicated during Nashville's centennial celebration in May 1880.

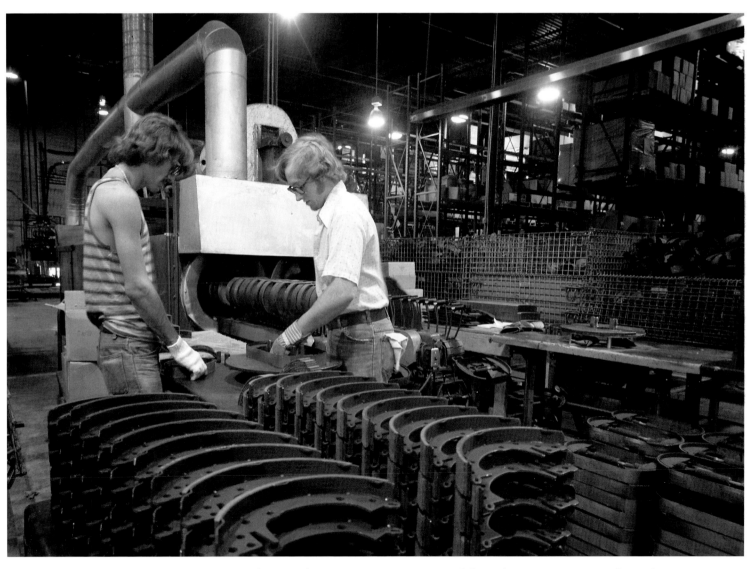

Employees at the Nuturn Corporation, around the mid-1970s. Nuturn manufactured automotive parts.

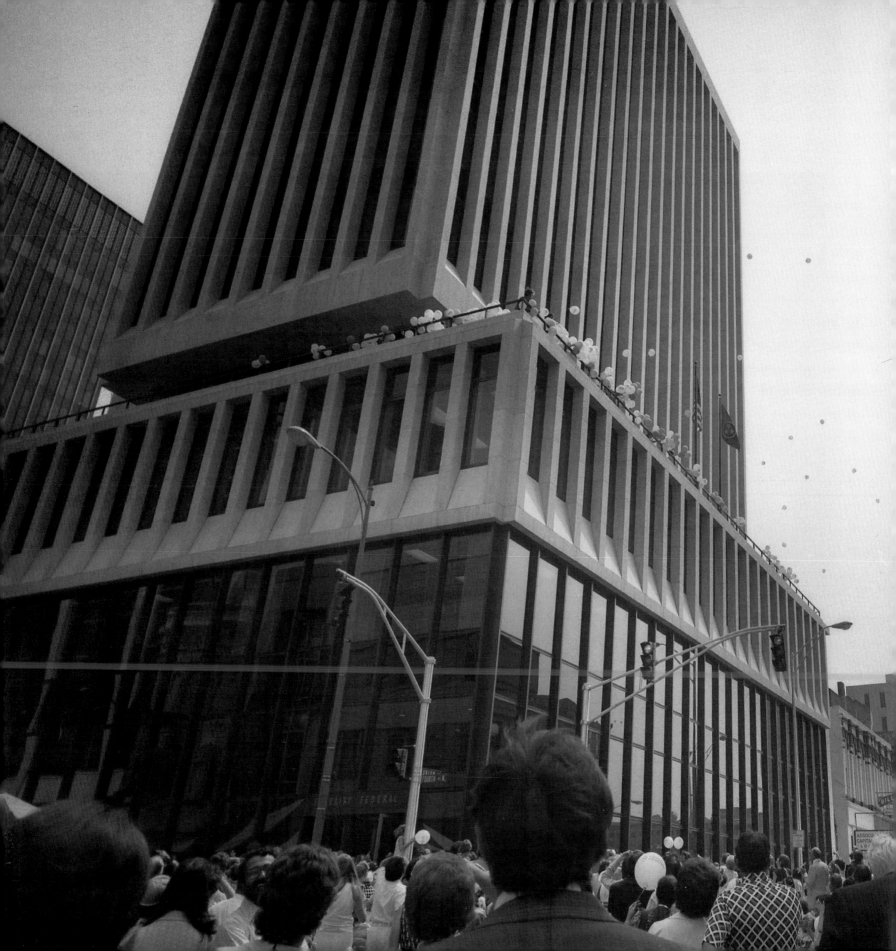

A crowd gathers for a Fidelity Federal open house in 1975. Fidelity Federal's new building was located on Union Street in downtown Nashville. In the distance stands the new Hyatt Regency Hotel, crowned by its circular revolving restaurant.

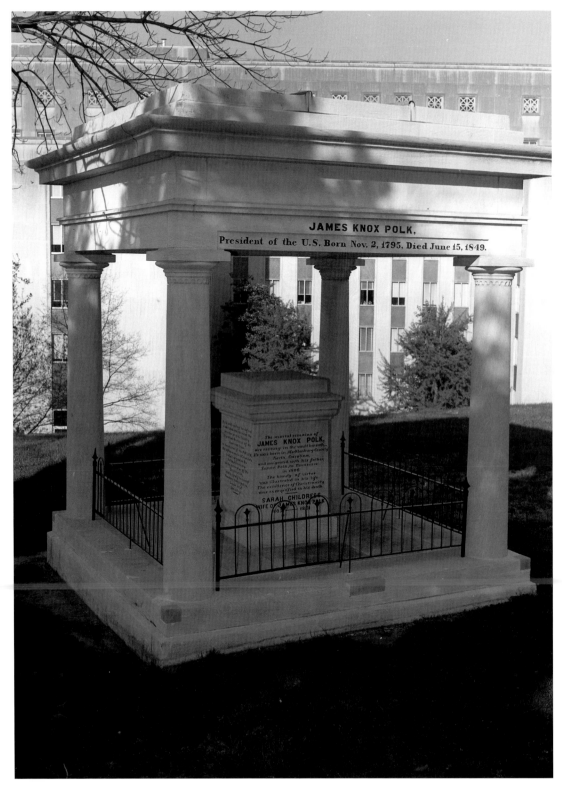

The tomb of James K. Polk, shown here in 1977, is located on the northeast grounds of the Tennessee State Capitol. Polk became president of the United States in 1844. First Lady Sarah Childress Polk rests beside him. In the background stands the Cordell Hull Building.

JAMES KNOX POLK,
President of the U.S. Born Nov. 2, 1795, Died June 15, 1849.

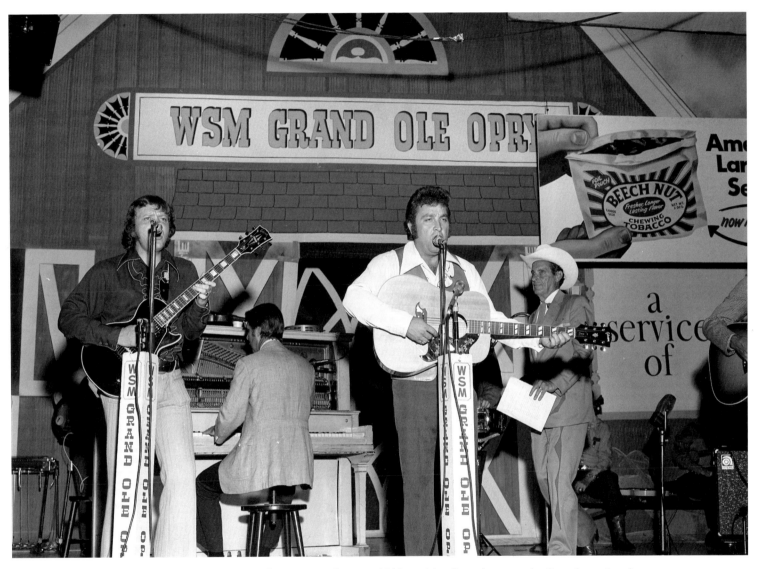

A Grand Ole Opry performance, with Ernest Tubb at right. Over the years, the Opry has enjoyed many sponsors, among them Beech Nut Chewing Tobacco, Martha White Flour, and most recently, Cracker Barrel Old Country Store and Restaurant, which originated in Lebanon, Tennessee.

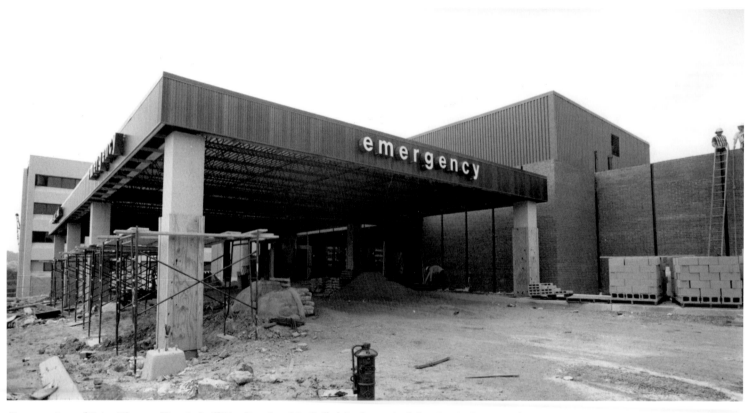

Construction of Saint Thomas Hospital off Harding Road in Belle Meade was in full swing in June 1974. St. Thomas was established in 1898.

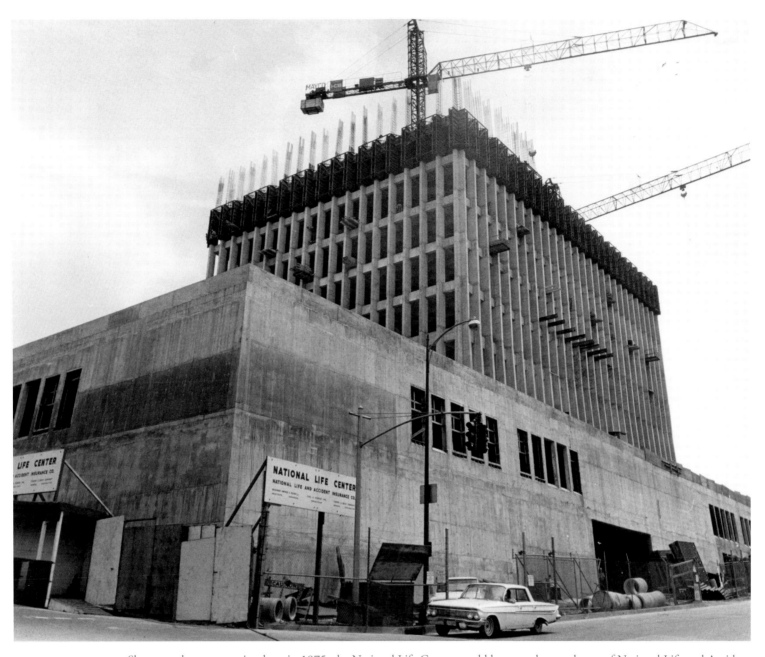

Shown under construction here in 1975, the National Life Center would become the new home of National Life and Accident Insurance Company. The company began WSM radio in 1923, taking the call letters from the company's motto: We Shield Millions. On WSM, National Life and Accident aired advertisements, a new concept at the time, and in 1925, a radio program began airing that later became known as the Grand Ole Opry.

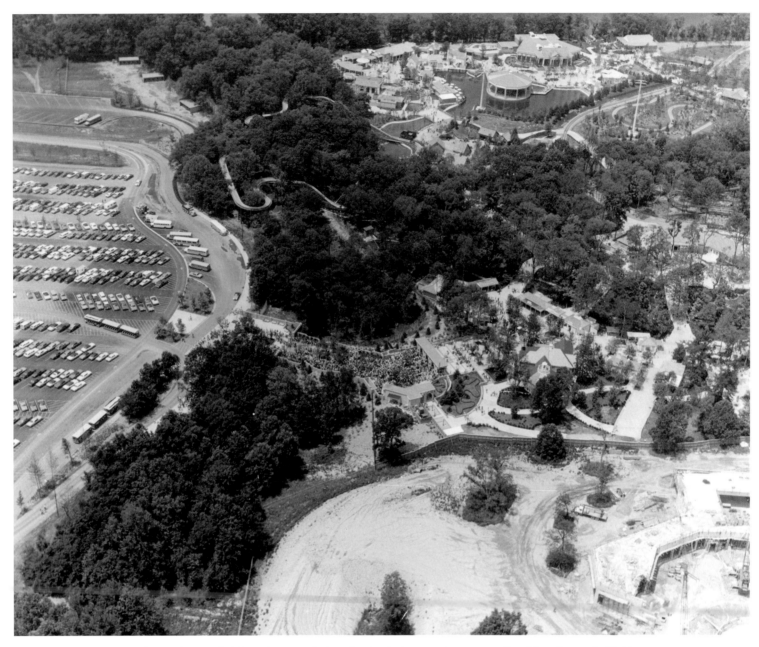

An aerial shot of Opryland USA shows a fledgling theme park. Opryland, which opened in 1972, offered live shows, thrill rides, a petting zoo, and more. Remember the rides Wabash Cannonball, Grizzly River Rampage, the Screamin' Delta Demon, and the Old Mill Scream? Many theme park enthusiasts may recall the flood of 1975, which delayed the park's season opening when the property was inundated by the Cumberland River. Opryland USA became Opryland Themepark in 1994, closing its gates in 1997 when Gaylord decided it was a liability. The property is now home to Opry Mills shopping mall.

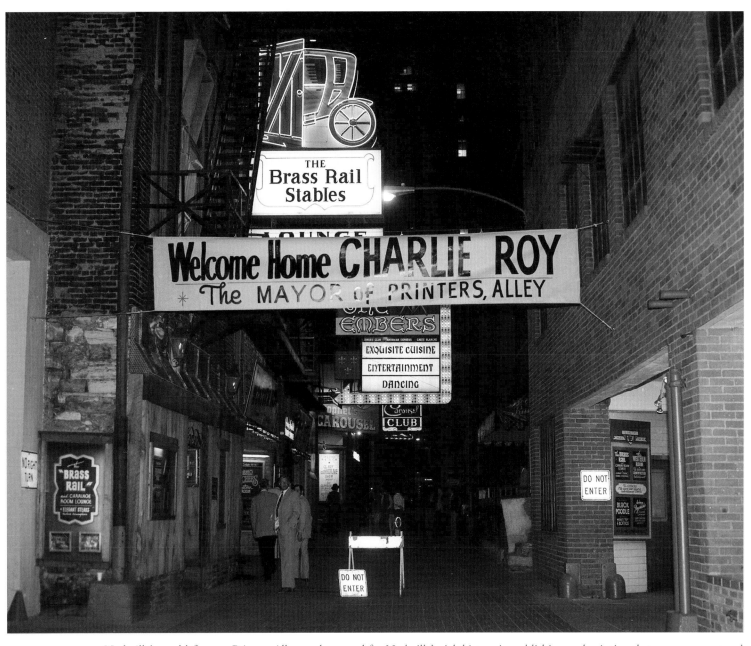

Nashville's world-famous Printers Alley, aptly named for Nashville's rich history in publishing and printing that was once centered there, is bound by Third and Fourth avenues and Union and Church streets. Convenient to nearby hotels, the alley hosted nightclubs beginning in the early 1940s, as well as several businesses of a less reputable sort. Printers Alley continues to be a popular destination for a night out for both locals and tourists, luring folks with its loud music and fine ales.

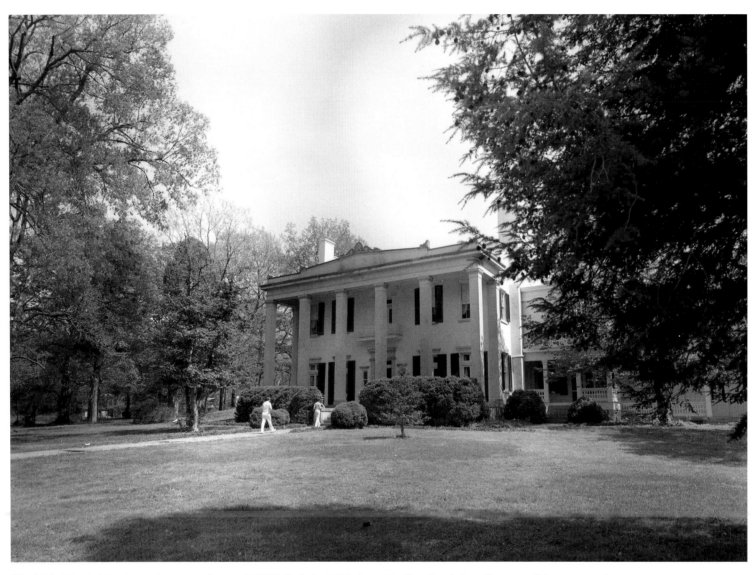

The Belle Meade Mansion as it appeared around 1974. Built in 1853 along Harding Road six miles west of downtown, the antebellum plantation home continues to draw visitors interested in the history of bygone Nashville.

NOTES ON THE PHOTOGRAPHS

These notes, listed by page number, attempt to include all aspects known of the photographs. Each of the photographs is identified by the page number, photograph's title or description, collection, archive, and call or box number when applicable.